ABSTRACT EXPLORATIONS IN ACRYLIC PAINTING

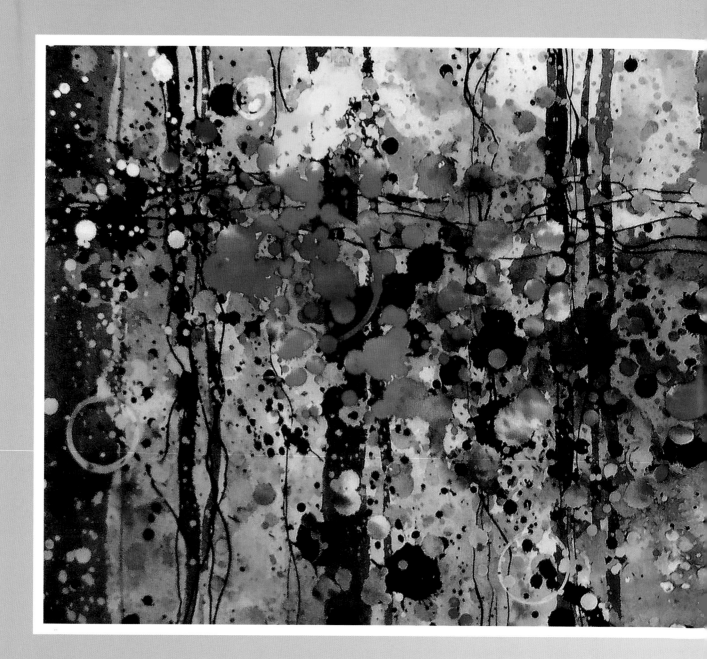

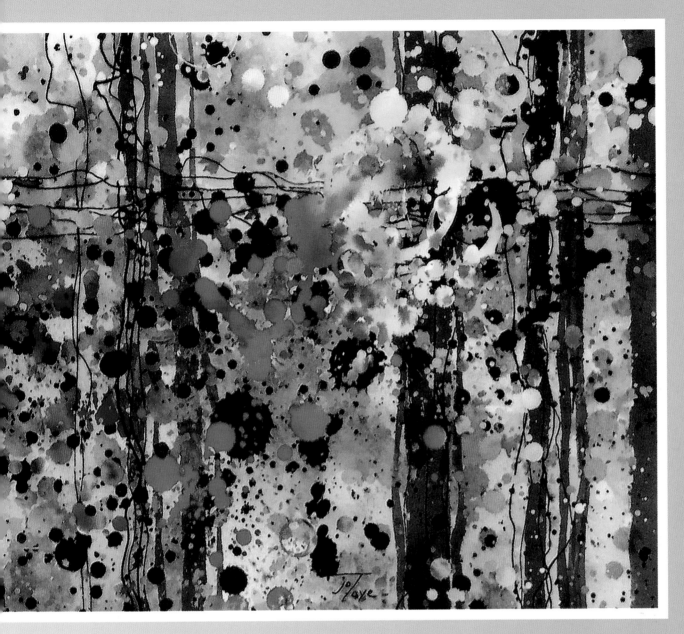

ABSTRACT EXPLORATIONS IN ACRYLIC PAINTING

JO TOYE

NORTH LIGHT BOOKS
CINCINNATI, OHIO
www.ArtistsNetwork.com

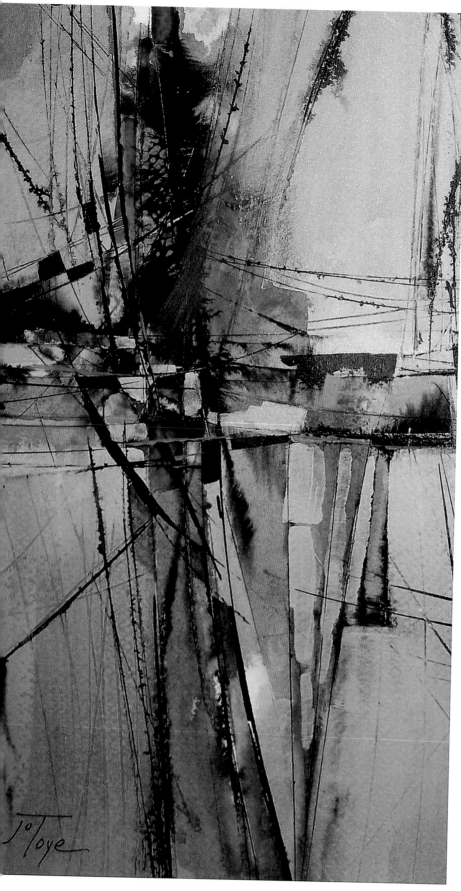

CONTENTS

WHAT YOU NEED

PAINTS, ASSORTED
FLUID ACRYLICS, ASSORTED
PAINTBRUSHES, ASSORTED
PAPERS, ASSORTED
PENCILS, ASSORTED
SCRAPER
SMALL CAT FOOD CAN
RAZOR BLADES, ASSORTED
PIPETTES OR EYEDROPPERS
MOUTH ATOMIZER
FOAM ROLLERS, ASSORTED
CRAFT KNIFE
RESIST PEN, ASSORTED
FINE MIST SPRAY BOTTLE

APPLICATOR BOTTLES, ASSORTED
RUBBER CEMENT PICK-UP
GLUE GUN
GLUE STICKS
TEFLON
SILICON SHEET
CARD STOCK
STYROFOAM PLATES (PALETTES)
CHALK, WHITE
MAKE-UP WEDGE SPONGES
DRY ERASE MARKER
CLEAR PLASTIC SHEET PROTECTOR
STENCILS, ASSORTED
BONE FOLDER

MASKING FLUID
ACRYLIC GLAZING MEDIUM
GESSO, ASSORTED
INDIA INK
PAPER TOWELS
PALETTE KNIFE
PLASTIC
YUPO
MASKING PEN
MASKING TAPE
OLD PAINTING
COTTON SWABS
SPONGE
CLEAR TAR GEL

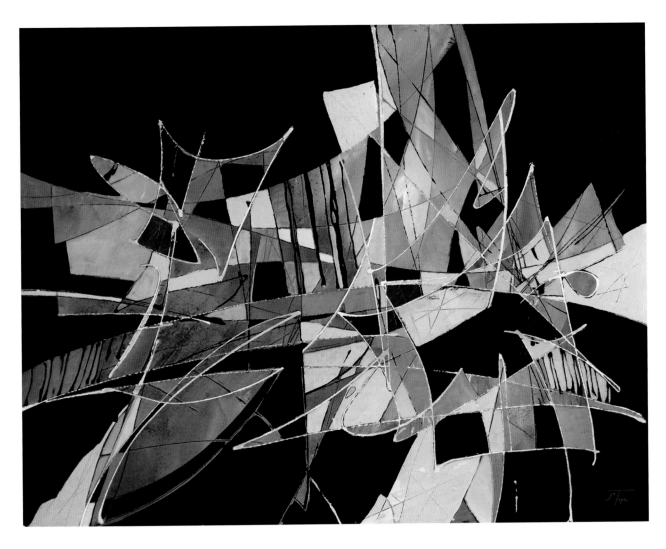

VISIT ARTISTSNETWORK.COM/ABSTRACT-EXPLORATIONS FOR BONUS CONTENT.

INTRODUCTION

"EDUCATION IS NOT THE FILLING OF A PAIL BUT THE LIGHTING OF A FIRE." WILLIAM BUTLER YEATS

I know most of us don't read art books but we love art books—we buy art books, we fill our bookcases with art books and sometimes we actually pick them up and look at the pictures (this is usually right after we buy them and right before we place them on the bookshelf). But, if you are reading this then you have happily proved me wrong and I can keep on writing with the confidence that at least one person is reading what I have to say. So, while I've got you and before you relegate me to a lonely and sedentary life on the shelf (at least sit me out in the studio or somewhere sunny), let me give you my pitch for why you might want to read the rest of this book as well as how this book might facilitate your growth as an artist.

THE WHY

In the first section of this book, Concepts and Materials, I share with you the "why." I explain why "playing" is fundamental to skill building; why I always start more than one painting at a time; why one small change in each painting can lead to big results; why I use line extensively in my paintings and why, in my workshops, I instruct my students to work on paper no larger than 100 square inches (254 sq. cm). Additionally, I explain why I use certain materials and why you too might want to give them a try.

THE HOW

In Parts 2 and 3 I share the "how." People are always intrigued by how I create my art. So, in these sections I show and explain how I do what I do. In Part 2, I demonstrate how to use the various tools that are the foundation of many of my techniques and in Part 3, I show how I accomplish these techniques through step-by-step demonstrations. I have been very careful to include extensive and detailed pictures and captions so that, if you wish, you could accomplish each technique as I have presented it.

THE REASON I WROTE THIS BOOK

I hope you will read this book because I can tell that you are someone I like. I know this because you, unlike the others (I won't name names), have not yet abandoned me

to your overflowing bookcase. And because I like you, I want to share with you why I wrote this book.

I wrote this book for you. Yep, you read that right—you. I wrote this book to serve as a kind of diving board to help plunge you into your own creative waters. As artists we have the amazing privilege to bring into this world something that has never existed before, and your art, your unique expression in this world, can not be brought forth by anyone but you.

So, I wrote this book on experimental techniques to help you dive into your art with a renewed sense of possibility and passion. As artists, I don't think there is anything more thrilling than to be immersed in our work in such a way that when we eventually come up for air, we realize we have created something that is beyond our ability or knowledge to create. We know that our hands have held the brush, but we sense that something beyond us has moved through us. This is the glory of creation, the glory of being an artist, the glory of being co-creators with the One who calls all things into being.

I wrote this book in the hope that it will inspire you to surrender to the art that percolates in you just waiting for the opportunity to be released. Take from this book what you find intriguing, play with it, morph it, incorporate it and make it a vehicle for your own expression. Bringing this book into existence has been a long but rewarding journey, and I am so honored that you hold it in your hands. I hope that throughout it you sense my heartfelt desire to be an open channel of information, encouragement and inspiration. It brings me great joy to be a small part of your artistic journey. And since I already like you, I hope one day that this journey of life and art will allow our paths to cross.

With Gratitude,
Jo

Reflections of Glory
Jo Toye
20" × 20" (51cm × 51cm)
Watercolor on canvas

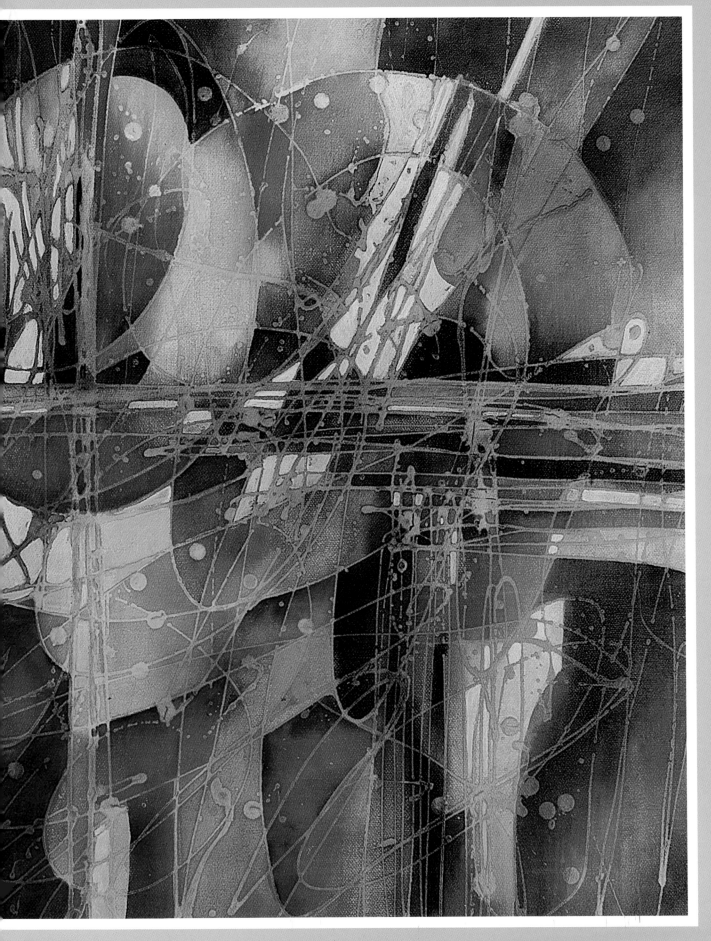

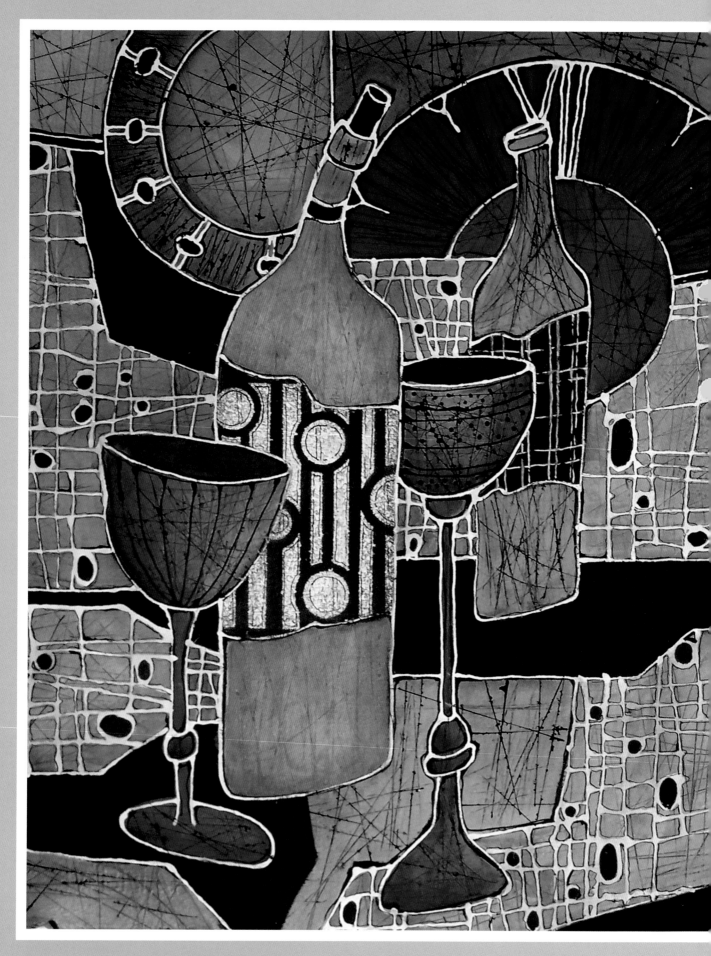

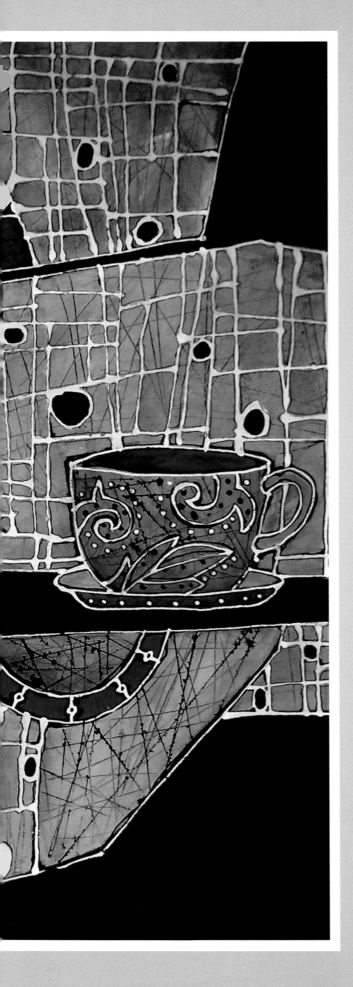

PART 1 CONCEPTS AND MATERIALS

"IF YOU HEAR A VOICE WITHIN YOU SAY 'YOU CANNOT PAINT,' THEN BY ALL MEANS PAINT, AND THAT VOICE WILL BE SILENCED." VINCENT VAN GOGH

OK, let's get started. As I stated in the introduction, this section explains the "why." The first part of this section contains the answers to why I do what I do and the second part explains why I use the materials that I do. I suppose the first section is really about inspiration. Perhaps you will find that the methods and materials I employ are not exactly suited to the way you work, but I do hope that something in this section inspires you to get going. That's the whole reason for everything in this book—to inspire you to create.

So, what are you going to create with? The pages about materials will give you some great suggestions. I outline all the different materials that I use and that I find are best suited for my techniques. If you don't have what I suggest then use what you do have. Most of us have more materials than we could use in three lifetimes, and I hesitate to imply that you need to go out and acquire more. However, I'd do you an injustice if I didn't tell you exactly what I use and why, but since this is a book on experimental techniques, if you don't have what I use, experiment with what you have and let me know about the exciting discoveries you make!

One last word (well, a few words) on materials. Any professional teacher or artist will tell you to use professional art supplies. This is because the quality of the materials is in direct proportion to the results. Student grade materials often will not render results that are possible with higher quality materials. Yet, let me make this perfectly clear, never let materials, or the lack thereof, keep you from creating your art. Use what you have and if you need to purchase something, buy the highest quality that you can afford. And if you can't afford much, improvise.

So, let's get going…

Good Times
Jo Toye
15" × 18" (38cm × 46cm)
Acrylic on 140-lb. (300gsm) watercolor paper

EXPERIMENTATION AND THE SPIRIT OF PLAY

"IT IS A HAPPY TALENT TO KNOW HOW TO PLAY." RALPH WALDO EMERSON

At first glance, Emerson's statement seems to have an odd juxtaposition of words. Most of us could easily identify with the statement if, right before he dotted that sentence with a period, good old Ralph would have slipped in a little word like *cello* or *violin* or even *golf*. "It is a happy talent to know how to play violin," would have had most of us nodding in agreement. But, our heads kind of tilt to the side when we contemplate that somehow, as this quote suggests, play itself is a talent—and a happy one at that! I may not know exactly what Ralph was thinking when he penned these words but I want to share with you how I believe this happy talent for play can benefit you as an artist.

First, let me offer that the quote does not suggest that some of us have this "talent" for play while others do not. Watch any young child and it is obvious that happy play is what we might term a "natural talent." To *play* is an inborn talent that reveals itself as one of the first ways we interact with and learn about our world. It is a simple talent that we never needed to learn but we struggle to retain.

Secondly, I believe that play, as it relates to your art is not so much a matter of what you are doing, but rather the manner in which you are doing it. You may play chess in a serious manner, yet you may work on a painting with a playful spirit. As an artist, you would, and should, be insulted if someone should suggest that you play at your art. I'm confident that you know far too well just how much work goes into a successful painting. Therefore, what I'm suggesting is that you come to your art with an open attitude of exploration: Open to whatever may happen and believing that whatever does happen is all part of the creative process.

The American psychologist, Abraham Maslow asserted that, "Almost all creativity involves purposeful play." If this is true, then play becomes an important route to mastery. To be sure, good art requires skill that has been acquired through learning and practice, but to create, not just imitate, it is important to give yourself permission to delve into your art with an attitude of abandonment and experimentation. Play allows you to enjoy the process, incorporate so-called mistakes, try something new and let go of perfect outcomes. "To know how to play" is to allow yourself to be plunged into, and totally immersed in, the realms of possibility and imagination. Play opens you to inspiration and releases you to the art that is fully yours—and only yours—to make.

Now, all this is good and valuable but you still may be wondering how all this playing can get you to a finished painting that is acceptable for an exhibition or even your own living room wall. It's my contention that if you approach your art with a playful attitude you will be more apt to keep making art, and the more art you make, the better your art will be. I firmly believe that you, and the rest of us, only learn to paint by painting.

Yes, you can learn useful techniques, better understand the elements and principles of design, glean helpful tips and build some skill as you study with other artists via classes or books. Yet, when it comes to putting together all that you've learned in a way that flows from your own inner vision in an exciting and dynamic way, you simply must paint. And paint. And paint. Having a happy talent like knowing how to play will make all this painting much more enjoyable and may even lead you to wildly successful paintings.

START THREE PAINTINGS AT ONCE

Let's say you've regained the happy talent to play. You bounce out to your studio full of possibility and an openness to experiment, but the first thing you face is that big sheet of white paper or that empty canvas… Ugh. Where do you start?

Hopefully, the demonstrations and exercises in this book will give you a nudge or two, or if you are really lucky, you have a painting waiting for you that you started but haven't finished. I say *lucky* because, for me, it is easier to come back to a painting in progress than to start a new painting. That's one of the reasons I'm going to suggest that you don't just start one painting when you bounce out to your studio—but three! I can hear you now, "Jo, you just said you have trouble starting one so why suggest three?" Because, starting three paintings at once has many advantages that will help you become a better artist.

On a practical note, starting three paintings at once gives you something to do while you are waiting for paint to dry. I don't know about you, but I am not a very patient person when it comes to drying paint. If you start three paintings, and all three are at various stages, you can leave one to dry and move on to the next, and then the next. By the time you come back to the first, voilà, it is dry and you can pick up where you left off.

Psychologically, having several paintings waiting for you helps to draw you back to the studio. There is a certain energy and momentum that builds while working on a painting that dissipates with its completion. A simple adaptation of Newton's first law of motion goes

MOVE BACK AND FORTH

Start three paintings at once and move back and forth between them through various stages of completion. What you discover while working on one can easily be applied when you move onto the next. While you want the three paintings to be different, you will learn the most if they are all similar in subject matter or technique—doing this when trying something new is very beneficial.

like this, "an artist at rest tends to remain at rest, and an artist in motion tends to remain in motion." Having another painting waiting for you after completing one, tends to lesson the inertia you may experience that prevents you from traveling that long distance (often a hall or simply a doorway) back to the studio.

Finally, having several paintings at different stages can accelerate your learning. Far too often, when I really don't know what to do next in a painting, I just do something, or worse, anything. After all, my painting time is precious and

fleeting, and it's often difficult to just wait around until inspiration strikes. Having other paintings available allows you to step away from the current painting, move on to another and then come back with a new perspective. And, because you learn to paint by painting, when you come back to your earlier painting, you come back a better painter.

In the excellent book, *Art & Fear*, David Bayles and Ted Orland make the astute observation that what you need to know for your next painting is contained in your last piece. Moving back and forth

between paintings in differing stages of completion allows you to apply newly acquired knowledge immediately while the lessons are still fresh. Starting three paintings at once will take commitment, but it is a commitment that will serve to enhance both your motivation and development as an artist.

CHANGE ONE THING

"WHEN YOU HAVE EXHAUSTED ALL POSSIBILITIES, REMEMBER THIS, YOU HAVEN'T." THOMAS A. EDISON

Now that I have encouraged you to venture out in a spirit of experimentation, I want to offer a little advice that may serve you on the journey. As an experimental artist, it is easy to take off in some exciting new direction every time a new inspiration comes my way. For the first few years that I painted, this was exactly what I did and in many ways it served me well. I explored a wide variety of materials, experimented with many exciting techniques and taught myself quite a bit about what did and did not work. Yet, it seemed that although I had a lot of good starts, and some decent middles, I consistently found my paintings lacking by the time I reached the end.

Experimentation by its very nature implies a degree of failure. Think of Thomas Edison and his legendary thousands of tries at a light bulb. Yet, even before he had succeeded, he is quoted as saying, "I have not failed. I've just found 10,000 ways that won't work." Failure in this sense has great value as it is a means of instruction and learning. Still, as artists we tend to get discouraged if, after hours at a painting, we have only discovered what doesn't work. This got me to thinking, if I am always experimenting, how can I increase my chances of reaching successful finishes in my paintings? Yes, we all know that painting is a process and we shouldn't be tied to outcomes—but really, who doesn't want to finish a day or week (or even a year) in the studio and have at least one painting that we say to ourselves, "Oh wow, I painted that!"

So here's my little secret: Each time you start a new painting, make yourself change one and only one thing. You see, our brain is a predictable creature, and the little guy is really into the "familiar." When you want to coax him into doing something new, he responds best if you lure him with a little of the familiar that he likes so much. If you change only one thing in your next painting, you are building on something you have already learned—whether it does or doesn't work.

In working this way, you are increasing your chances of success because you're going to move only one step away from something you have already done—the familiar. On the other hand, if every time you paint, you brave new territories where no one has gone before, you most likely will meet some pretty steep challenges along the way. Not that challenges are not useful, but if you want to increase your learning and your chances of successful completions, making one change at a time will serve you well.

In addition, when you work this way, you slowly build a cohesive body of work without getting bored or falling into the rut of repeating your past successes. Building on the familiar while changing one thing will allow you to develop a personal style that will be identifiable from one painting to the next, even as your work evolves. Every technique in this book was developed as I followed this practice of "changing only one thing."

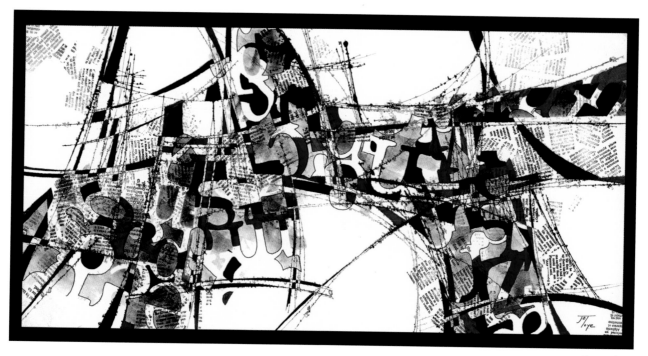

Unspoken
Jo Toye
24" × 12" (61cm × 30cm)
Acrylic and Ink on Yupo

LINE AS UNDERSTRUCTURE

In my paintings, often line is like the armature in a sculpture. It is the framework that holds the painting together and provides both the understructure and direction for the piece. I literally build my painting on top of a linear structure while leaving some of the lines exposed and burying others as I build up subsequent layers.

There are many ways to build up a painting. Some of you will choose other elements of design to guide your journey such as texture, color or shape. By starting with one element and pushing it in new directions (one change at a time), you too will discover and develop exciting ways of painting your own personal vision.

Below I illustrate how "changing one thing" plays out in relationship to the use of line.

MAPPING THE POSSIBILITIES

Using a technique known as *clustering* or *mind mapping*, I've created a visual representation of the concept: Change one thing. The main idea, line, is in the middle with the changes surrounding it. This is how I have developed all of my unique experimental techniques. Try this by starting with your own idea in the middle and then adding one possible change you could make in the circle around it. Have fun and remember, "When you think you have exhausted all the possibilities… you haven't!"

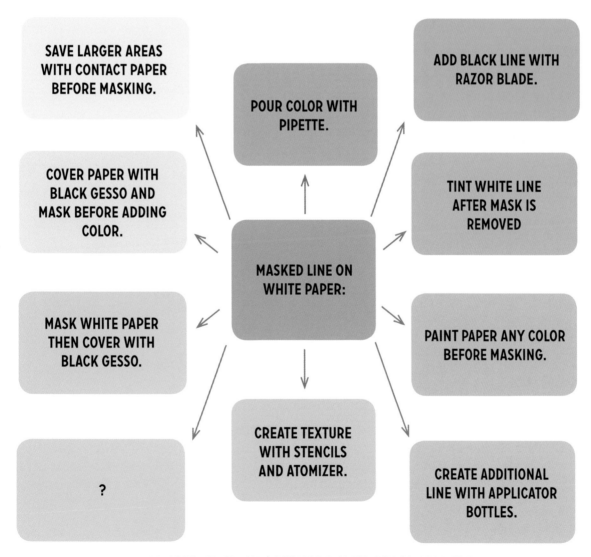

SAVE LARGER AREAS WITH CONTACT PAPER BEFORE MASKING.

POUR COLOR WITH PIPETTE.

ADD BLACK LINE WITH RAZOR BLADE.

COVER PAPER WITH BLACK GESSO AND MASK BEFORE ADDING COLOR.

TINT WHITE LINE AFTER MASK IS REMOVED

MASKED LINE ON WHITE PAPER:

MASK WHITE PAPER THEN COVER WITH BLACK GESSO.

PAINT PAPER ANY COLOR BEFORE MASKING.

?

CREATE TEXTURE WITH STENCILS AND ATOMIZER.

CREATE ADDITIONAL LINE WITH APPLICATOR BOTTLES.

VISIT ARTISTSNETWORK.COM/ABSTRACT-EXPLORATIONS FOR BONUS CONTENT.

WORKING SMALL

In my classes and workshops, I instruct my students to bring paper that has been cut into pieces no larger than 100 square inches (254 sq. cm). In fact, I encourage them to work no larger than 8" × 8" (20cm × 20cm) as that is the size I use for my demonstrations.

At first, most are skeptical, but I have queried all of my past students and they all agree that working this way while learning has immense and immediate benefits. My goal is to set them free to play and experiment and in the process learn the techniques that are being offered in each demonstration. Working small sets the stage for this to take place. While you are free to work at whatever size you wish, I would encourage you to consider working in a small format just as if you were in one of my classes.

INVESTMENT IS SMALL

By working small you will have very little investment in time, effort, paint or paper. When the only risk is a tiny little piece of paper, it is easier to adopt the attitude, "What do I have to lose?" Oddly enough, it is when you feel you don't have anything to lose that you often come up with some of your best and most innovative work.

FOCUS ON LEARNING

Working small allows you to focus on the specific technique you are learning. Instead of setting out to make a finished painting, and all that it requires, your goal will be to simply concentrate on learning the technique that is being presented. This will give you more freedom to enjoy the process and move beyond your usual way of working—which can be uncomfortable.

It is really a wonder that we learn anything as adults since—silly as this sounds—as adult learners we don't like to do anything that we don't already know how to do well. Really, it's true. So by working small, and focusing on learning only the technique rather than producing some awesome work of art, you will have greater confidence to give something new a try.

REFERENCE FOR LARGER PAINTINGS

Making small reference samples is perhaps the greatest advantage to working small while trying out a new technique or process. Small sample pieces are invaluable for future reference.

In my classes I hand out step-by-step instructions for each technique I present. I then encourage my students to take their finished reference sample, along with any notes they may have taken about the process, and place it in a clear sheet protector with the detailed instructions. You can do something similar while working through the demonstrations in this book.

As you work, make note of what is working and what is not. Reference the page in the book that pertains to the specific sample and then follow with helpful notes. For example you may note that, "I think saving more line with the masking pen would have resulted in greater design possibilities." Or, something like, "Loved the colors that I used, they were…" You can then slip your notes with the sample into a sheet protector and start a notebook that will serve as an invaluable reference for incorporating the techniques into your own style of painting at a later time. Another option is to write your notes on the back of the painting once the sample is dry.

I am sure you can relate to looking at an old painting and wondering how you painted it or what colors you used. This becomes more problematic the more you move into an experimental way of painting, but having these small reference samples for each experiment will prove invaluable.

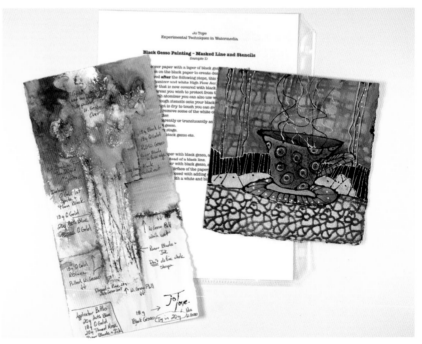

MAKE SMALL REFERENCE SAMPLES

When trying out a new technique, work on a piece of watercolor paper that will fit into an 8" × 11" (22cm × 28cm) sheet protector. After the sample is finished, place it and any printed instructions, or handwritten notes, into the sheet protector. These can be filed away or kept in a three-ring binder—you can also take notes on the front or back of your sample once it's dry. Referring back to these small samples with notes will inspire and direct you when you wish to incorporate the technique into a larger painting.

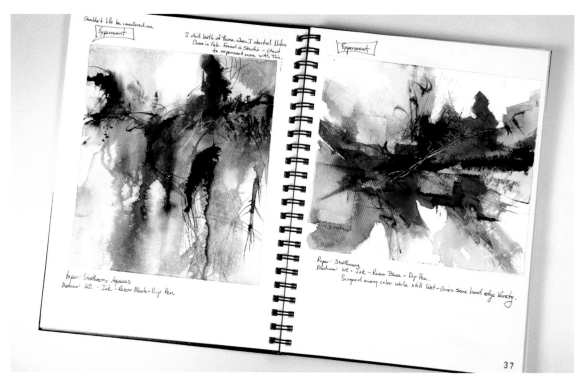

KEEP AN ART JOURNAL

Another way to preserve your small reference samples is to glue them into a spiral-bound notebook or an art journal. Be sure to cut your paper to a size that will fit on the page and leave you room to write in the margins.

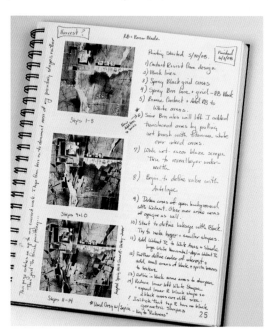

PRECIOUS PRESERVATION

If taking pictures of your painting during the painting process is a daunting prospect, consider documenting the process once the painting is finished. Take a picture of the finished painting, glue it in your art journal and then jot down anything that you want to remember. Include both the things that worked well and the things that didn't. It's also helpful to note any ideas about possible directions for future paintings. The idea is to preserve what you've taught yourself about painting before the lesson is lost or forgotten. Even though it takes effort to do this, you will benefit greatly from having preserved this information.

DOCUMENT STAGES OF A PAINTING

When trying out new techniques, it is also useful to document various stages of larger paintings for future reference. Take pictures throughout your painting process. You can then print these out and glue them into an art journal and include helpful information about each step. This helps you keep track of how you've incorporated various techniques into one painting. Once again, this type of documentation is invaluable when you are working in an experimental way. Without it, exciting discoveries can be easily forgotten.

VISIT ARTISTSNETWORK.COM/ABSTRACT-EXPLORATIONS FOR BONUS CONTENT.

PAINT

Over thirty years ago I bought my first set of watercolor paints. They sat unused and unloved until many years later when I took my first watercolor class. Immediately afterwards I took another workshop taught by a local artist, the late Dick Phillips, a wonderful man, teacher and artist who was pivotal in my painting career. He explained that the class concentrated on abstract composition using fluid acrylics on paper. I was not interested in abstract work, and I certainly didn't want to change to acrylic after just being introduced to watercolor. However, after a week under his tutelage, I was hooked on both a more fluid way of painting and the fluid acrylic paints. Long story short, I've never looked back.

ACRYLIC

Golden's Fluid Acrylics won my heart (and paintbrush) over for several reasons. Their low viscosity allows them to be substituted for many watercolor techniques but with one important advantage; dried acrylic is insoluble and does not lift when dry. This makes them ideal for the glazes that are so familiar to watercolor painters. Depending on the pigments used in manufacturing, Fluid Acrylics range from transparent to opaque. When transparent colors are used, they can produce outstanding luminosity.

In addition, acrylic paint is compatible with a wide variety of gels and mediums. Its handling properties can be altered so that it can serve a vast array of applications and painting requirements. I will introduce you to only two, Tar Gel and Glazing Medium, but I encourage you to try some of the many exciting products available.

A WORD ABOUT WATERCOLOR

Every artist has a preference for materials, and many artists, no matter how much they may enjoy experimenting with acrylic, still prefer to return to the mystery and magic of watercolor. Although I prefer fluid acrylic and use it almost exclusively in my studio and in my classes, most of the techniques in this book can be adapted to work with watercolor.

Several of my students have worked through many of my techniques using watercolor with great success and stunning results. When a technique calls for diluting paint with water or mixing paint with white, it is important to use watercolor straight from the tube to obtain the best color intensity and viscosity. Also, when you wish to make transparent watercolor opaque and retain its solubility, white gouache must be used in place of white acrylic or white gesso. The Using Watercolor In Lieu of Acrylic chart describes how watercolor can be substituted for acrylic in the demonstrations throughout the book.

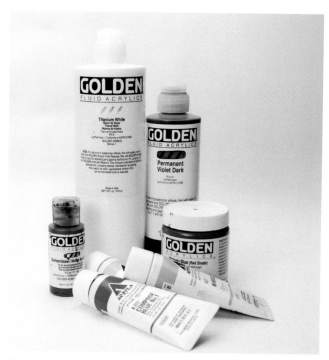

WHAT TO BUY
You can purchase acrylic paint in jars, tubes or bottles depending on the brand and formulation.

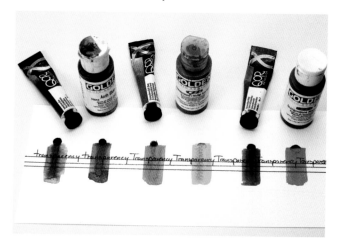

RIVALING THE TRANSPARENCY OF WATERCOLOR
The brilliance of acrylics can rival that of watercolor when transparent colors are applied in thin washes and glazes. Here, dabs of watercolor and acrylic of similar color were placed on a piece of paper. Using a brush loaded with water, the paint was pulled down over the writing and black line to demonstrate the transparency of the acrylics.

USING WATERCOLOR IN LIEU OF ACRYLIC

Yupo:
Watercolor can be used directly on Yupo or on Yupo coated with gesso.

Gesso:
Gesso can be mixed with watercolor to obtain opaque and translucent paint. The addition of gesso will make these layers insoluble once dry. White gouache mixed with watercolor straight from the tube works well and will allow you to lift and adjust the paint layer once it is dry.

Glazing Medium:
Glazing medium is not needed with watercolor.

Tar Gel:
Watercolor can be painted and dried before a layer of Tar Gel is added. You can use watercolor over Tar Gel, but it will have a tendency to bead up over the areas where the Tar Gel is applied.

Masking Fluid:
Masking fluid can be used with watercolor.

Applicator Bottles:
Tube watercolor can be diluted with water to a desired value and intensity and used with the fine-tip (20-gauge) applicator bottle.

Pipettes:
Tube watercolor can be diluted and applied with the pipettes. The resulting "poured" lines may be disturbed by subsequent layers of paint because watercolor is soluble once dry.

Mouth Atomizer:
Tube watercolor diluted with water can be sprayed through the mouth atomizer. They are easily cleaned from the atomizer because they are soluble even when dry. If white and black are desired, it is best to use only the High Flow Acrylic paint for this purpose.

Razor Blade and India Ink:
When applied with a razor blade, India ink will diffuse beautifully into wet watercolor. Be careful not to draw the ink into standing puddles of paint or the spreading ink may take over your painting.

Make-Up Sponges:
White gouache can be substituted for white gesso and sponged through stencils.

Foam Rollers:
White gesso can be rolled over an old watercolor painting with exciting results. The white gesso will absorb some of the watercolor and your white veil will be tinted by the colors beneath. This layer will then be permanent. White gouache can also be rolled in this manner, but its higher cost may make this prohibitive on larger paintings.

HIGH FLOW ACRYLIC

High Flow Acrylic is an exciting new Golden paint that lends itself to a wide range of techniques. It has a very low viscosity, and although it is 100 percent acrylic, it can be substituted for applications where you might normally use ink. You can use them with an airbrush, mouth atomizer, applicator bottle, dip pen, paint brush or pour them directly onto your surface from their original bottle in large flowing strokes. Due to their high pigment load, you can produce intense color washes, or you can dilute them as needed with water to add thin passages of color and glazes. They are formulated to have a slower drying time but, like all acrylic, once dried they are insoluble.

WATERPROOF INDIA INK

You can use India ink in many of the same ways as High Flow Acrylic including airbrushes, technical pens and the mouth atomizer. In the techniques that follow, you will be using Black India ink with a razor blade, but you can achieve exciting effects by placing it in a fine tip applicator bottle. Because of its composition, it blooms beautifully on paper saturated with water or wet washes of diluted paint. Acrylic ink has a different formulation and will not produce the same results as waterproof India ink.

LOW VISCOSITY

High Flow Acrylic and waterproof India ink have a very low viscosity and can be used for drawing and painting techniques.

USE HIGH FLOW ACRYLICS WITH STENCILS

Spray Titanium White High Flow Acrylic through a handmade stencil onto a black gessoed (or any previously painted) surface. The custom-made mouth atomizer and the super low viscosity of the High Flow Acrylic makes spraying possible even with white paint (which tends to be thicker and thus harder to spray). While any color of High Flow Acrylic can be used, the advantage of spraying opaque white is that once it's dry, any color of the acrylic you normally use can be glazed over the white. By spraying white and then glazing over it with color, you eliminate the need to purchase additional colors of High Flow Acrylic paint.

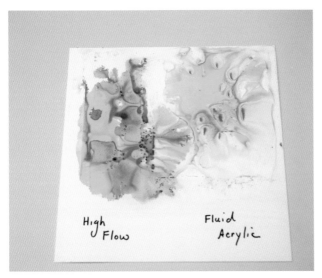

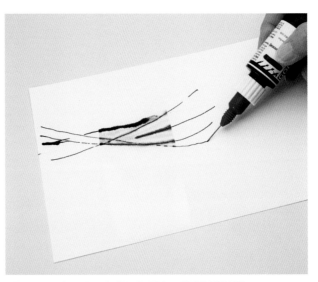

USE HIGH FLOW ACRYLIC TO ACHIEVE VIBRANT WASHES

When you want vibrant wet-into-wet washes of color, High Flow Acrylic will outperform even the highly pigmented Fluid Acrylics. When High Flow Acrylic is dropped onto a Yupo surface coated with water, it blooms but retains its intensity. Fluid Acrylic will bloom and disperse more widely thus lowering its vibrancy as it spreads. Choose either one for different but equally stunning effects.

USE HIGH FLOW ACRYLIC WITH A FINELINE TIP

Because High Flow Acrylic has a pourable top, you can pour it directly from the original bottle. If you want more control, transfer it to an applicator bottle or use the Fineline applicator caps made specifically to fit onto the small High Flow Acrylic bottles. For fine lines, draw the applicator bottle filled with paint over dry paper. When you want the lines to diffuse, draw the paint through an area of wet paper or wet paint.

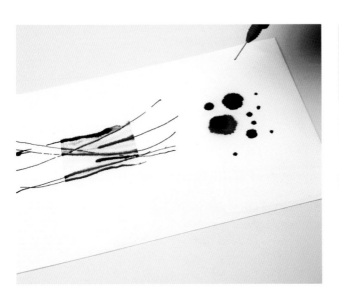

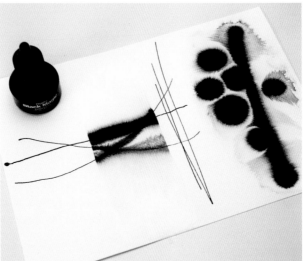

DRIP HIGH FLOW ACRYLIC ONTO DRY OR WET PAPER

Instead of spattering or dripping paint from a brush, you can obtain more control of paint placement by using the applicator bottle. The height and amount of pressure on the bottle will determine the size of the drops. High Flow Acrylic is so highly pigmented that even when you drop it onto wet paper it retains a high level of color strength.

APPLY WATERPROOF INDIA INK TO WET PAPER FOR UNEXPECTED RESULTS

Transfer India ink to a fine tip (20-gauge) applicator bottle and experiment with applying it to dry and wet paper. You will get similar results to what you achieve with the High Flow Acrylic, but you will find that India ink will be a bit more aggressive in its desire to take over the paper surface. Be careful to apply it sparingly to wet paper, or over washes of wet paint, as it will spread and bloom very quickly.

VISIT ARTISTSNETWORK.COM/ABSTRACT-EXPLORATIONS FOR BONUS CONTENT.

GESSO

Gesso is a versatile material that has been used by artists for centuries. Historically, gesso is made with rabbit skin glue and calcium carbonate and has traditionally been used to seal canvases from the corrosive properties of oil paint. However, the gesso that you'll find on most art shelves today is an acrylic-based primer combined with calcium carbonate (chalk) and pigment.

Gesso is used to seal, prime and add tooth to a wide variety of surfaces including paper, wood and canvas. You can purchase it from many manufacturers and in a wide range of viscosities. While standard gesso is white, you can now obtain it in a variety of colors including black and clear.

Like paper and paint, gesso comes in both student and artist grades. The main difference between student and artist grade gesso is the amount of pigment contained in the formulation and the degree to which the pigment and chalk is ground. These factors effect the gesso's ability to cover the surface and the final smoothness of the application.

WHITE GESSO

The white gesso I use in my studio is the Professional Gesso by Liquitex. It comes in a pourable bottle, and its viscosity and pigment load is perfect for both adjusting the opacity of paint and for covering the paper's surface with only one coat. Its main advantage is that it is formulated to offer the ideal degree of absorbency for various uses.

When this gesso is applied to the surface of Yupo, it not only gives it tooth but adds a measure of absorbency. This slight absorbency affords more control of the wet paint layer than working directly on an uncoated Yupo surface. As with all artists supplies, often the choice is a matter of personal preference. Experiment with different brands and viscosities of gesso to obtain the surface texture that will meet your particular needs.

BLACK GESSO

Black gesso is one of my favorite materials and I prefer to use the Golden brand. This gesso is a rich, dark black and easily covers the white paper surface with one coat. Since black gesso is archival, surfaces prepared with it will not fade over time. Coating white Yupo or watercolor paper with black gesso generates a surface that invites the artist's imagination to venture into new and exciting territory.

Working on black is very counterintuitive for most watermedia painters who take advantage of the white of the paper and are most familiar with transparent applications of color. Therefore, working on a black gesso substrate requires that translucent and opaque color be applied to build up paint layers. Several of the techniques that follow employ this beautiful and seductive surface.

Additionally, black gesso can be substituted for those times when you would normally use black acrylic paint. The advantage of black gesso is that it dries to a matte versus glossy finish and maintains some absorbency because of its tooth.

OTHER GESSO USES

- Coat nonabsorbent Yupo paper with gesso to increase the absorbency.
- Add gesso to acrylic paint to produce an opaque or translucent paint.
- Coat traditional watercolor paper with gesso to make it less absorbent.

MIXING

While some artists insist that only white acrylic should be mixed with acrylic paint to produce opaque colors, there is no chemical issue when gesso is mixed with acrylic paint. Gesso is also a more economical choice. Yet, if you prefer a glossy opaque appearance, mix your acrylic paint with Titanium White acrylic instead of gesso.

CLEAR GESSO

Clear gesso is an interesting product. It has considerably more tooth than other gessoes and dries clear to translucent. Coat Yupo with clear gesso when you want even more tooth than what white gesso normally provides, or mix clear gesso with acrylic paint to create your own custom color.

MIX GESSO WITH TRANSPARENT PAINT

Mix transparent acrylic with white gesso to produce an opaque or semiopaque paint. By mixing gesso with your paint, you will create a flat matte finish. The best results can be obtained by mixing fluid paint and a low viscosity gesso.

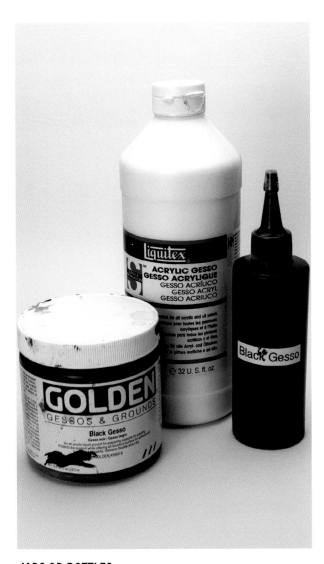

JARS OR BOTTLES

When possible, purchase gesso in bottles for ease of dispensing. You can later transfer gesso that comes in a jar into airtight bottles that you purchase at the art or hobby store. Be sure they seal tightly or your gesso will dry out.

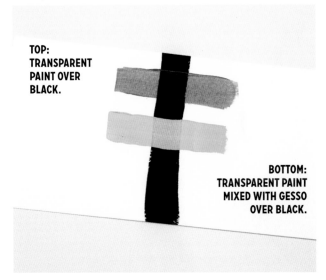

TOP:
TRANSPARENT
PAINT OVER
BLACK.

BOTTOM:
TRANSPARENT PAINT
MIXED WITH GESSO
OVER BLACK.

DIFFERENT MIXTURES

It's not possible to cover a dark or black surface with transparent paint. However, when working on black, mix white gesso with your transparent paint to achieve an opaque or semiopaque paint.

DIFFERING WHITES AND THEIR USES

In general, white gesso, Titanium White and Zinc White acrylic paint can be used alone or mixed with acrylic to produce opaque and translucent color mixtures. All of these whites have differing characteristics and will serve different purposes depending on your desired results.

You can also mix any of these whites with watercolor, but the paint layer will then become insoluble. To avoid this, you can use white gouache. In addition, you can paint white gouache on top of dried acrylic. This creates interesting possibilities because the gouache, once dry, can be lifted off the surface revealing the underlying acrylic color. When doing this, you will not disturb the underlying acrylic because, unlike watercolor, it cannot be lifted once dry. Avoid getting any layer containing gouache too thick, as it can crack or flake off your surface when dry.

DIFFERENT OPACITIES

A layer of four different whites have been painted across a strip of red to highlight their different opacities. You can see that the white gesso and the Titanium White are similar in their covering ability. Whereas, in contrast, Zinc White is very transparent, and has $1/10$ the tinting strength of Titanium White. Both Titanium and Zinc White dry to a semigloss sheen while the white gesso will dry to a matte finish. White gouache shares more characteristics with white gesso in that it is very opaque and also dries to a matte finish. The main difference is that white gouache is specifically intended to be used with watercolor and shares watercolor's ability to remain soluble once dry.

CAUTION!

If you use gesso or white acrylic to mix with your watercolors, be sure not to get any of the gesso or acrylic on your watercolor palette. Also, be sure not to mix it into any paint in the wells. It cannot be removed from the palette or from the paint on the palette. Always use a separate disposable palette when you are creating mixtures with any form of acrylic and watercolor.

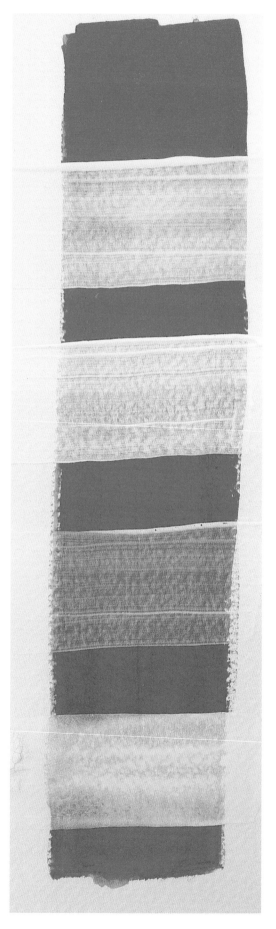

From Top to Bottom: White gesso, Titanium White, Zinc White, White gouache.

MIXING DIFFERING WHITES WITH COLOR

All whites can be mixed with color. When white gesso and Titanium White are mixed with another color they both lighten the color and increase its opacity depending on the ratio of the white to color. With the addition of enough white, the paint layer can become completely opaque but it will also lighten to a pastel tone.

When using white gesso or Titanium White, for a more translucent paint application use less white or use white with the addition of glazing liquid. Because Zinc White is intrinsically translucent, when you add it to transparent color, the resulting mixture will be translucent rather than opaque. Also, unlike Titanium White, when you add it to another color to lighten it, it doesn't immediately change it to a pastel tint.

Furthermore, white gouache can be quite opaque when mixed with color, but it will vary depending on the amount of gouache used. Mixtures of gesso and gouache will dry to a flat matte finish while Titanium White and Zinc White mixtures will dry to a semigloss sheen. All of these different characteristics will determine which white will suit your particular needs.

Another option, when you desire opaque or translucent paint, is to purchase paint that already has the desired opacity. The advantage is that you can purchase the value and hue you desire and can avoid lightening your colors with the addition of white. The disadvantage is that you will have to determine the opacity of each particular paint, and you will have to purchase all the various opaque colors that you want to use. Fluid acrylics range from transparent to opaque, but for certain colors the only option is to add white if an opaque paint is desired. Opaque color is more easily found in tube paint, and most paint brands will note on the label the opacity of each specific color.

USE WHITE TO MIX OPAQUE AND TRANSLUCENT COLORS

Transparent Phthalo Turquoise is painted across the top of a strip of black gesso. It is then mixed with white gesso, Titanium White, Zinc White and white gouache. Choose your white depending on your desired opacity and the sheen of the finished paint layer.

MIXING WITH GOUACHE

When mixing white gouache with paint, always use fresh gouache directly from the tube so that your paint mixture does not become too diluted. When you want vibrant hues of color, you can use colored gouache instead of mixing white with your watercolor.

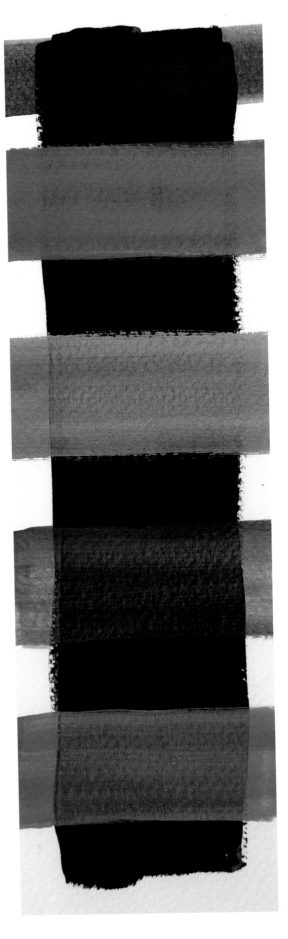

COLOR REFERENCE CARDS

Color, glorious color! Of all the choices we make in a painting, color is one of the most important and one of the most personal. Color is generally the vehicle through which we have the most freedom of expression, and it's often what elicits or strengthens an emotional response from our viewers.

I must confess that of the many bottles and tubes of paint that I possess, when it comes time to put paintbrush to paper I almost always reach for just a few. Why? Because I have found that the fewer colors I allow to play together on my paper, the better they get along. When I don't invite too many colors to my painting party (in color terms this is known as a limited palette) and allow these few colors to mingle and create new colors, this results in combinations I would have never chosen and mixtures that all look beautiful together. There is no easier way to achieve stunning color harmony than by selecting a few colors and seeing what happens.

COLOR REFERENCE CARDS ON WHITE PAPER

Some colors play together better than others. There is nothing like the excitement of seeing colors bleed and blend together on a wet piece of paper, but there is also a great disappointment when colors combine to produce muddy, dull mixtures. I have never been able to bring myself to do complicated color charts, but I have found doing individual color reference cards to be easy, quick and invaluable.

It's useful to start with a triad (three) of colors that you already tend to use. It is most useful to choose primary combinations of yellow, red and blue because these will mix to create secondary hues of green, purple and orange. These mixtures will produce a full spectrum color wheel. As you experiment, you will find some triads that result in luscious colors all the way around the wheel, while others may only produce one or two colors that appeal to you.

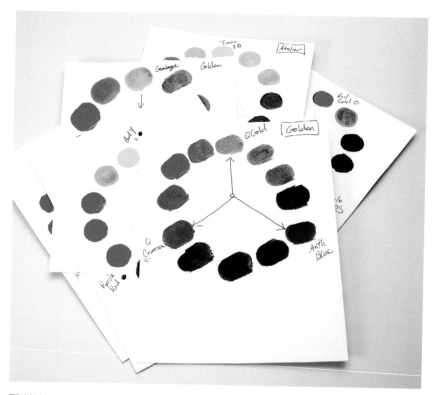

TRANSPARENT COLOR REFERENCE CARDS

When working with transparent color on white paper, try to keep your mixtures somewhat diluted. If you mix fluid acrylic straight from the bottle, some colors will be so dark that the resulting mixtures will look black.

PRIMARY COLORS

I use the term *primary* loosely when referring to color card combinations. True primary colors are pure hues of yellow, red and blue that cannot be created by mixing any other colors together. Feel free to use colors that are in the yellow, red and blue family. Avoid using three secondary colors in the green, orange and purple family. Combining these will result in dull and lifeless mixtures because of the complementary hues contained in each.

COLOR REFERENCE CARD ON WHITE PAPER

Every time you get a new tube or bottle of paint, consider doing a color reference card. Combine this new color with two other colors that you're already familiar with and see what happens.

MATERIALS LIST

BRUSH

PAINTS, ASSORTED

PAPER

1 SELECT PRIMARY COLORS
Place a small amount of red, yellow and blue paint on your palette and cut a small rectangle or square of watercolor paper to use as your reference card. Then draw three equidistant lines, or a triangle, onto the center of the paper.

2 PAINT SWATCHES
At the end of each line, paint a small square or circle of each color. It doesn't matter in what order you place the colors, but it's useful to keep the order the same from one reference card to the next.

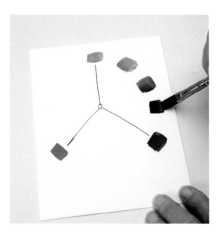

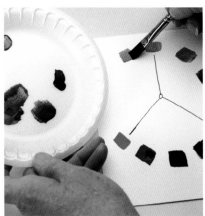

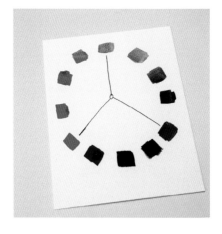

3 MIX BLUE AND YELLOW
Mix a small amount of blue with your yellow and paint a small area just to the right of the yellow. Now mix in a little more blue and paint another swatch of color. Add just a little more blue and place this just below the last swatch you painted. Depending on the ratio of yellow to blue, your colors will progress from yellow-green to green, to blue-green.

4 MIX THE COLORS
Proceed to mix the blue with the red and the red with yellow just as you did with the yellow and blue. Try to mix at least three intermediary steps between each set of colors as this will provide a full spectrum range of colors for reference.

5 COMPLETED REFERENCE CARD
It only takes a few minutes to complete the color card. Once it's finished, don't forget to place the name of the paint you used next to the three original colors.

COLOR REFERENCE CARDS ON BLACK PAPER

At no time are color reference cards more valuable and necessary than when you are planning to create a painting on a black surface. Most of you will be much more familiar with how transparent colors mix and mingle on white paper and may have little or no experience painting with translucent or opaque paint on black. The black background makes paint appear differently than the same paint on a white surface. Also, because you will be adding white to your paint to make it translucent and opaque, the color reference cards can give you a chance to test out different ratios of paint color to white for varying levels of opacity.

For your black painting surface you can use a studio grade watercolor paper that you coat with black gesso. Once again, start with a triad of colors in the yellow, red and blue family that you enjoy working with; but, this time add white gesso, white gouache or Titanium White to the center of your palette.

Without the addition of white, your transparent paint will disappear when applied to the black surface. The more white in your mixture, the more opaque the color will be and the more it will be visible on the black surface. An opaque mixture (which covers the black surface) is not necessarily better than a translucent mixture (which partially covers the black but allows some of it to show through). You will have times when either opaque or translucent color will be preferred, but when creating your color reference cards make sure to mix enough white with the paint so that the color is clearly visible.

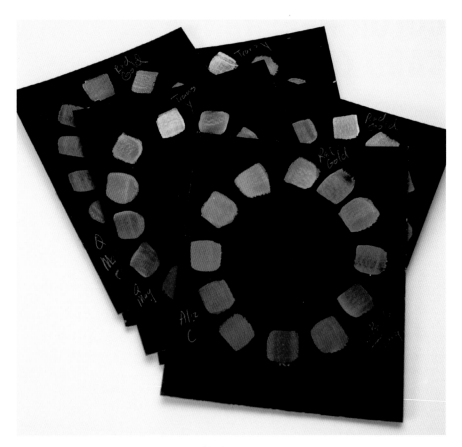

BEFORE PAINTING ON A BLACK SURFACE

Try paint color combinations on paper that has been coated with a layer of black gesso. Coat a sheet of studio grade watercolor paper with black gesso and then cut it into small squares or rectangles to make several black color cards at once. Because you may not be familiar with opaque paint and how it appears on a black surface, these reference cards are even more useful and valuable than those you make with transparent color on white paper.

AVOID UNPLEASANT SURPRISES

Until you become familiar with the opaque and translucent mixtures that your paints produce when white is added, always try out your colors before starting a painting. Reds will become pink or mauve with the addition of white, and some hues are difficult to integrate into a painting. By creating a color reference card you can avoid problematic color combinations.

COLOR REFERENCE CARD ON BLACK PAPER

Use color reference cards on black paper to discover exciting color combinations. By starting with just three colors and white, you will achieve a full spectrum of harmonious opaque mixtures.

MATERIALS LIST

BRUSH

GESSO, ASSORTED

PAINTS, ASSORTED

PAPER

PENCIL, WHITE

1 MIX YELLOW AND WHITE
Select three colors and white gesso. Mix some of the yellow paint with a small amount of white gesso. Be sure not to mix in too much white or the color will be too light; yet, it is important to mix in enough white so that the mixture will be visible on the black surface.

2 APPLY PAINT TO PAPER
Place a small brushstroke of the yellow mixture onto your black card. If the color you lay down is too transparent or too light in hue, you can adjust this mixture as needed and paint over the first application of paint.

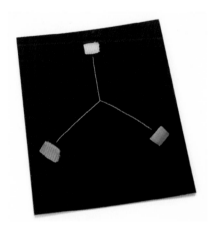

3 MIX THE COLORS
Repeat steps 1 and 2 with both the red and the blue, and paint a small square or circle of each color on your reference card in the appropriate location.

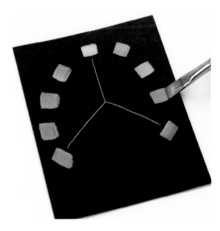

4 MIX PROGRESSIVE AMOUNTS
Mix a very small amount of blue into a mixture of yellow and white, then apply to the card. Mix a little more blue and paint another swatch of color, adding more white if necessary. Proceed to mix the blue with the red and the red with the yellow.

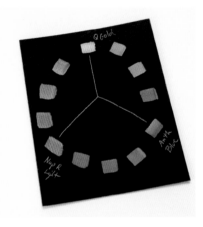

5 COMPLETE REFERENCE CARD
Use a white colored pencil to place the name of the paint you used next to the original colors.

ACRYLIC GLAZING MEDIUM

If you work with acrylic, one product you will want to have in your studio is acrylic glazing medium (or liquid). Acrylic glazing medium can be mixed with acrylics to both extend the working time of the paint and to increase transparency.

Acrylic paint applied in a thin manner dries very quickly. Since glazing medium increases drying time, it enables you to blend layers of color. This quality is invaluable when you are working with translucent and opaque paints on a black gesso surface. In addition, when you add glazing medium to opaque paint, it optimizes your ability to create translucent color mixtures, that are difficult to obtain by adding white alone. When you add glazing medium to transparent acrylic, it not only extends the drying time but increases its transparency.

Several manufacturers offer glazing medium or liquid, and it is available in both gloss and satin finish. Because I often use it with paint mixed with gesso, and because gesso produces a matte finish, I prefer to use the satin formulation. The satin glazing liquid will produce a slight sheen that blends more seamlessly with those areas of the painting that have been rendered with a matte finish.

While you can mix glazing medium into the paint with a palette knife before the start of a painting session, placing the paint and glazing liquid separately on your palette will give you more flexibility. As you paint you can adjust the ratio of glazing liquid to paint and therefore adjust transparency as you go. Simply load paint onto your brush and then pull out as much medium as desired; blend the two on your palette before applying the mixture to the painting surface.

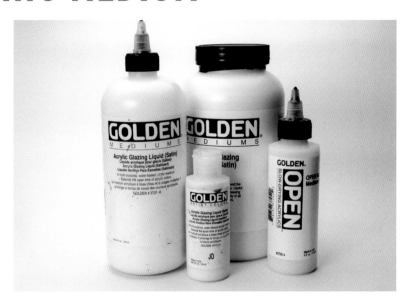

AVAILABLE IN SEVERAL FORMULATIONS AND SIZES

Depending on your use, you may prefer either the gloss or satin formulation of glazing medium. Use the gloss when you desire a high sheen. The satin variety is useful when you are only using it in some areas of the painting as it blends in better with the sheen of thinly applied acrylic. Golden's Open Medium can also be used to extend the drying time of your paint.

MIX IN GLAZING MEDIUM

To allow yourself freedom to adjust the degree of transparency as you paint, place your glazing medium on your palette separately from your other colors. Load your brush with color and then pick up some acrylic glazing medium. Mix the paint and medium together on the palette until you obtain the desired level of transparency.

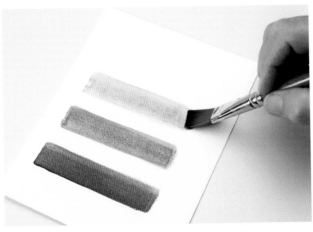

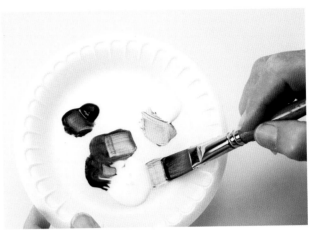

ADJUST THE DESIRED LEVEL OF TRANSPARENCY

The first line is Permanent Violet Dark without any glazing medium added. The next two lines have increasing amounts of glazing medium added. It's helpful to have a scrap piece of paper available to test the level of transparency before applying it to your painting.

MIX GESSO, PAINT AND GLAZING MEDIUM

Load your brush with color and then blend in some white gesso until you obtain the value you desire. Pull out some glazing medium with the loaded brush and blend thoroughly on the palette before applying to your paper surface.

PRODUCE A TRANSLUCENT BLEND

Make translucent paint by adding less gesso to your paint and more glazing medium. The first line is where Permanent Violet Dark has been blended with white gesso to produce an opaque paint. On the next line, glazing medium has been added to the gesso and paint mixture.

WHEN YOU WANT TO BLEND TWO COLORS

Add glazing medium to the colors before you apply them to the painting. Lemon Yellow mixed with glazing medium was painted on the black surface, then Phthalo Blue (mixed with medium) was added. The two colors blend on the surface to produce a variation from yellow to green to blue. This is very difficult to achieve without using the medium.

SCRAPE BACK THROUGH THE PAINT LAYER

Because the glazing medium will keep the paint layer open or workable for a longer time, you can make adjustments like scraping back through the paint to reveal the layer or paper beneath. Often scraping back through a translucent or opaque layer to reveal what lies beneath will help integrate that layer into the rest of the painting.

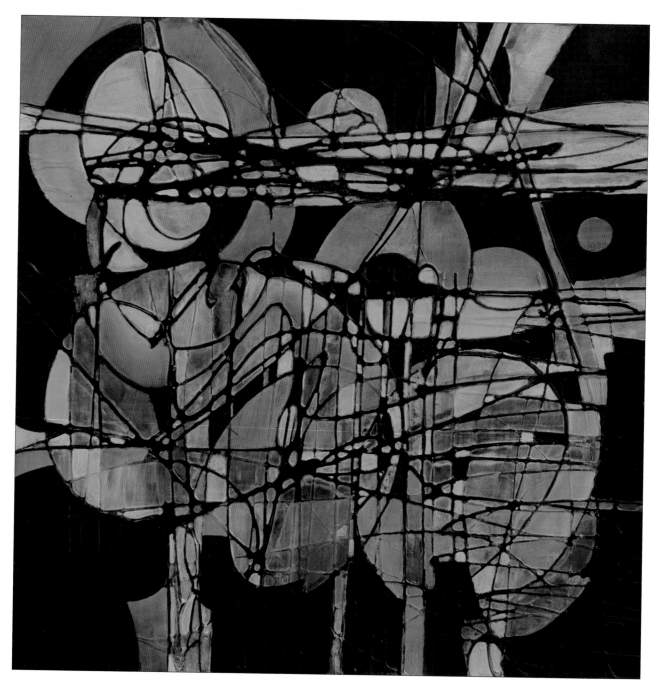

Twilight
Jo Toye
12" × 12" (30cm × 30cm)
Acrylic on Yupo

CLEAR TAR GEL

If you are like many of my students, you just might have a jar of Tar Gel sitting unopened, or at least unused, in your studio. Until you play with it and experiment with its varied applications, it can seem a bit mystifying. I have come to love Tar Gel, and you will have the opportunity to explore it later in one of the projects in this book.

I think you will find that it's a product that has properties quite unlike any other gel or medium you've ever used. It has an extremely resinous and stringy consistency much like that of honey. You can drizzle it in fine lines from a palette knife or squeeze it from bottles. You can vary the size of the line by the speed of application, the distance from the surface and, if a bottle is used, the size of the opening. While wet, the gel appears milky but will dry clear and the lines will retain their raised appearance. You can also mix it with fluid acrylic to create an unlimited range of colors.

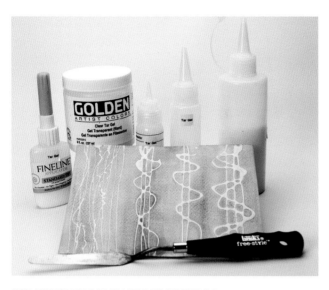

USE DIFFERENT APPLICATION METHODS

You can purchase Clear Tar Gel in a jar and then transfer it to bottles or applicators with various sized openings. Drizzling Tar Gel from a palette knife and applying it with an applicator bottle produces the finest lines. A small amount of water can be added to the Tar Gel to reduce the viscosity so that you can dispense it through the standard applicator tip (18-gauge). When dispensing from a larger tipped bottle, be careful not to get the lines too dense as the Tar Gel will tend to spread into a solid film rather than maintain its linear quality.

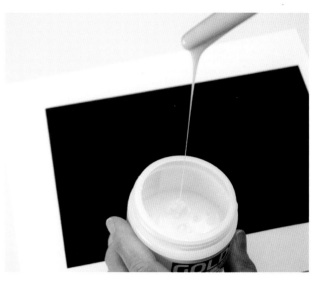

TEST THE VISCOSITY OF THE TAR GEL

As with any acrylic product, Tar Gel will tend to thicken with age after opened. Test the flow of your Tar Gel by dipping a palette knife into the gel and allowing the Tar Gel to drip back into the jar. Raise and lower the palette knife in relation to the jar which will vary the width of the flow. By doing this you can test how long the gel will continuously flow from the knife and how thin the line will be when applied at various heights from the paper.

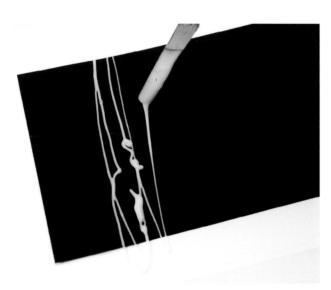

DRIZZLE TAR GEL ONTO THE SURFACE

Tar Gel will appear milky but because it will dry clear, the dried line will appear to be the color of the surface upon which it has been applied.

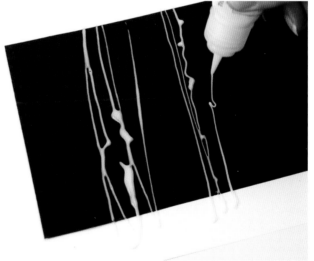

TRANSFER TAR GEL TO VARIOUS SIZE BOTTLES

If you want a little more control of line placement, transfer some of your Tar Gel into squeeze bottles. The size of the tip will determine the width of the line. Do not place the tip of the bottle directly on the paper, but rather move the bottle above your painting surface and allow the gel to flow from the tip onto the surface below. Be sure to purchase bottles that have an airtight seal if you plan to leave the gel in the bottle for any length of time.

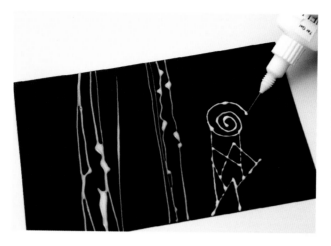

USE AN APPLICATOR BOTTLE

For a more controlled design, place Tar Gel in the standard tip applicator bottle. You may need to add a small amount of water, but be sure not to thin the gel too much as the lines will not retain their raised appearance. Use the applicator bottle when you want precise placement and very fine lines.

APPLY TAR GEL TO WHITE PAPER

Because Tar Gel is clear, the lines will appear the same color as the paper upon which they are applied. When you apply transparent paint over tar gel on white paper, the lines will be tinted by the paint but will remain visible.

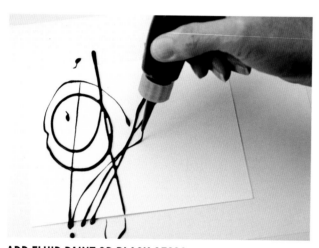

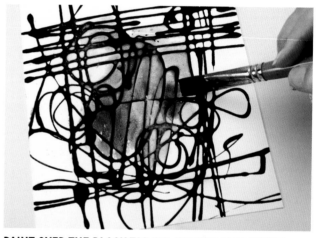

ADD FLUID PAINT OR BLACK GESSO

Give Tar Gel a color by adding fluid acrylic or a low viscosity black gesso. Only add about 10 percent paint or gesso in order for the gel to retain its resinous properties. Gently stir until it is completely mixed. Because the gel will release foam when mixed, let the gel sit for a day to allow the bubbles to disperse, then you can apply the colored gel with a palette knife or bottle.

PAINT OVER THE BLACK TAR GEL WITH TRANSPARENT PAINT

Once the Tar Gel is dry, paint over the lines with transparent paint to allow the black line to remain visible. If you wish to cover any of your lines in order to adjust the design, they can be painted over with white, black or opaque color.

CATCH THAT?

When applying Tar Gel, always place scrap or newspaper under your painting surface. If you get Tar Gel on your painting support or table and it dries, you will have irritating raised lines that are next to impossible to remove.

DEMONSTRATION
TAR GEL APPLICATIONS

Tar Gel applied to a black surface gives you an additional way to obtain black lines. Using a combination of white gesso, an old credit card and transparent paint you can create an unusual and interesting surface texture.

MATERIALS LIST

BRUSH

GESSO, WHITE

PAINTS, ASSORTED

PAPER

SCRAPER

TAR GEL

WHAT PAPER?

Working on Yupo (rather than watercolor paper) that has been coated with black gesso is better suited for this process as the white gesso will not absorb as quickly into the surface.

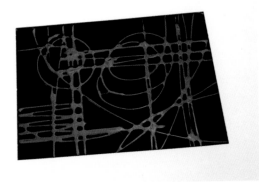

1 APPLY TAR GEL TO THE SURFACE
Apply Tar Gel to a black surface. The gel will dry clear and the Tar Gel lines appear black.

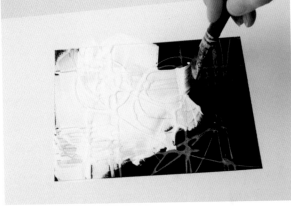

2 COVER THE SURFACE WITH WHITE GESSO
Cover the dried Tar Gel with a layer of white gesso. Because you will be scraping some of this layer off, it is important to work quickly so that the gesso remains wet.

3 SCRAPE OFF THE WHITE GESSO
Take an old credit card and, while the gesso is wet, scrape across the surface. Because the lines are raised, you will remove most of the white off of the lines while leaving most of the gesso on the surface below.

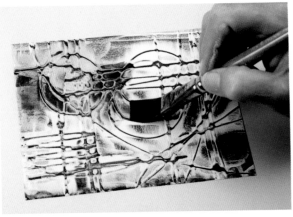

4 APPLY TRANSPARENT PAINT
Once the gesso is dry, add transparent paint which will allow the black lines to remain visible. Because the credit card removed some of the white gesso off of the underlying black surface, some of the black shows through from below—this creates a rich surface texture and the appearance of depth.

PAPER

While quality supplies are important at all stages of a painting, having a good quality artists' grade paper lays a solid foundation. Although you will be "experimenting" with new materials and processes, it's important to use artists' quality paper in order to achieve the desired results. Paper composition, sizing and texture all affect the way paint reacts with the painting surface, and often student grade papers make certain techniques difficult to perform.

WATERCOLOR PAPER

Most brands of watercolor paper produce both a students' and artists' quality paper, and usually the distinction is clear in the description. Look for 100 percent cotton paper that is acid free. The two most popular weights are 140-lb. (300 gsm) and 300-lb. (640 gsm), and in most brands you will have the choice of three finishes: hot, cold and rough.

The weight and surface texture of the paper is often a personal preference. A popular choice for many artists is 140-lb. (300 gsm) cold press. Cold press paper has a semirough surface that accepts water and pigment well and can stand up to the rigors of various techniques. Experiment with different surfaces to find those that best suit your way of working.

YUPO

Yupo is a synthetic paper that has been adopted from the commercial printing industry. It is 100 percent synthetic and is extruded from polypropylene pellets. It is an exciting alternative to traditional art papers and is gaining popularity with watermedia artists. By its very nature it is ideal for experimentation. It has a bright white surface and is waterproof, recyclable, tree-free and remains flat no matter how much water and paint is applied to the surface.

Also, it responds to paint differently from traditional paper because the plastic surface is nonabsorbent. Watercolor washes can be removed with a wet paper towel even when dry. You can remove dry acrylic with alcohol but it will often stain the paper.

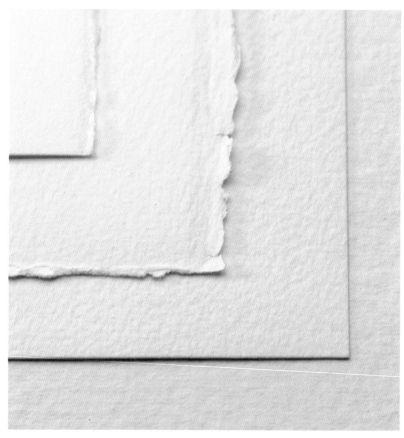

DIFFERENT KINDS OF PAPER
From top to bottom: Strathmore Aquarius, Fabriano Artistico Soft Press 140-lb. (300 gsm), Arches Cold Press 140-lb. (300 gsm), Arches Cold Press 300-lb. (640 gsm). All of these papers differ in their surface texture and absorbency.

UNIQUE SURFACE

A unique surface can be obtained by coating Yupo with a layer of white or black gesso. The gesso layer adds tooth and a bit of absorbency, which allows for more control of your paint. For the demonstrations later in the book, I will use Yupo coated with both white and black gesso.

CHANGE THE SURFACE AND COLOR OF YUPO

Coating Yupo with white or black gesso creates a different and more absorbent surface texture. Coating the surface with a good quality black gesso yields a deep rich, almost velvety surface.

COAT YUPO WITH GESSO

Use a damp soft bristle brush to cover the entire surface of the Yupo with gesso. Do not add any additional water to the gesso, or it will be too thin to completely cover the surface. You may want to delegate an old brush for this purpose, especially when coating larger surfaces.

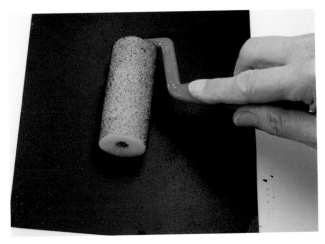

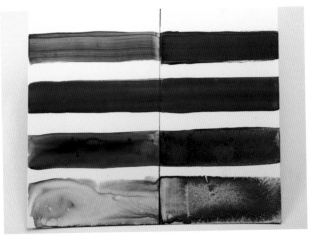

ROLL THE GESSO WHILE WET

Once your Yupo is covered with gesso and while it is still wet, roll the surface with a small foam roller. Be sure the roller is completely dry. Depending on the amount of gesso on the surface, bubbles may appear—just keep rolling until most of them are gone. This process eliminates the appearance of brush strokes and produces a beautifully smooth, even surface. You may find it useful to coat several pieces of Yupo at one time as once you clean the roller in water you must wait for it to dry to use it again.

UNCOATED VERSUS COATED

From top to bottom: Paint with very little water added, paint with gesso added, paint thinned with water on a dry surface, and paint thinned with water on a wet surface.

Fluid acrylic paint has been brushed across the surface of both the uncoated and coated sides of the Yupo. On the uncoated Yupo, on the left, the paint remains floating on the surface while the gesso coated surface on the right offers more absorbency and control of the paint application.

DON'T HEAT THINGS UP!

Yupo paper and heat are not good playmates! Never dry Yupo with a hot hair dryer or leave it out in the direct sun. Also, in warm weather, do not leave Yupo, or paintings that have been created with it, in a hot car. All of these situations will cause Yupo to buckle and warp, and you will never be able to return it to its original flat state.

TOOLBOX

I love tools, any type of tool—even the ones that don't have anything to do with painting. I love to walk up and down the hardware aisles in wonder. When I see tools, I see possibilities.

I am going to offer you a toolbox of possibilities that will hopefully spark your imagination and inspire you to use them in a way that is uniquely yours. You may find that some work well for you and others do not. The word *tool* originates from an Old English word meaning "prepare." Tools are used as we prepare our art, just as we use various implements to prepare a cake. A cake mix can be prepared with a spoon, a spatula, a whisk, a hand or electric mixer. Once the cake is finished, the tools used are not apparent, and the goal of our preparation is to enjoy the delicious result. Tools should serve the same purpose in our art; they are a means to prepare our art, but should not be so evident in the finished painting that they overshadow our enjoyment of the painting as a whole.

To do this, we must make sure that what we create with our various tools can be integrated layer by layer into the finished painting. Our goal is always a finished piece of art that communicates our vision, and we use our tools for this purpose. Yet, using a new tool can expand our vision and open our eyes to a whole new way of working.

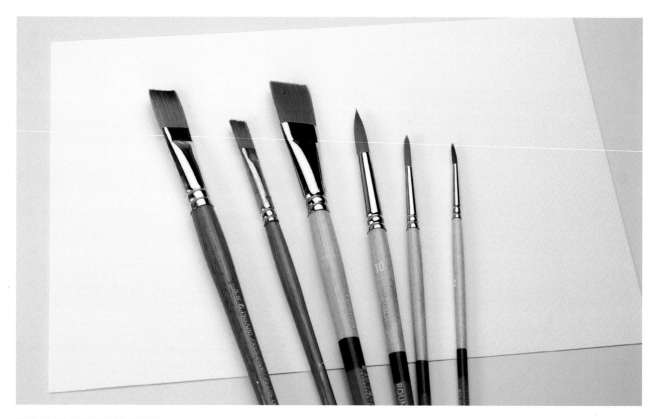

USE SOFT BRISTLE BRUSHES

Because you will be working with acrylic paint in a fluid manner, it's important that you use good quality, soft, synthetic bristle brushes. You can use the same type of brushes you use for watercolor, but you must be careful to wash the paint out of them immediately, as it will dry and harden in the bristles. Acrylic paint is insoluble once dry. For this reason avoid using sable or more expensive brushes.

NO DRY SPELLS!

When working with acrylic, always wet your brush before picking up paint. Wet the brush and then blot it on a paper towel until you pull out some of the excess moisture. Some techniques require more water to be left in the brush than others. Having some moisture in the hairs allows the acrylic to flow better and keeps the paint from drying out in the bristles.

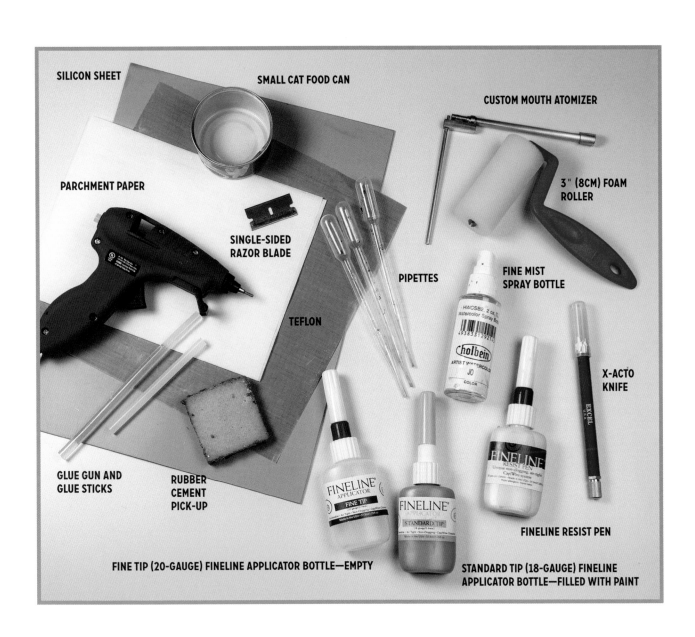

SILICON SHEET

SMALL CAT FOOD CAN

CUSTOM MOUTH ATOMIZER

PARCHMENT PAPER

3" (8CM) FOAM ROLLER

SINGLE-SIDED RAZOR BLADE

PIPETTES

FINE MIST SPRAY BOTTLE

TEFLON

X-ACTO KNIFE

GLUE GUN AND GLUE STICKS

RUBBER CEMENT PICK-UP

FINELINE RESIST PEN

FINE TIP (20-GAUGE) FINELINE APPLICATOR BOTTLE—EMPTY

STANDARD TIP (18-GAUGE) FINELINE APPLICATOR BOTTLE—FILLED WITH PAINT

VISIT ARTISTSNETWORK.COM/ABSTRACT-EXPLORATIONS FOR BONUS CONTENT.

OTHER MATERIALS

Before we get started, there are just a few other materials that you will need to complete the projects in the book. Most of these can be easily found at your local art, hobby, office or big box retailer. Indeed, you may already have many of them around the house. Often ordinary materials can be an inspiration for a new art technique or process, so those of you who have a slight tendency towards hoarding may just find a creative outlet for some of your treasures.

STENCILS

One of the most enjoyable uses for "found treasures" is to employ them as stencils. Later I will show you how to make glue gun stencils. Exciting stencil material can be found everywhere from the kitchen to the garage. After you start using stencils you will never look at anything with holes in it the same way. You can also cut your own designs out of clear plastic sheets using a craft knife or a special heated cutting tool.

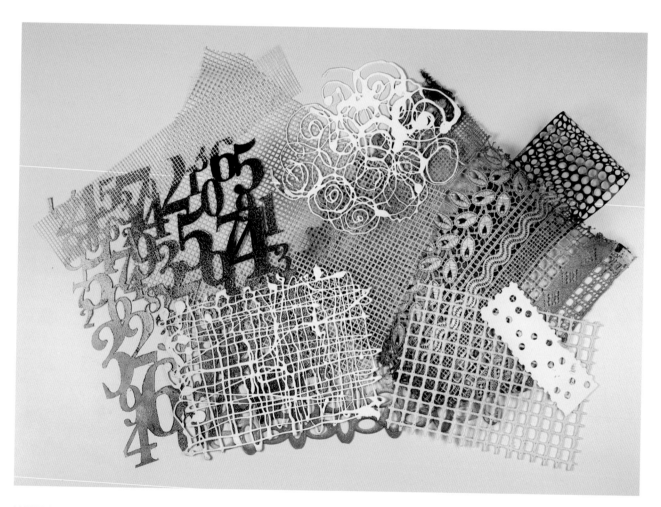

MAKE OR USE FOUND OBJECTS AS STENCILS

Once you start looking you will find stencils everywhere. You can use rug backing, needlepoint plastic, drywall tape, sequin waste, hot glue, onion bags, Halloween webbing, lace and even kitchen sink mats. You can even make a wide variety of stencils out of card stock using decorative scissors and a hole punch. For more durable stencils, you can also create a design and then cut it out of a thin sheet of clear plastic. The black stencil design with the number pattern was made this way.

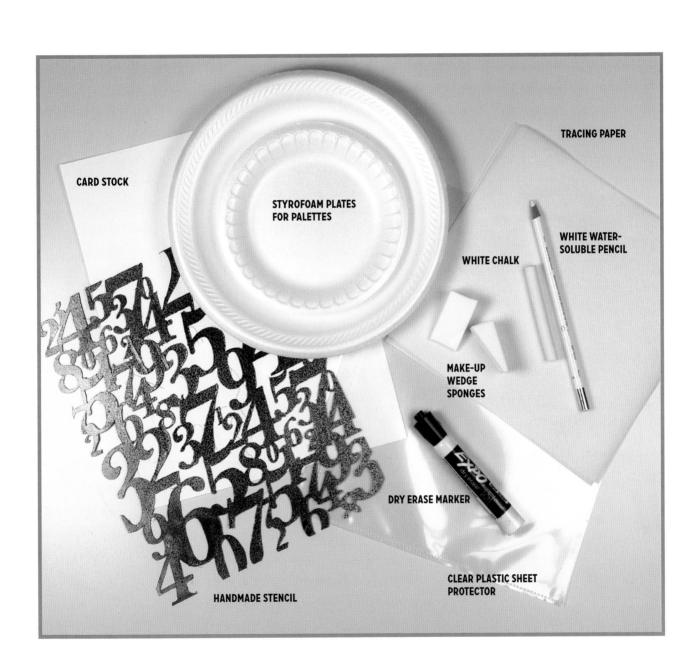

CARD STOCK

STYROFOAM PLATES
FOR PALETTES

TRACING PAPER

WHITE WATER-
SOLUBLE PENCIL

WHITE CHALK

MAKE-UP
WEDGE
SPONGES

DRY ERASE MARKER

CLEAR PLASTIC SHEET
PROTECTOR

HANDMADE STENCIL

VISIT ARTISTSNETWORK.COM/ABSTRACT-EXPLORATIONS FOR BONUS CONTENT.

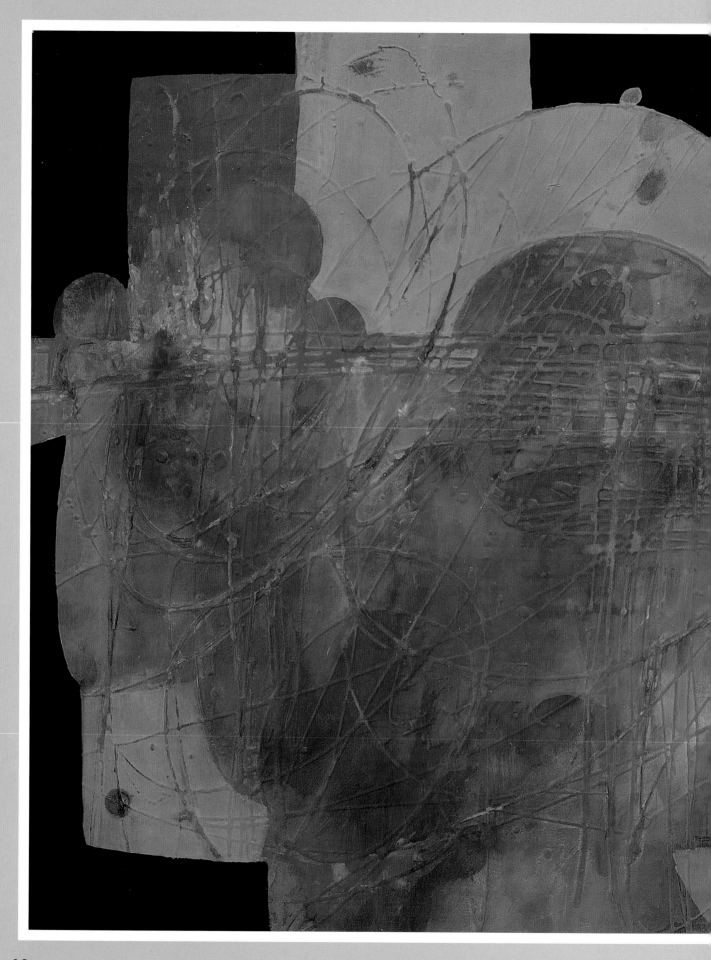

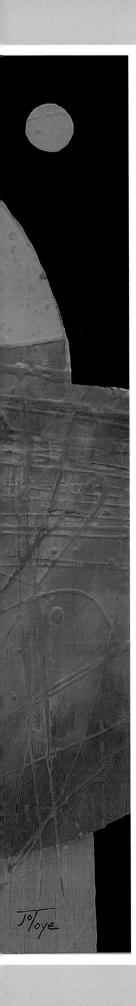

PART 2 TOOL KIT INSTRUCTION MANUAL

"IT TAKES COURAGE TO GROW UP AND BECOME WHO YOU REALLY ARE." E.E. CUMMINGS

As I told you in Part 1, I love tools. There is nothing more valuable and efficient than having the right tool for the job. In this section I share with you the tools that I find most useful in making my art. I explain the advantages they have over other tools that I have tried and why I find them to be the "right" tools for my purposes. Yet, never allow the fact that you don't have the "right" tool keep you from trying the techniques or achieving your vision.

After all, this is a book on experimental techniques—so experiment! If you don't have a mouth atomizer, use a spray bottle or a sponge. If you don't have an applicator bottle, find a fine tipped plastic bottle at the hobby store. If you don't have a Resist Pen, use a dip pen or stick. All these things will work and some work amazingly well. As I demonstrate each tool, I attempt to show how they can be used to achieve various results as well as offer ideas on how you can achieve the same results using alternate methods.

This section is not only an instruction manual but is meant to serve as a reference manual as well. In the step-by-step demonstrations in Part 3, I use all of the tools and materials mentioned in Parts 1 and 2. Also, some of these items may not be readily available in your area, so I have included a limited Resources section at the back of the book.

As always, have fun experimenting and I hope you discover applications that will benefit your own artistic vision.

The Journey
Jo Toye
20" × 20" (51cm × 51cm)
Acrylic on Yupo

MASKING FLUID AND THE RESIST PEN

From my early beginnings as an artist I have been intrigued by finding unusual and exciting ways to explore the use of line in the painting process. I have used various means and tools along the way, including latex resist or masking fluid.

Masking fluid is available in small bottles or jars and is usually applied using an old brush protected with a fine layer of soap. Unlike other methods of creating line, masking fluid creates line by "saving" the white of the paper rather than adding color to an already existing surface. My early attempts at creating line with masking fluid were quite frustrating and involved everything from sticks, toothpicks, rubber tips, brushes and an implement familiar to the calligraphy industry, the "dip pen." While each resulted in some modicum of success, the process was less than ideal and quite time intensive.

A few years into my exploration, a product came out that saved my sanity and changed the way I would work with line forever. A California company, Fineline, created what is now known as the Resist Pen. It's composed of a plastic reservoir containing latex masking fluid along with a cap and wire closure system that maintains an air tight seal to prevent the resist from drying out in the bottle. It's available with either an 18- or 20-gauge stainless steel applicator tip, allowing for the precise application of a variety of line widths.

Once you become comfortable with the Resist Pen, making lines with it is effortless and efficient. While rubber cement pick-up tools can be used for removal, the Resist Pen's fine lines can be easily removed by simply rubbing a finger over the masked area. Because I have used this tool from its inception, I have developed some useful guidelines that I call, The Commandments of Masking Fluid. Most of these guidelines can be applied to both the Resist Pen and to masking fluid in general.

THE COMMANDMENTS OF MASKING FLUID

Thou Shalt Not...

• Shake the bottle (gently tip back and forth)

• Leave the bottle open or leave the top off the Resist Pen

• Use on wet or damp paper

• Paint over mask until completely dry

• Leave on paper a loooooong time

• Leave masked paper in the hot sun or expose to a hot hair dryer

• Thin with water

• Correct mistakes while mask is wet

• Expect exact perfect results, especially when first using the Resist Pen

Thou Shalt...

• Start the Resist Pen on a paper towel or other scrap paper before applying to the painting

• Store the capped Resist Pen laying on its side or upside down

• Clean off the rod insert of the Resist Pen after each use and before inserting back into the stainless steel applicator tip

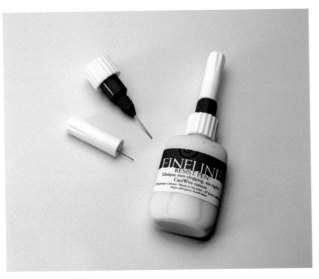

THE RESIST PEN

The Resist Pen by Fineline offers a unique cap and wire system that prevents clogging and evaporation as well as provides for precise placement of thin lines of masking fluid. The pen comes in two different tip sizes. For general use, choose the standard (18-gauge) tip.

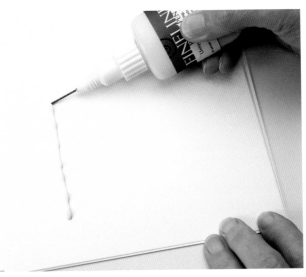

VARY THE LINE QUALITY

You can adjust the quality, thickness and smoothness of the line by varying the angle of the pen, the speed of application and the amount of pressure on the bottle. Moving the pen slowly over the paper surface at a rather low angle produces an irregular and bumpy line. Be patient when you start using the Resist Pen as line consistency will come with practice.

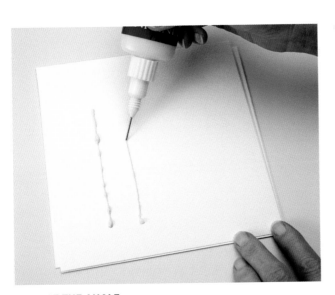

CHANGE THE ANGLE

To produce a smoother line, increase the angle of the pen to the paper while keeping the applicator tip on the surface of the paper. You will obtain a more even line if you resist the temptation to squeeze the applicator bottle as you draw the line. A gentle squeeze may be required at the start. Once the masking fluid is flowing, gravity and capillary action will draw the liquid onto your surface.

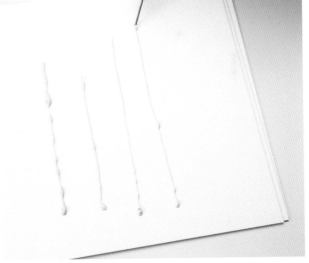

MOVE THE PEN QUICKLY

Another way to ensure an even line is to move the Resist Pen at a faster pace. Both lines on the right were created by moving the Resist Pen more quickly than those on the left. One was made with the pen at a low angle while the line just being completed was created by holding the pen at a higher angle.

VISIT ARTISTSNETWORK.COM/ABSTRACT-EXPLORATIONS FOR BONUS CONTENT.

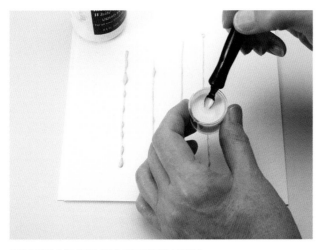

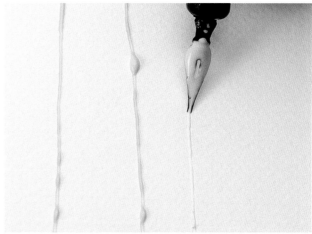

USE THE DIP PEN FOR PRECISE LINES

Transfer some of your masking fluid into a small container, then dip the nib into the masking fluid and fill the pen's reservoir with masking fluid—it must be thin. A new jar of masking fluid is usually the right consistency. Buy the smallest jar you think you will need as the masking fluid will begin to thicken within a short period of time after opening the jar. Different brands of masking fluid can be diluted with water or ammonia, but this must be done before the fluid begins to congeal.

APPLY DIP PEN TO PAPER

Place the dip pen loaded with masking fluid on your paper, and apply pressure as you begin to draw the line. The line will be thin, and you will only be able to get a few inches of a line before you have to dip the pen once again into the masking fluid. The reservoir must be cleaned every few strokes, or the masking fluid will build up and restrict the flow onto the paper. (Do not dip your brushes in the water used to clean the mask off the dip pen.)

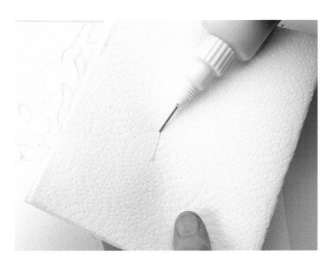

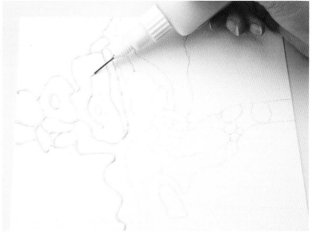

TEST FLOW BEFORE USE

Before you begin using the masking pen always test its flow on a piece of paper towel or scrap paper. One of the big advantages of the Resist Pen is that the fluid in it will not thicken as quickly as other masking fluids, but always test its viscosity before starting on your painting surface.

MASK OVER DRAWN LINES

If you have a drawing, place the tip of the Resist Pen on your paper and start to follow your lines. Once you are comfortable with using the pen, covering the complete design can be accomplished in a very short time.

GOT A CLOG?

If your masking fluid is not flowing easily from the applicator, make sure that the dispensing rod is not clogged or that your fluid has not become thickened with age.

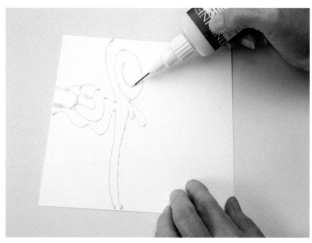

ALLOW MASK TO DRY

Once the mask is applied, allow it to completely dry before applying water or paint to the paper surface. To confirm that the mask is dry, lightly touch a finger to one of the masked areas. If no mask is transferred to your finger, you can proceed with the painting. Avoid the temptation to speed up the drying process by using a blow dryer or by placing the painting in the hot sun. The masking fluid may become gummy and difficult to remove.

APPLY MASK FREEHAND

Live on the wild side and try applying the masking fluid freehand. This will often produce a more dynamic design and allow your intuitive design sense to emerge. I'm always amazed how differently we each make lines; it's almost as distinctive as our signature. Once the mask is dry, if you're not happy with the results, remove all or part of the design and start again.

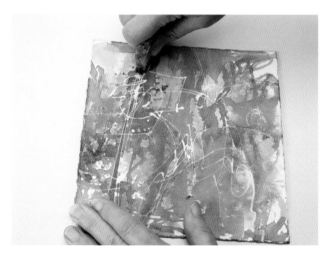

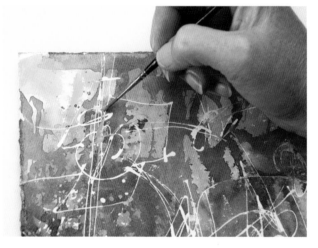

REMOVE MASKING FLUID

After you have painted over your masked lines, allow the paint to completely dry before removing the masking fluid. A rubber cement pick-up is useful when removing large quantities of masking fluid, but small areas of thin masked lines are easily removed by rubbing your finger over the surface of the paper and rolling the mask free.

TINT WHITE LINES

Once the mask is removed, you can leave the lines white or use thin paint and a small brush to drop in color. If you paint the line with clear water and then touch the wet line with a brush loaded with paint, the color will flow in a very organic and natural way.

VISIT ARTISTSNETWORK.COM/ABSTRACT-EXPLORATIONS FOR BONUS CONTENT.

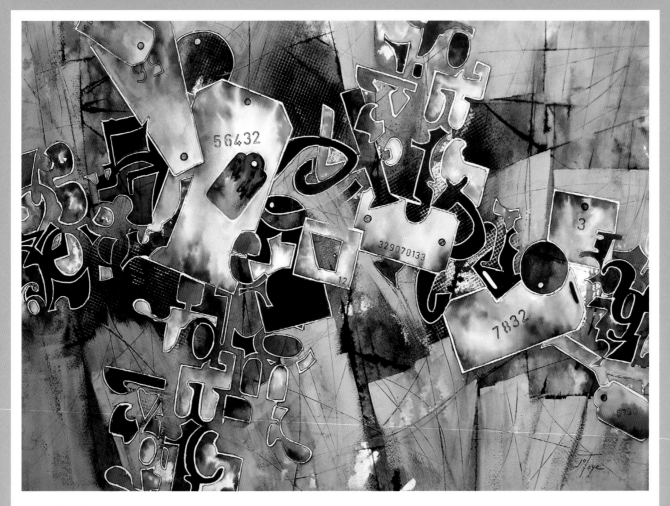

Paying the Price
Jo Toye
Ink and acrylic on paper
16" × 22" (41cm × 56cm)

MASKING FLUID AND CONTACT PAPER

Another useful way to use the Resist Pen is with contact paper. While masking fluid alone can be used to save large solid areas, a self-adhesive clear vinyl (contact paper) can serve the same purpose.

Contact paper can be found in the kitchen section of your local department store and may be better known as shelf liner. You can also purchase a graphic art product known as Frisket Film, but it's more expensive and not as readily available. Try to find a "low" or "lite" tack version of clear contact paper to prevent it from tearing your paper upon removal.

One disadvantage of using contact paper as a resist is that the paint often seeps under the edges, especially when wet applications of paint are applied. You can easily solve this problem by sealing the edges with the Resist Pen. Once the masked edges are sealed and dry, you can paint the exposed area of the painting with abandon and no worries that paint will spread to unwanted areas. As with masking fluid, be sure that your paper is completely dry before applying or removing contact paper.

CONTACT PAPER RESIST

This technique is very useful for when you want to use wet applications of paint while preserving some of the white of your paper. By using contact paper and masking fluid you can pour, spatter and paint wet into wet without being concerned that your paint will seep under the resist.

MATERIALS LIST

APPLICATION BOTTLES

BONE FOLDER

BRUSH

CONTACT PAPER

CRAFT KNIFE

MASKING FLUID

PAINTS, ASSORTED

PAPER

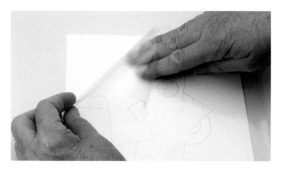

1 APPLY CLEAR, LOW TACK CONTACT PAPER
Cut a piece of contact paper a little larger than the paper you will be using. Remove the backing and gently press the adhesive side to your paper. By using clear contact paper you will still be able to see your design for reference. Using low tack contact paper will prevent your paper from being torn while removing the contact paper.

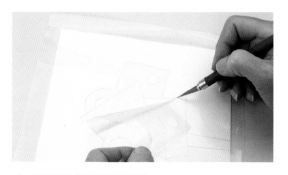

2 CUT THE CONTACT PAPER
Use a sharp craft knife to cut around the area that you want to remove from the paper. Remember to remove the areas of contact paper where you want the paint to be applied and leave the contact paper over the areas that you wish to preserve. Do not cut along all of your lines, only those that will allow you to remove the main shape that you wish to expose.

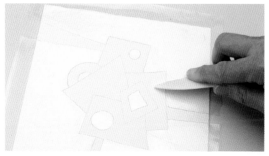

3 BURNISH EDGES
Use a bone folder or other flat hard tool to burnish the cut edges of the contact paper. Burnishing alone will not prevent wet paint from seeping under the edges but it will ensure that the contact paper is tightly adhered before the masking fluid is applied.

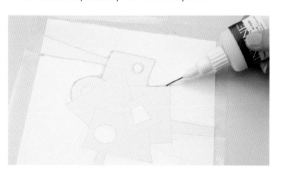

4 MASK THE EDGES
Apply masking fluid over the edges of the contact paper. Be careful to place the line of the mask so that it spans both the paper and the contact edge to provide the desired seal. If you wish to have saved white lines inside the large shape, mask these also while the contact paper is in place. Allow the mask to dry before applying water or paint.

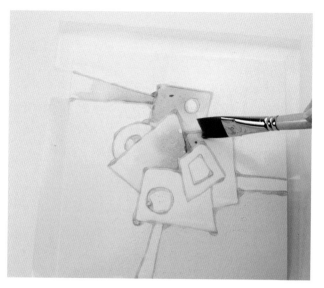

5 ADD PAINT WITH ABANDON
Once the mask is dry, thoroughly coat the surface with clear water and then drop paint onto the wet surface with a brush.

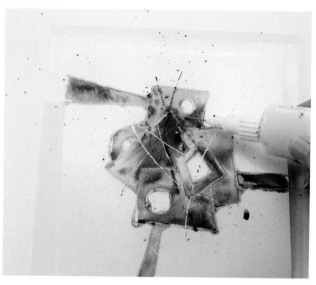

6 CREATE LINES
Draw lines with applicator bottles filled with paint.

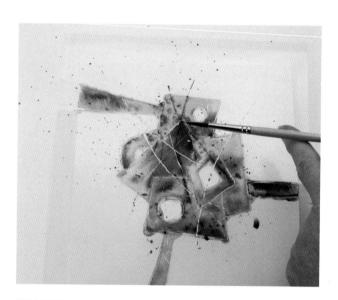

7 APPLY SPLATTER TECHNIQUE
Use a paintbrush or toothbrush to create spatter. Remember that not only are your edges preserved, but any masked lines will resist the paint and remain white. These lines will be more visible once the mask is removed.

SOLVING A STICKY SITUATION

If a low tack version of contact paper is not available, remove the contact paper from its backing and apply the sticky side to the surface of an old T-shirt. Lightly smooth the contact paper with your hand, then remove it from the shirt and apply it to your paper. The adhesive will pick up small fibers from the cotton T-shirt and you'll now have a piece of contact paper that will have the perfect amount of adhesion!

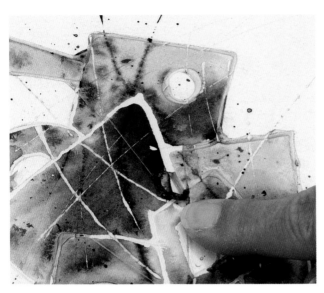

8 REMOVE THE MASKING FLUID

Once the paint and paper are completely dry, remove the masking fluid. Remove the lines made by the Resist Pen by rubbing your finger across the surface.

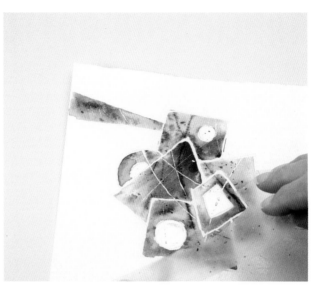

9 REMOVE THE CONTACT PAPER

After you have removed the mask, gently remove the contact paper. If you wish, you can transfer this piece of contact paper to a new surface and reuse. If you've saved the original backing sheet you can place the contact paper back onto it for later use.

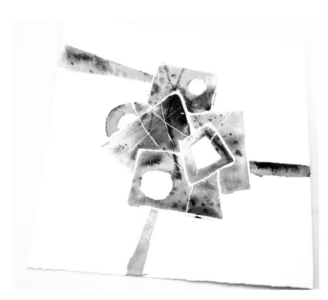

10 FINAL TOUCHES

Leave the background white or paint as desired.

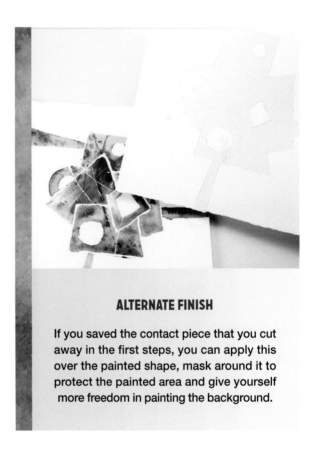

ALTERNATE FINISH

If you saved the contact piece that you cut away in the first steps, you can apply this over the painted shape, mask around it to protect the painted area and give yourself more freedom in painting the background.

VISIT ARTISTSNETWORK.COM/ABSTRACT-EXPLORATIONS FOR BONUS CONTENT.

APPLICATOR BOTTLES

Applicator bottles made by Fineline are one of my favorite ways to make line. Over the years I have tried several methods to dispense a line of paint: Oiler boilers, metal tips attached to small plastic craft bottles, dip pens, ruling pens and even razor blades! Most of these gave me satisfactory results but they all had limitations. Although the different types of bottles and tips that I tried did the job, no matter what I did I could not find a way to seal the dispensing tips, and therefore I could not leave my paint in the bottles.

In the summer of 2011, I was sent an applicator bottle by Fineline and I have been in love with them ever since. Unlike bottles of similar construction, these bottles have a unique cap and rod system that render them virtually air tight. I have had acrylic in mine for at least three years, and the acrylic is still flowing. Although I use them in different ways throughout the book, you do not need them to do any of the demonstrations. But if you ever do get the chance to try one, beware, they are addictive! My students have bought a boatload of them and continue to discover exciting ways to use them.

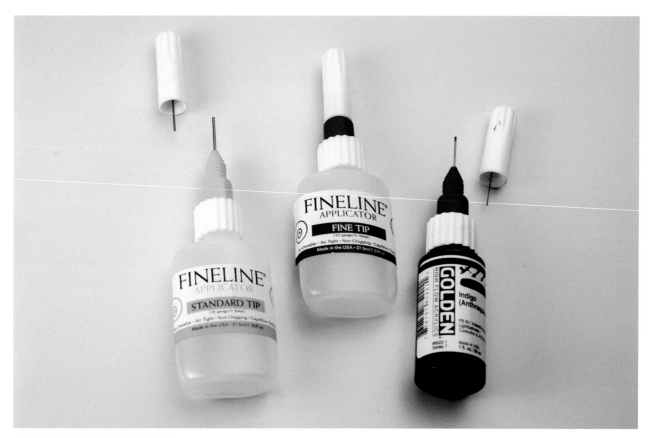

FINELINE APPLICATOR BOTTLES

Fineline Applicator bottles come empty with two different tip sizes: standard (18-gauge) and fine (20-gauge). These tips are designed to be air tight so that once you fill the bottles your paint can remain in them. Fineline also makes replacement caps for High Flow Acrylic paint, which eliminates the need to transfer the paint out of the original bottle. Remember to always recap your bottles immediately after use.

SUGGESTIONS FOR USE

Applicator bottles can be filled with a variety of materials. I primarily use the standard tip, but depending on your purposes both sizes can be very useful. For some suggestions for general use as well as guidelines for when you might choose to use one tip over the other visit ArtistsNetwork.com/abstract-explorations.

TEST THE FLOW

Before you use your filled applicator bottles, test the flow on a paper towel or scrap of paper. If your paint isn't flowing as you like, adjust the viscosity with distilled water. To avoid over-diluting your paint, use an eyedropper or pipette to add water to the bottle. If your paint flows too easily, you can always add more undiluted paint to the bottle.

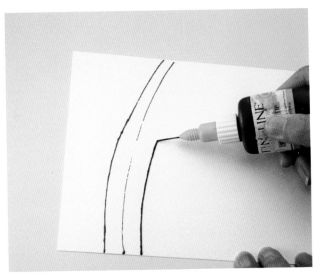

FINE AND STANDARD TIP BOTTLES ON DRY PAPER

If you wish to have well defined lines and lines with a variety of widths, fill both the fine and standard tip applicator bottles with fluid acrylic and use on dry paper. Test the flow. You may not need to dilute the paint in the standard tip bottle, but you'll have to dilute the acrylic for use with the fine tip. Viscosity and speed of application all affect the quality and width of the line.

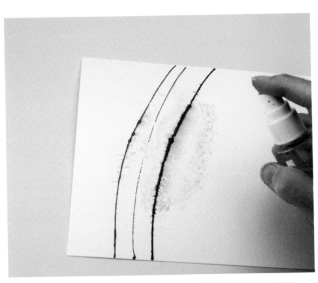

FEATHER YOUR LINES WITH A FINE MIST SPRAY BOTTLE

While the lines are still wet, use a fine mist spray bottle and spritz them with water. The effects will vary by how dry the line is, how thin the paint is and the mist pattern of your bottle.

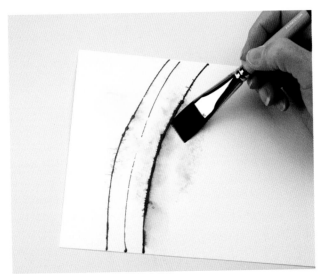

EXTEND COLOR USING A BRUSH

While the line is still wet, draw a damp brush down the side of the line. This will pull color out from the line while leaving the line in tact. This can be an effective way to integrate lines into underlying layers of paint.

VISIT ARTISTSNETWORK.COM/ABSTRACT-EXPLORATIONS FOR BONUS CONTENT.

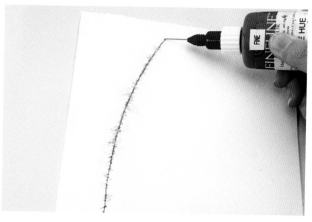

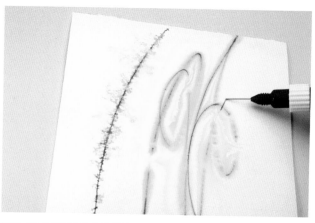

MIST PAPER WITH WATER

Use a fine mist spray bottle and lightly spritz water onto the paper. Immediately draw a line of paint across the surface. The line will feather as the paint comes in contact with the droplets of water. To achieve this effect, do not saturate the paper with the spray bottle.

USE APPLICATOR BOTTLES ON WET PAPER

Use a fine or standard tip applicator filled with fluid acrylic that has been diluted just enough to dispense easily from the bottle. Completely wet your paper with water, and begin to draw lines of paint across the surface. The paint will disperse while retaining its linear quality.

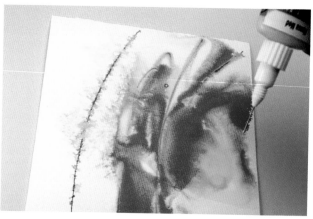

USE VERY DILUTED PAINT

Use the fine tip applicator filled with paint that has been diluted to a watery consistency. Quickly draw the tip across a surface that is saturated with water or paint. The lines that you draw won't maintain much of their linear quality but will instantly bloom out in riotous color. Be careful to apply little or no pressure to the applicator bottle to avoid dispensing too much paint.

DRIP DILUTED PAINT

Use paint that is diluted to a watery consistency in the fine tip applicator bottle. Hold the bottle above the surface of your paper, and drip paint onto a wet surface. Combine this with lines drawn through the wet surface to produce a variety of free-flowing patterns. For a more defined drip pattern, drip paint onto a dry surface.

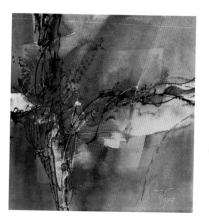

DEMO SAMPLE

This little painting was done almost completely with the applicator bottles. It was one of the first times that I used the applicator bottles, and I was demonstrating them to my students. After the initial lines of color were applied to damp and wet paper, I extended some of the color with a brush and let it dry. Then I simply added a glaze to create the outer frame of color.

USE THINNED WHITE GESSO IN THE STANDARD TIP

Pour white gesso into a standard tip applicator bottle and thin with distilled water as necessary. Use the applicator bottle to draw patterns onto paper or Yupo that has been coated with black gesso.

USE GESSO OR OPAQUE PAINT FOR YOUR SIGNATURE

In addition to pattern, you can produce legible or illegible calligraphy with little effort using opaque paint or gesso.

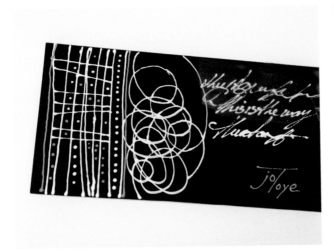

GLAZE TRANSPARENT PAINT OVER THE WHITE GESSO

Once your white pattern is dry, you can transform the white into whatever color you wish by glazing transparent color over all or portions of the pattern or writing. The underlying black gesso will tint a bit with the application of transparent glaze, which can aid in integrating the pattern into the black layer.

USE APPLICATOR BOTTLES TO ADD FINISHING DETAILS

Add pizazz to paintings by adding little details with an applicator bottle. Cobalt Teal is used to add dots and circles to finish up this little sample. White gesso was used to add the steam coming off the cup.

MAP OUT THE POSSIBILITIES

Right now your heart may be beating a little faster just thinking of all the different things you can do with these little bottles filled with different paints and used on different colored papers. I have a dozen ideas to suggest, but I want you to have the joy of discovering some of them on your own. Use the mind mapping example from earlier, and let your imagination run like a child.

MOUTH ATOMIZER

Using a mouth atomizer is a wonderful way to create pattern and could be called the poor artist's airbrush. It requires no set up, no compressor, is quickly cleaned and can be placed right in your original bottles of paint if they are the right consistency.

Additionally, I like the less polished results of the atomizer over the airbrush. The fine spatter that you obtain from the mouth atomizer, creates a lovely texture whether used with a stencil or on its own. Any paint that you can use with an airbrush can be used with the mouth atomizer and there are many brands of airbrush paint available. Almost any ink, diluted watercolor, diluted fluid acrylic and all the High Flow Acrylics can be sprayed through an atomizer. Never try to spray fluid acrylic right from the bottle. It must be diluted to a watery consistency, and it will spray beautifully once thinned. The advantage of the High Flow Acrylic is that it's formulated to be used in airbrushes so you can spray them directly from the original bottles.

If you haven't used a mouth atomizer you want to be aware of a few things. First of all, when you spray, assume that droplets of the spray will travel well beyond the area where you intend the paint to be applied. Be sure to clear your table to avoid getting overspray on other paintings, walls, tools or the cat. Secondly, always test how each paint sprays through the atomizer before spraying directly on your painting. Application will be influenced by the viscosity of your paint, how much force you use and how far away you are from

USING THE MOUTH ATOMIZER

The mouth atomizer has two tubes. Place the bottom, smaller diameter tube into your paint. Take a deep breath (like you are getting ready to blow out candles on a birthday cake), place your lips securely around the free end of the top (larger diameter tube) and blow a steady stream of air. This creates a vacuum and sucks the paint up from the bottle, which is then sprayed onto your surface. Be sure to blow out. Lower viscosity paint will take very little force while white paint takes the most effort.

your surface. Most importantly, you want to be sure to hold the atomizer and paint bottle at a right angle to your painting. This necessitates that you raise your painting off the flat surface of your table by either inclining it at an angle or attaching it vertically to an easel. Lastly, always use care and caution, as

you would with any spray application of paint, and consider using a surgical mask to avoid breathing in any paint particles. The droplets from the atomizer are not finely atomized, but it is always wise to use precautions.

OTHER OPTIONS

If you do not have a mouth atomizer nor wish to purchase one, you can still do the projects in the book that call for an atomizer by using a make-up sponge. I demonstrate this in the stencil section. However, if you are interested in purchasing an atomizer check out the Resources section in the back of this book.

Be aware that the inexpensive folding atomizer, while able to spray ink and diluted paint, will not be able to spray the white paint. The atomizers mentioned in the Resource section in the back of the book will spray the heavier white High Flow Acrylic as well as the thinner paints.

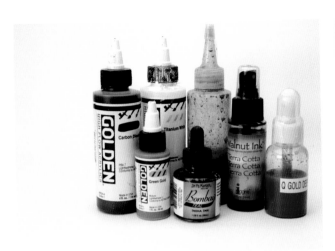

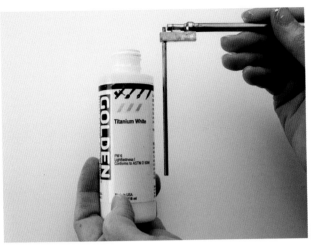

USE PAINT THAT IS THE RIGHT VISCOSITY

You can spray any paint that is the right viscosity. All inks can be sprayed right from the bottle. Dilute your watercolor or acrylic to a watery consistency, and spray it from any small container. I like to keep my diluted acrylic or watercolor in air tight containers so it's available when needed for pouring or spraying.

SPRAY WHITE HIGH FLOW ACRYLIC

The White High Flow Acrylic contains solids that render it opaque, and therefore it is thicker and harder to spray. When spraying white, I suggest that you spray from a 4 oz. (113 gm) bottle. When you place the atomizer into this size bottle, it will almost fill the bottom tube, and the vacuum needed to draw up the paint will be much less.

USE LACE OR OTHER FOUND OBJECTS AS STENCILS

Because the mouth atomizer sprays a fine pattern of paint, you can use material that has rather fine openings as stencils. To practice, choose a stencil and spray onto scrap black paper. If you are not getting enough paint spray, be sure to check that the tube is not resting on the bottom of the bottle.

REMOVE THE STENCIL

If you are spraying on an absorbent surface you can remove your stencil almost immediately after spraying. Allow the paint to dry before layering additional paint. One of the advantages of spraying white is that now, by glazing, you can transform it into any color you want. This is especially advantageous on black. Spraying onto black is difficult because transparent color is not visible on the black surface. Most opaque color, once it is diluted enough to spray through the atomizer, will not cover the black adequately. The White High Flow Acrylic is formulated to spray yet remain opaque. Once it is sprayed and dry, you can glaze any color over it, and you will achieve luminous color on your black surface.

PRACTICE

When you first try your atomizer, spray plain water through it before trying to spray paint. This will give you an idea of how much effort you will need when you start to spray paint or ink.

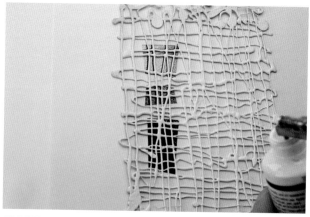

CREATE MASKS

Cut any shape out of heavy weight paper or plastic to use as a mask to prevent spray from covering areas you wish to remain untouched. Before spraying, place the mask on top of your paper and then place the stencil on top of that. You may need to tape the mask and stencil down to keep them from moving when you begin to spray.

REMOVE THE MASK AND STENCIL

The advantage of using a mask is that you control where the spray is allowed to go. Once you remove the stencil and mask you will have a sprayed area that is the shape of the mask and filled with the pattern of the stencil.

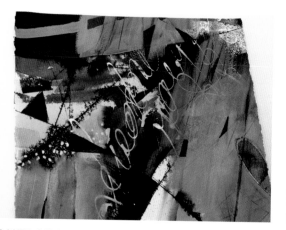

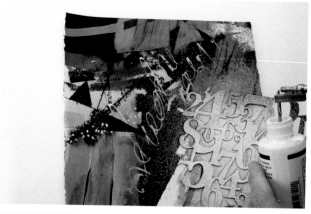

SPRAY ONTO AN OLD PAINTING

Transform a less than successful painting by spraying white over portions of the painting and then glazing over the white with a color already in the painting. Choose a painting that has some solid areas of color where the stencil design will show up when sprayed.

SPRAY WHITE THROUGH A STENCIL

Chose a stencil that you feel will integrate well into the design of the painting. Spray white through the stencil and allow it to dry.

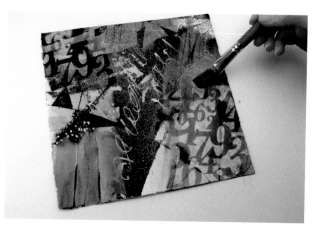

GLAZE A COLOR OVER THE WHITE

To integrate the white into the painting, choose a color that is already in the painting and use it to glaze over the sprayed white areas. The luminosity of the glaze over the sprayed white paint can infuse a dull and lifeless painting with excitement. Use restraint when adding sprayed areas to a painting. If you spray too much of the painting you will lose the contrast you are creating between the sprayed and unsprayed areas.

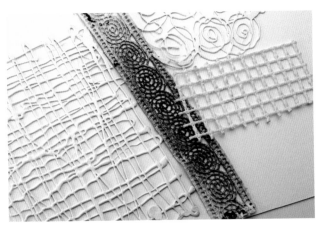

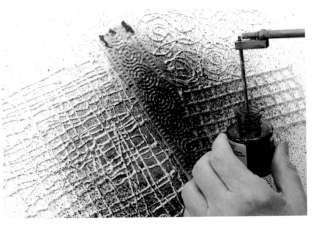

START A PAINTING BY SPRAYING THROUGH STENCILS

A great way to start a painting is to lay various stencils down across the surface of your paper. Keep in mind that you want some repetition and variation in the pattern. To retain some of the white of the paper it is important to lay down all of your stencils before you start to spray. If you lay one stencil down at a time and spray in succession, each time you spray you will cover more of the unprotected white paper with color. By the time you spray your last stencil very little of the white paper will remain to show through the pattern.

SPRAY ONE OR SEVERAL COLORS

Depending on your purposes, spray one or several colors through the stencils. You must thoroughly clean the atomizer before each color change. If you do not clean out the paint between color changes you will contaminate your bottles of paint with residual paint left in the atomizer.

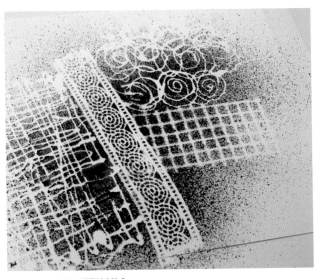

REMOVE THE STENCILS

Remove the stencils to reveal the pattern created by the sprayed paint. Use this as the start of a new painting. You can leave or cover up as much of the sprayed pattern as you desire.

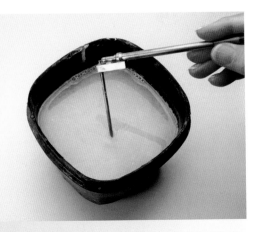

CLEAN THE ATOMIZER

Between color changes and after you are done spraying, be sure to clean the atomizer. Do not leave the atomizer sitting in your paint or on the table after spraying. You want to clean the paint out of the tube before it has a chance to dry. Completely immerse the intake tube into water and swish it around until most of the paint has been removed from the atomizer. Then place the intake tube in clear water and spray onto a paper towel until the spray is clear. Remove the atomizer from the water and spray air through the atomizer to remove most of the water from the tube. If you are going to spray another color you will need to shake or tap more of the water out of the tube so you don't dilute your paint. I often use two atomizers when spraying so that I don't have to clean in between color changes.

RAZOR BLADE AND INDIA INK

A razor blade, really? Unorthodox as it may seem, using a razor blade in conjunction with India ink is quite fun, although it may seem a bit scary. I must admit that I have spurned the little fellow a bit since I have started my love affair with the applicator bottles, but the razor blade and India ink can't be beat when you want fine, straight lines that explode when they play with water or wet paint.

For these techniques, use the waterproof variety of India ink. The bottle must say "India Ink" as there are many acrylic inks available, but they will not behave like the India ink. The charm of India ink is that it is a tad unpredictable when it hits wet paint or water and can take on a life of its own. You will either love or hate working with it. I find it adds excitement and a quality of line that can't be produced any other way. It's a nice technique to have in your arsenal of line making.

Be sure to use only single sided razor blades that are only sharp on one edge.

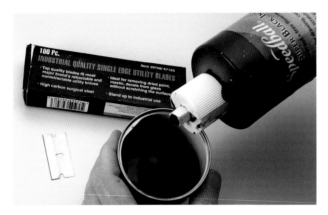

POUR INK INTO A SMALL CAT FOOD CAN

To use the razor blade you must transfer your ink to a stable, flat bottomed, shallow container like a small cat food can. If you don't have a cat, and you want one, use this as a good excuse to adopt one. The reason I like the smaller cat food can is that the smaller the can, the less ink you have to pour out and risk spilling.

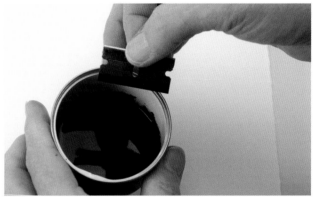

DIP YOUR RAZOR BLADE INTO THE INK

Only pour enough ink to cover the bottom of the can, approximately ⅛" (3mm) will do. If you get too much ink in the can, every time you dip your blade you will get ink on your fingers and then you will get ink on everything else.

AVOID A MESS

Be sure to pour your ink back into the original bottle for storage. If you should spill ink, saturate the spill with water before wiping it up. Remember this saying when dealing with spilled ink or acrylic paint, "The solution to pollution is dilution." If you wipe ink or acrylic paint up without diluting it first, it will smear and dry on the spot. Instead, flood the spill with water and absorb it with a paper towel. Add more water and blot until you have blotted up all of the ink.

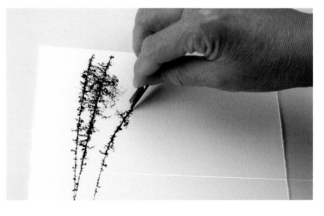

USE THE RAZOR BLADE TO DRAW SPARKLING LINES

To create a "sparkling" effect, spritz your dry paper with a fine mist of water, and then draw the razor blade that has been loaded with ink across the surface. When drawing the line with the razor blade, hold the blade at an angle so only the tip of the blade touches the paper. The ink will flow down the edge to the tip and deposit on your paper.

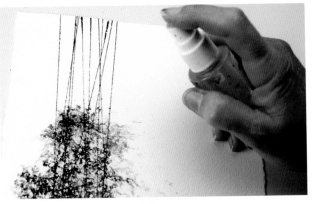

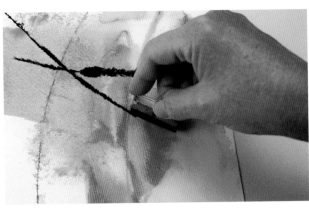

DRAW INK LINES AND SPRITZ

Draw a line with the razor blade on dry paper, and while it is still wet spritz it with a fine mist of water. Control how much the ink feathers out by the amount of water you spritz onto the wet ink lines.

DRAW INK LINES THROUGH WET PAINT

Draw a razor blade loaded with India ink across the surface of wet paint. Avoid applying ink through puddles of wet paint. If your paper is too wet, the ink will spread out into large uncontrollable black areas. If the paint is too dry, the ink will not transfer easily off your blade.

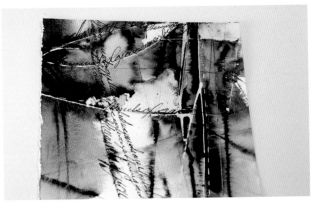

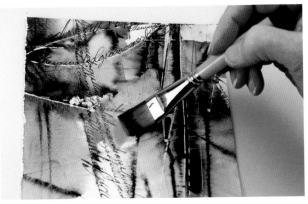

EXPERIMENT WITH OLD PAINTINGS

This sample is a section from one of my less-than-successful paintings where I had originally used the razor blade and India ink. Some of the ink lines are less feathered than others, which is due to the wetness of the paper and paint when they were applied. The more the ink feathers, the less dense the black will be. This can be used to your advantage as it automatically sets up a range of values in the painting.

ADD MORE PAINT TO THE DRY PAINTING

Before adding another layer of ink with the razor blade, make the paper wet by adding more color or a layer of water. You need the moisture to ensure that the ink will transfer to the paper.

ADD INK LINES

Draw the razor blade dipped with ink across the painting. Be sure to travel across the width of the surface. Where your paper is dry or slightly damp, you will get a very fine line and once you hit the area where the paper is wet the ink will bloom. This creates a variety of line with one application. Spritz some of the line created on the dry portion of the paper to make it feather.

PIPETTES

There are very few methods of paint application that render the exciting results obtained by pouring paint. When discussing the pouring of paint, I am referring to the process of applying very thin or diluted paint to paper by pouring it out of a container without the aid of a brush. Your paper is usually elevated so that the paint moves and runs in random patterns which can be manipulated by tilting the paper in various directions.

Paint can be poured onto dry or wet paper, but the results will be very different. On dry paper, poured paint will run in rivulets of color down the paper's surface; on wet paper the paint will spread, blend and create soft edges. Either way, pouring renders a surface that is difficult to replicate with a brush.

Pouring paint becomes problematic when working small. Even when using very small containers, it's difficult to limit the amount of paint poured with each application of color. To solve this problem, I started putting my diluted paint into bottles that had tips from which the paint could be poured. This gives more control over the amount of paint being applied to the paper. I also tried eyedroppers, and although I like their ability to control the quantity of paint being poured, they don't hold a lot of paint and must be refilled often. Then I tried some pipettes—which were perfect!

Pipettes will hold a great deal of paint which can be dispensed in a controlled manner like that of an eyedropper. You can use them to pour paint, to draw lines or to drip paint onto your surface. They will dispense more paint than applicator bottles, and they can be used in many of the same ways.

Pipettes are ideal for backgrounds and are a great way to start a painting. The whole surface can be covered with the poured texture or you can save areas of the white paper by using masking fluid or contact paper. The texture created by pouring on dry paper is absolutely stunning when it's glazed with transparent paint. If you work in a more representational way, use pipettes on dry paper to loosely draw in your design.

The main disadvantage of using pipettes is finding them. While they can be a bit difficult to locate, they can be found at chemical supply stores, online and in some craft and hobby stores. Sources are listed in the Resource section.

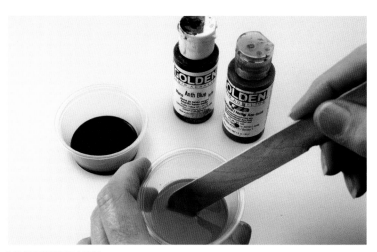

DILUTE THE PAINT

Pipettes can be used with ink, High Flow Acrylic, diluted watercolor or acrylic. The paint must be thin enough to be drawn up into the pipette and flow out easily when applied to paper. If using fluid acrylic, dilute it with water in a small container. Put a small dab of paint in the cup, and gradually add water and stir until it's well mixed. If the mixture is too dark, add more water. You want the paint diluted to a middle value.

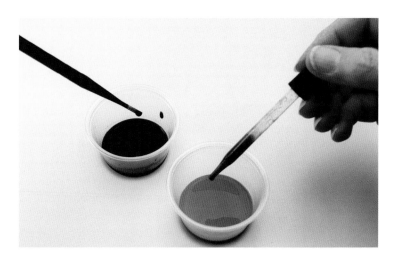

DRAW UP PAINT INTO THE PIPETTE

Eyedroppers can be used instead of the pipettes. Eyedroppers will only draw up a small amount of paint; therefore, you can only apply a small amount of paint at one time. However, pipettes are not as readily available so using eyedroppers is a good but slower alternative.

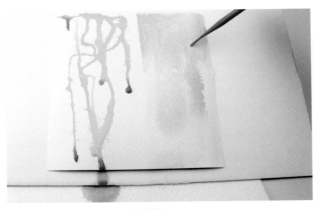

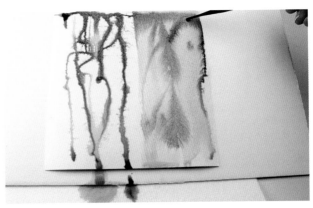

USE PIPETTES TO POUR COLOR

Elevate your paper surface so the paint will flow. Place a few pieces of masking tape on the back of your paper to hold it in place. Place a paper towel under the bottom edge of your painting support to collect excess paint. Leave the left side of your paper dry, and wet the right half of your paper from top to bottom. With a pipette filled with diluted paint, draw the pipette across the top of the paper while squeezing the pipette to release paint. Where the paper is dry, the paint will flow down in rivulets of color. Where the paper is wet, the paint will spread and blend.

POUR SEVERAL COLORS

After you have poured one of your colors and while it is still wet, fill another pipette with paint and draw it across your paper on top of the first layer. The paint will mix to form a third color. Direct the paint by placing the pipette anywhere on the paper's surface. You can also turn your paper and pour paint from the other edges. Three colors give a variety of pattern and color.

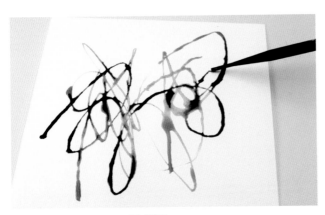

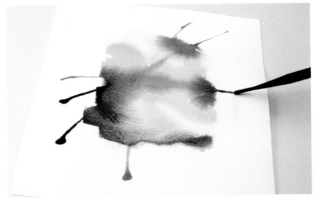

USE PIPETTES TO DRAW LINES

Use pipettes to draw lines in much the same way as you use applicator bottles. Place a piece of dry paper flat on your painting table and fill a pipette with color. Draw random or specific designs with several colors of paint and let them intermingle on the paper.

DRAW ON WET PAPER

Create interesting effects by wetting portions of your paper and leaving other areas dry. Place your paper flat on your table. Wet a portion of the paper with water and draw the pipette filled with paint across the dry paper into the wet area. The paint will bloom and spread when it touches the wet paper.

SAVE LEFTOVER PAINT

If you have any diluted paint left, place it in a bottle with an airtight tip. The paint will be ready for the next time you want to use the pipettes. You can also use paint straight from the bottle to pour on larger pieces or to spray with the mouth atomizer.

DRY ERASE MARKERS AND SHEET PROTECTOR

Using dry erase markers with a sheet protector or other plastic sheet is a risk free way to try out ideas before committing paint to paper. This is especially useful when using black gesso to help define your design.

The addition of black gesso, or any other opaque paint, enables you to add structure and direct the eye throughout the painting. Once black gesso is applied it is difficult to make corrections so being able to test its placement is very useful. For small samples you can simply use sheet protectors that you can get at any office supply store. When working on larger paintings use clear acetate, Mylar or any other clear polyester film or sheet. Regardless of the plastic that you use, the most important item is the dry erase marker. Unlike other markers, dry erase markers will mark on the plastic, but the marks can be easily removed with a dry or damp cloth. This allows you to try unlimited variations before you begin to paint with the black gesso.

ADOBE PHOTOSHOP

If you are proficient with a computer image editing program, such as Photoshop, you can also accomplish this process digitally. This is especially useful when working on a large painting because the changes can be made more quickly. Before you begin to paint the black, take a picture of your unfinished painting and load it into your computer. Use the brush tool in your editing program to play with the black placement. Once you are satisfied, print out a copy for reference.

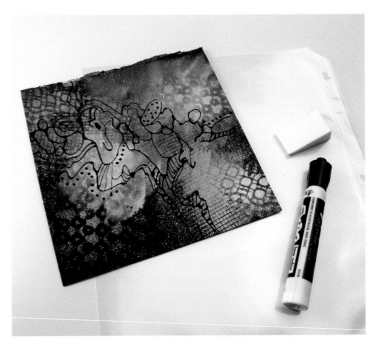

SUPPLIES
Use plastic and a dry erase marker to try different options on an unfinished painting. The dry erase marker can be easily removed from the plastic with a small sponge or paper towel.

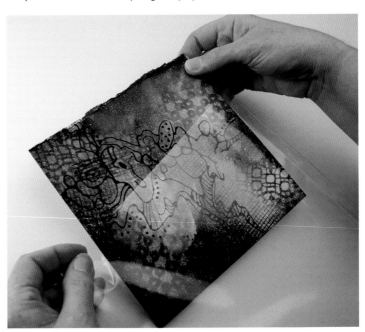

SHEET PROTECTOR
An easy plastic to use is a sheet protector. Slip the art sample into one corner of the sheet protector, and it will be held in place while you make marks on the plastic surface.

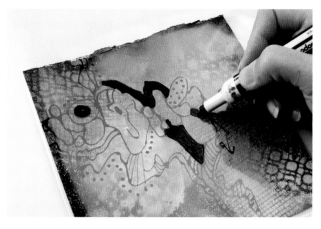

USE THE MARKER TO ADD BLACK

Use a dry erase marker to begin adding black to the plastic sheet covering the original design. The marker dries very quickly and gives you a good idea of how black gesso or other opaque paint will look once painted onto your painting.

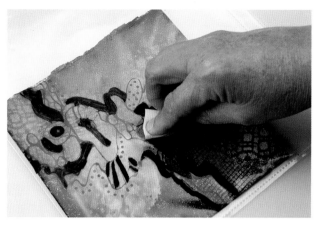

ERASE WITH A SPONGE

Continue to add black areas and try different possibilities. Remember that you can easily erase any marks with a small sponge or paper towel. Use a cotton swab when removing small detailed areas, and use a paper towel to remove large areas or to completely start over by removing all of the marks.

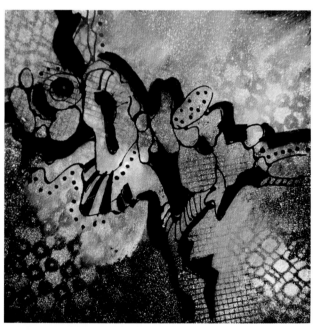

DEFINE SHAPES

Continue to add black with the marker until you are satisfied with the design. Adding black will give structure to your design and lead the eye through the painting. Use the black layer to define shapes and add interest. You can experiment with the black placement at any stage, but it's best to do it after several layers of color have been added.

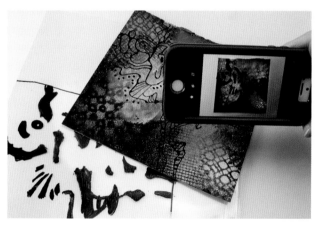

TAKE A PHOTO

Once you're happy with the design you've made with the black marker, take a picture of the painting while it's still in the sheet protector. This will serve as a reference once you begin to actually paint the black on to your painting. Remove the sample from the plastic and begin to paint in the black using the photo as a reference. You can refer to the photo right on the camera screen or print out a larger photo for reference.

REUSE

Once you have a picture of the black superimposed over the painting, you can remove all of the marker and use the plastic over and over again. The longer the dry erase marker is on the plastic the harder it is to remove. Use a damp cloth or a little alcohol if you're having trouble removing the marks.

GLUE GUN STENCILS

Using stencils made from melted glue sticks can add dramatic and exciting passages to your paintings. Most likely you have a glue gun stashed somewhere in your studio, and making glue gun stencils is guaranteed to be the most fun you'll ever have using it. Stencils made from glue guns are easy to make, are durable and can be made in a variety of shapes and sizes. One of the most exciting aspects of making and using these stencils is that they will be your own unique designs. They can be made in random sizes or designed for a specific purpose. Be warned, making these stencils is addictive, and once you start making them it will be hard to stop.

There are several sizes and temperatures of glue guns available at your local hobby store. When purchasing a glue gun, you will have several options: the size of the gun, the wattage of the gun, the size of the tip and whether the gun is corded or battery operated. The most important feature is the wattage. The higher the wattage the faster the glue will melt and the faster you can lay down your design.

If possible use a glue gun that accommodates 1/2" (1cm) diameter sticks that are 10" (25cm) long. Glue gun stencils take a lot of glue for each stencil, and these sticks will give you more working time without having to stop and reload the gun in the middle of a design.

It's important, when working with the glue gun, to use caution and follow the safety instructions that come with the gun and the sticks. Be sure not to touch the hot tip or the melted glue until it has cooled, and remember to place a protective surface under the tip of the gun when it is not in use. Oftentimes the glue may continue to drip out of the gun.

Additionally, you will need to make your stencils on a surface that will release them easily once they are cool. Wax and freezer paper will not release the stencils, but you can use one of the following: parchment paper, silicone mat or a piece of teflon. Parchment paper is the easiest to find, the least expensive and it works great. Silicon and teflon surfaces are more durable and release the cooled stencil a bit more easily. Do not make your stencils on your working surface as they may not release once cooled.

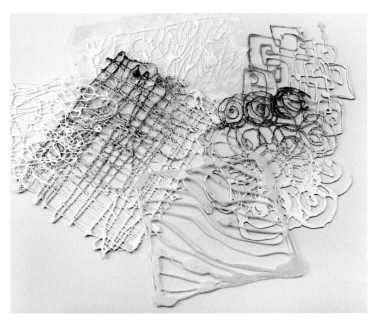

MAKE AN ASSORTMENT OF STENCILS
Glue gun stencils can be made in any size and pattern. They are durable, and they do not need to be cleaned after using them with paint. The paint will dry on them and will not interfere with their function. Once you make one, you will be addicted and will quickly build up a stash of your own individual designs.

USE A HIGHER WATTAGE GLUE GUN
To make glue gun stencils you will need a glue gun, glue sticks and a nonstick surface upon which to make them. Any glue gun will work, but a higher wattage will make the process easier and faster. I use two glue guns—one with a standard tip and one with a fine tip. The fine tip produces more delicate lines and can be used to create more detail.

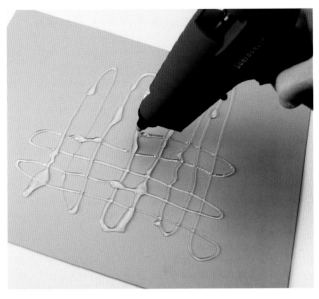

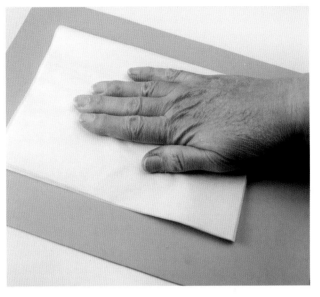

USE THE GLUE GUN TO DRAW A DESIGN

Use a nonstick surface and a glue gun with a standard tip to draw your design with hot glue. If you run out of glue in the middle of your design, don't be alarmed. Just place another stick in the gun and continue where you left off. You can draw with the tip right on the surface or hold it slightly above the surface.

COVER WITH PARCHMENT PAPER

Once the design is finished, and the glue is still hot, place a piece of parchment over the design and rub. This step is not necessary, but it will help to both flatten and cool the stencil.

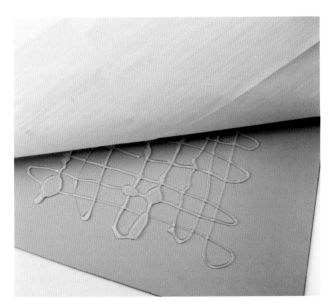

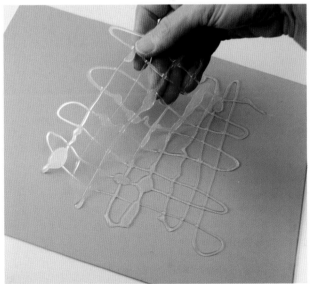

REMOVE PARCHMENT PAPER

Remove the parchment paper once the stencil has slightly cooled. If the parchment sticks, allow the stencil to cool a little while longer before lifting the parchment paper.

REMOVE STENCIL FROM THE SURFACE

The stencil should peel cleanly off the nonstick surface. If it doesn't, give it more time to cool.

VISIT ARTISTSNETWORK.COM/ABSTRACT-EXPLORATIONS FOR BONUS CONTENT.

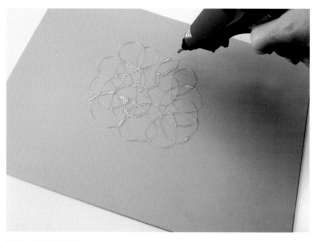

USE A FINE TIP

For finer lines, use a glue gun with a fine tip. You do not need to flatten these stencils with parchment paper as they will not be very thick. Allow them to cool and then remove them from the surface. The stencil will seem very delicate but it's durable.

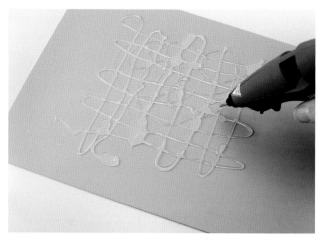

COMBINE THE FINE TIP WITH THE STANDARD TIP

For variety, both the standard and fine tip glue gun can be used to create a single stencil. Lay down glue with the standard tip, flatten if desired and then fill in additional details with the fine tip.

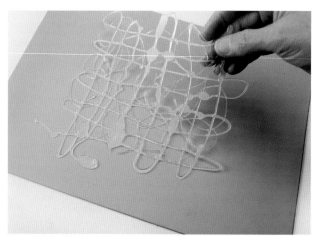

ALLOW THE STENCIL TO COOL

Let the stencil cool before lifting it off of the surface. The variation in line width will add interest to the pattern created.

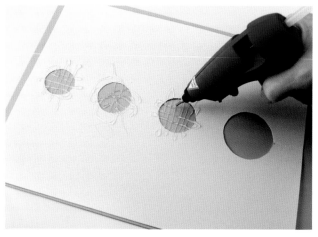

CREATE SHAPES

In addition to free-form designs, you can use heavy weight paper to create a stencil of any shape. Cut the shape out of the paper and then lay the glue across the opening. Be sure to run the glue over the edges of the shape so that it's securely held in place across the open space.

APPLY PAINT THROUGH THE STENCIL

Use a sponge or the mouth atomizer to apply paint through the open area of the stencil. When using the mouth atomizer the paper will not only define the shape but will help protect the area around the shape from overspray.

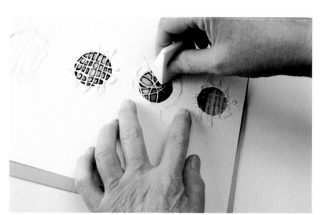

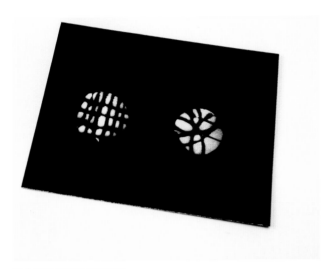

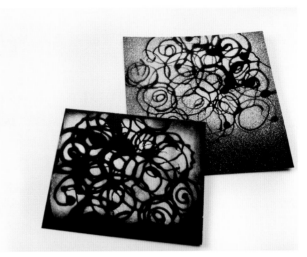

REMOVE THE STENCIL
Remove the stencil for perfectly formed shapes.

USE THE SPONGE OR ATOMIZER FOR DIFFERENT EFFECTS
Use the mouth atomizer (top painting) to achieve a more random and textured application of paint. The mouth atomizer will produce a fine spray of small dots and sprays through the smallest of openings. When your stencils are thick, use the mouth atomizer.

Use the sponge when you want more control of the placement of paint (bottom painting). The sponge will produce a more even application of paint than the mouth atomizer, but only if the sponge is loaded properly. Dab the end of the sponge in paint, and then tap it on the palette several times until the excess paint is pushed into the sponge and is uniform across the sponge's surface.

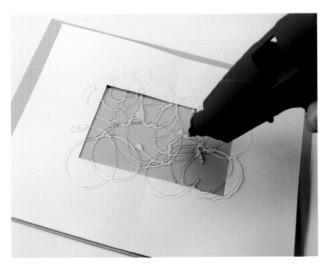

MAKE STENCILS ANY SHAPE
You can make paper stencils any size or shape. You're only limited by the size of the paper you use for the stencil. Very large stencils could be made using thin poster board. Remember that stencils made with paper will create very distinct shapes when sponged or sprayed and can be harder to integrate than the free-form stencils.

USE STENCILS WITH ANY COLOR OF PAINT
Use your stencils on any colored surface and with any color of paint. When you use glue gun stencils on white paper the open areas of the stencil will be the chosen color, and the lines will be white. Leave the lines white or tint them with a glaze of color once the sponged or sprayed paint is dry.

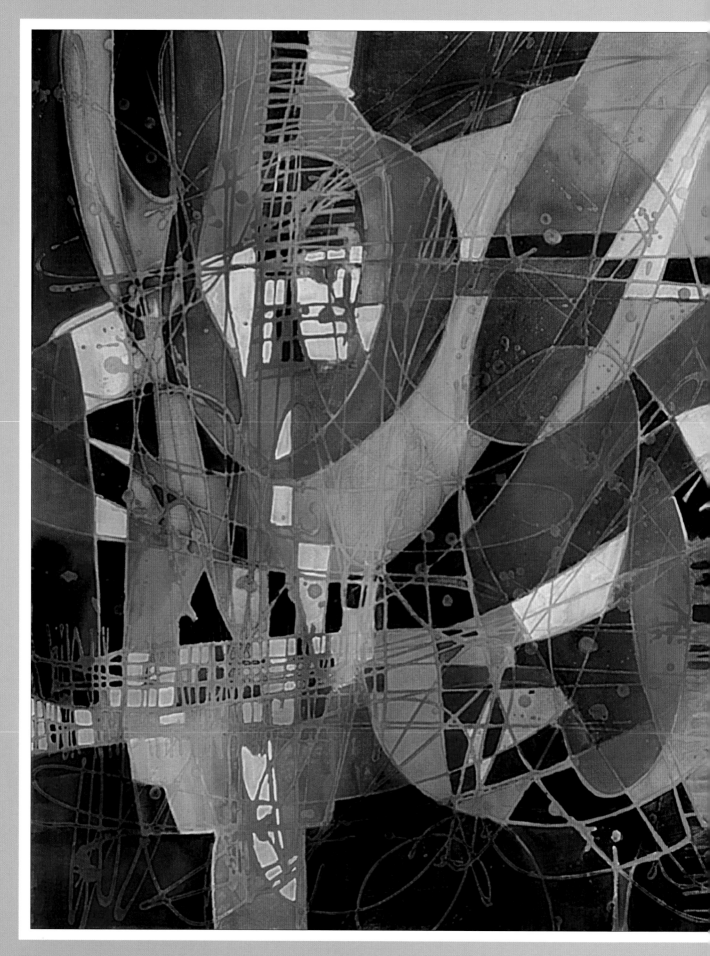

PART 3 PRACTICE SAMPLES

"ONLY WHEN HE NO LONGER KNOWS WHAT HE IS DOING DOES THE PAINTER DO GOOD THINGS." EDGAR DEGAS

By the time you reach this third and final section you should have a pretty good idea of why I do what I do and how I employ various materials and tools in the process. Now you are to the part of the book where the magic begins.

This is the part of the book where I hope you will trot out to your studio, (even if it's the kitchen table) lay the book open and come play along with me. I'm going to take you through detailed step-by-step explanations and tons of pictures that demonstrate eight different techniques. Each one of these demonstrations are designed to incorporate the tools and materials from the first half of the book and clearly illustrate how these techniques can be used in actual paintings. I believe this is the most valuable part of the book. No matter how many techniques you learn, experimental or otherwise, if you don't know how they might be effectively used in an actual painting, they lose some of their instructive value.

As in my workshops, we will be working small. No larger than 10"×10" (25cm×25cm) and in most instances I am demonstrating on paper that is cut 8"×8" (20cm×20cm) square. These are not meant to be great pieces of art but rather small representations of each technique that can be used as a reference for further exploration and finished paintings. As I stated in Part 1, I believe allowing ourselves the freedom to make "practice" samples increases our learning and enhances our creativity. What do you have to lose but a little piece of paper and small amount of time? At the beginning and end of each demonstration I have included several examples of my own work that are representative of each technique.

So delve in, follow along, get the hang of what I am showing and most of all, remember that these are just small practice samples. Now, let's get going.

Star Catcher
Jo Toye
24" × 24" (61cm × 61cm)
Watercolor on canvas

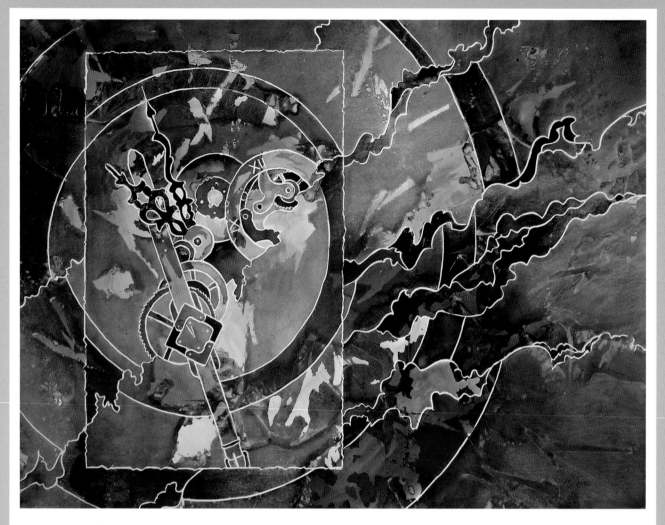

Wrinkle in Time
Jo Toye
22" × 30" (56cm × 76cm)
Acrylic on 140-lb. (300 gsm) watercolor paper

LET IT FLOW

In this first demo you will learn the technique that birthed the idea for all the techniques that will follow.

Having been a stained glass artist in another lifetime, I was fascinated with the concept of using line as a dominant element in my paintings. Shortly after I started painting, I was taking a workshop with Betsy Dillard Stroud, a fabulous artist and a dear friend. She instructed us to paint a painting while leaving a white line between each element. I thought this sounded like way too much effort and set off to discover an easier way to produce a white line. So, with a dip pen in hand and a jar of masking fluid, I created my first line painting, *Wrinkle In Time*.

The process was slow and tedious but the results were exciting. A few years later, the Masquepen made its debut and I was in love at first "use." It's now called the Resist Pen and you will find detailed information about it in the previous section on tools.

DEMONSTRATION
RESIST PEN TECHNIQUE

The following demo is an exercise to get you familiar with the Resist Pen as it's the foundation for many of the techniques that follow. If you do not have a Resist Pen, or do not wish to purchase one, this technique (and any others that use the Resist Pen), can be accomplished with a dip pen and masking fluid.

MATERIALS LIST

ACRYLIC GLAZING LIQUID
FINE MIST SPRAY BOTTLE
FLUID ACRYLICS
GESSO, WHITE
PAINTBRUSH
PAINTS, ASSORTED
PIPETTES OR EYEDROPPERS
RESIST PEN
RUBBER CEMENT PICK-UP
WATERCOLOR PAPER

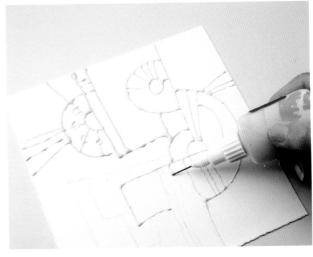

1 MASK THE DESIGN
Use a pencil to draw your design directly on watercolor paper. Then use the design as a guide to apply the masking fluid. Let the mask dry completely.

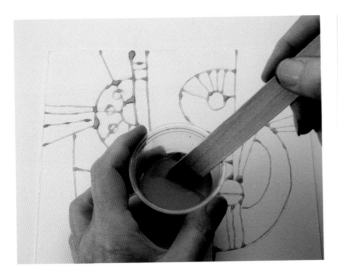

2 MIX PAINT WITH WATER
In a small container, mix a dab of paint with water to dilute the fluid acrylic to a watery consistency. Mix all of the colors in separate containers so they're ready for use once you start painting. Three colors usually work best for a small sample like this, I used Quinacridone Nickel Azo Gold, Anthraquinone Blue and Permanent Violet Dark.

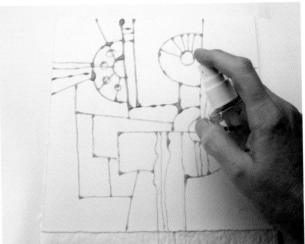

3 ELEVATE THE PAPER AND SPRITZ
To encourage the paint to flow down the paper, elevate the painting support and paper. Lightly mist the paper with water using a fine mist spray bottle. To achieve the pattern that the pour creates, make sure you do not get too much water on the paper. Too much water will cause the different colors to blend and diffuse, and the paint will not retain its linear quality.

71

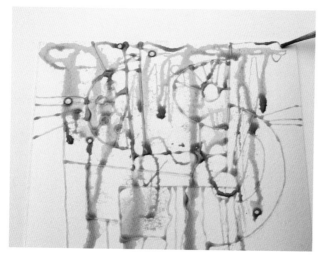

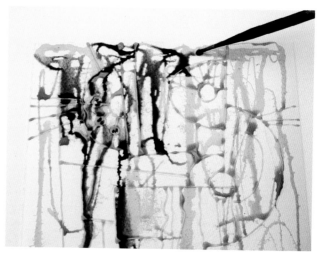

4 POUR THE LIGHTEST COLOR

Load a pipette with your lightest color, Quinacridone Nickel Azo Gold, and pour the paint across the top of the paper. The paint should flow all the way to the bottom. Place a paper towel at the bottom edge to catch the overflow. The masked lines may stop some of the paint from flowing, so use the tip of the pipette to nudge the color downward. If desired, pour more color directly on the lower portions of the painting.

5 POUR THE SECOND COLOR

Fill a pipette with Anthraquinone Blue and release the paint across the top of the paper. With each color be careful not to cover all of the white. The pattern created by the poured paint will show best where the color contrasts with the white of the paper. Because you'll be pouring three colors, keep in mind how much of the paper is being covered with each pour and be sure to leave some of the white paper visible.

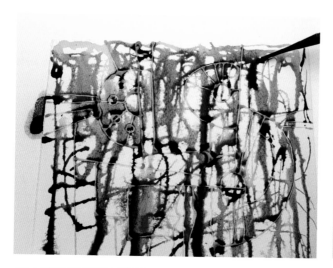

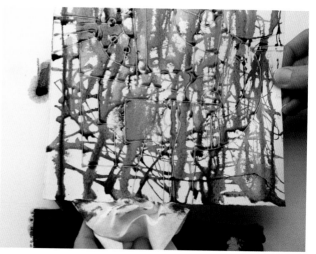

6 POUR THE THIRD COLOR

Repeat step 5 with Permanent Violet Dark. If a lot of the Quinacridone Nickel Azo Gold has been covered by the subsequent pours, reapply another layer. Carefully place this color with the pipette so that it doesn't blend with the other colors and still leaves some of the white showing.

7 MOP UP THE EXCESS PAINT

Remove the sample painting from the elevated surface and run a paper towel across the bottom edge to absorb any paint that is collecting there. This will aid in the drying time and will prevent the back of the paper from adhering to the surface.

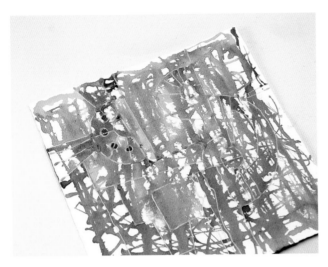

8 ALLOW THE PAINTING TO DRY

Because you have masking fluid on the paper, allow the painting to dry without the use of heat. The painting must be bone dry so that the subsequent glazes will achieve their maximum brilliance.

9 BEGIN TO GLAZE

Much of the poured paint has mingled together to produce additional, less saturated colors. By placing thin glazes of the original color over these areas you will create stunning color passages. Begin to glaze with the lightest color, Quinacridone Nickel Azo Gold.

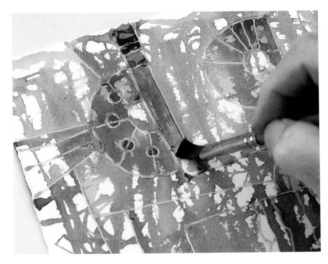

10 CONTINUE TO GLAZE ANOTHER COLOR

Continue to glaze the painting with Permanent Violet Dark and Anthraquinone Blue. Start with fresh paint when glazing and water it down as needed. You can use the leftover diluted paint that you used for pouring, but you won't be able to control the value of the glaze and it may be too light to be effective.

MASKING FLUID

It is best to leave the masking fluid in place until the whole surface has been painted. The masked lines should be visible through the poured layers and they can be used to guide the color placement. If you remove the mask, which will reveal white lines, you will need to be careful not to cover them as you paint the subsequent layers. You can always tint the lines after you remove the mask but you can never get the original white of the paper back once it is gone.

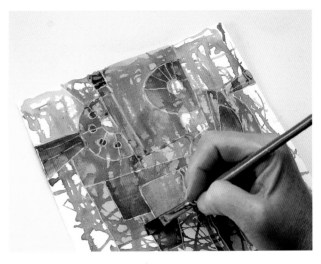

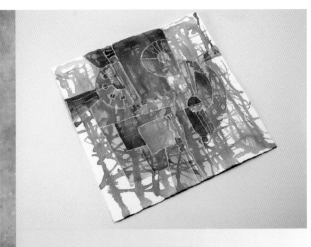

11 FINISH GLAZING TRANSPARENT COLOR

Apply a final glaze layer of transparent color. When placing color, be aware of where you may want the focal point and consider putting your lightest and darkest colors in that area for contrast. Also, position your colors so that they draw the eye throughout the painting.

DECISION TIME

At some point you may wish to begin to paint some areas translucently. Due to the poured lines the background is very busy, so using translucent or opaque paint as a contrast to the vibrant transparent layers can be very effective.

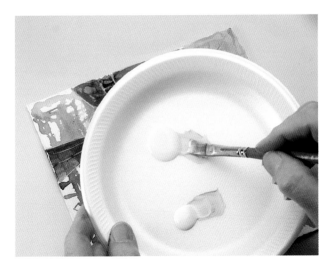

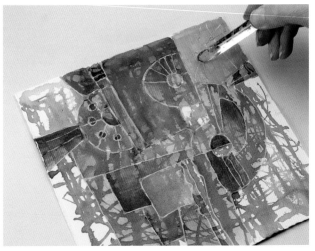

12 MIX THE PAINT

Mix white gesso and glazing liquid with Anthraquinone Blue and Quinacridone Nickel Azo Gold paint to produce a translucent paint. Mix in the white gesso first to obtain the correct value and then add the glazing medium to achieve your desired translucency. Then apply the paint mixture to a small area of your painting.

13 SCRAPE THROUGH THE PAINT

Immediately after painting the area, use the end of the brush or palette knife to scrape through the wet paint. By scraping back though this translucent layer, some of the underpainting will show through to integrate the layers.

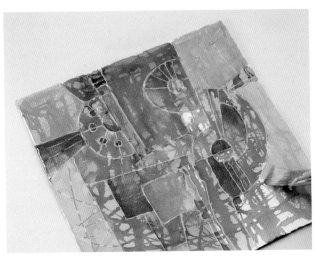

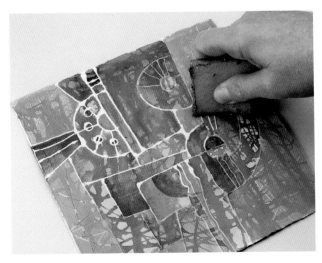

14 **CONTINUE TO ADD TRANSLUCENT PAINT**
Mix white gesso with the Permanent Violet Dark and then add glazing liquid. Get the application of paint translucent enough that it contrasts with the transparent areas but is thin enough that some of the texture below can be seen. You can always make it more opaque later with another layer. Continue to add layers, as desired, then let the painting dry.

15 **REMOVE THE MASKING FLUID**
Use a rubber cement pick-up to remove the masked lines from the dry paper.

16 **ADD A WHITE LINE**
Create additional shapes as needed. I added more green and the semicircular shape. Now that the mask is off, it's the only shape that's not bordered by a white line. Use a standard tip applicator bottle filled with white gesso and trace around any added shapes. Once this is dry it will look like it's part of the original line saved by the masking fluid.

17 **TINT THE WHITE LINE**
You may choose to leave the white line as is or to paint it. Use a fine brush and some diluted Cobalt Teal paint to glaze over the lines. You can paint all of the line, some of the line or make the line several colors.

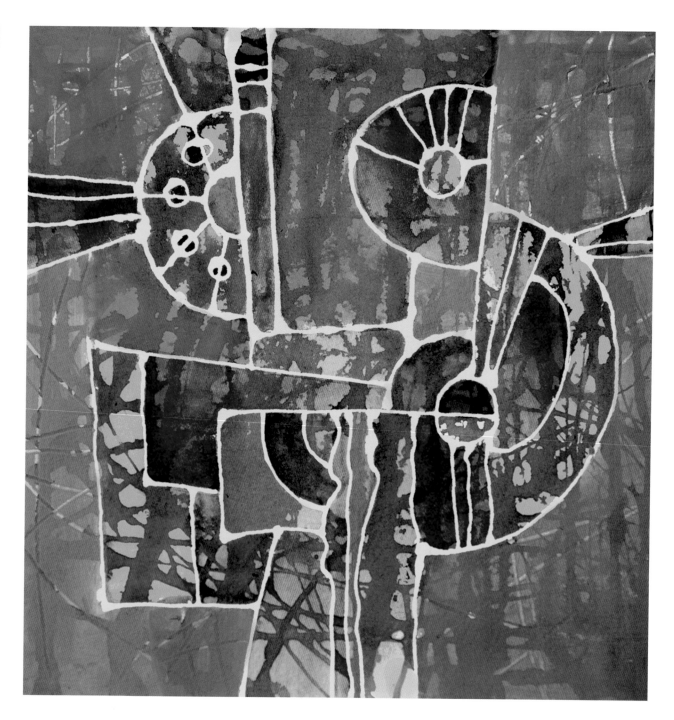

18 ADD FINAL DETAILS

Add any final details, as desired, and let the painting dry. The glazed areas have depth and brilliance while the translucent areas still allow the pattern to be seen underneath. For more contrast you could make the translucent areas more opaque.

Finished Practice Sample
Jo Toye
8" × 8" (20cm × 20cm)
Acrylic on 140-lb. (300 gsm) watercolor paper

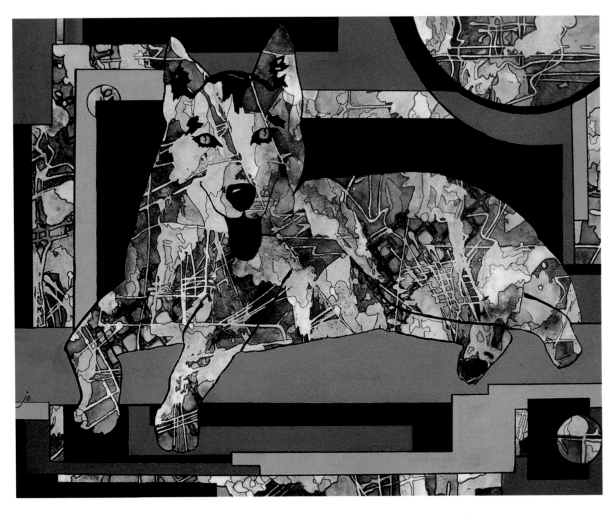

Cheyenne
Jo Toye, Collection of Burt Bork
11" × 14" (28cm × 36cm)
Acrylic on aquabord

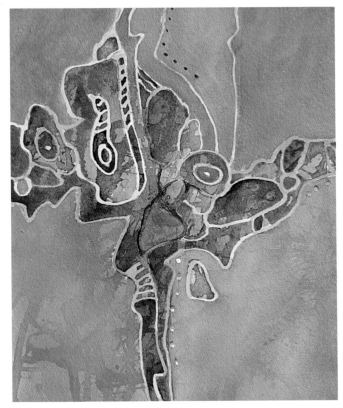

Previous Class Demo
Jo Toye
8" × 7" (20cm × 18cm)
Acrylic on 140 lb. (300 gsm)
watercolor paper

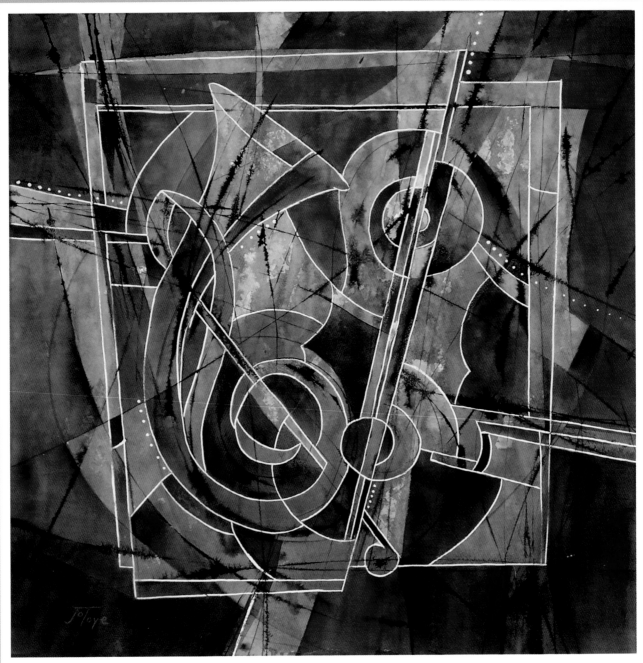

Pieces of a Theme
Jo Toye
20" × 20" (51cm × 51cm)
Acrylic and ink on 140-lb. (300 gsm) watercolor paper

DRAWING THE LINE

Of all the ways to make line, using a razor blade is probably one of the most unusual. I must thank the late Dick Phillips for introducing me to its possibilities. In this technique you will once again start with the Resist Pen to save white lines. Then once you add color, and while it's still wet, you'll use a razor blade and India ink to add a series of black lines.

Drawing a black line of India ink through wet color does have its challenges. If the paper is too dry, the ink will not trans-fer off of the razor blade and onto the paper. If the paint is too wet, the ink will bleed so profusely that it can obliterate the colors around it. And lastly, the combination of India ink and wet paint produces results where control seems to be left out of the equation. It can be a bit intimidating to run an uncontrollable line of dark black ink right through a wet, vibrant underpainting, but the results and quality of line are not possible with any other method.

RAZOR BLADE TECHNIQUE

The straight black line, produced by the razor blade, is a great contrast to the more organic white line made with the Resist Pen. The more you use this technique the more comfortable you will become with both how the ink behaves and the results it will produce. Remember, this is just a practice sample so be bold and draw the line.

MATERIALS LIST

ACRYLIC GLAZING MEDIUM

CONTACT PAPER

FINE MIST SPRAY BOTTLE

GESSO, WHITE

WATERPROOF INDIA INK

MAKE-UP SPONGE

PAINTBRUSH

PAINTS, ASSORTED

PAPERTOWELS

RAZOR BLADE, SINGLE SIDED

RESIST PEN

RUBBER CEMENT PICK-UP

TITAN BUFF FLUID ACRYLIC (OPTIONAL)

WATERCOLOR PAPER

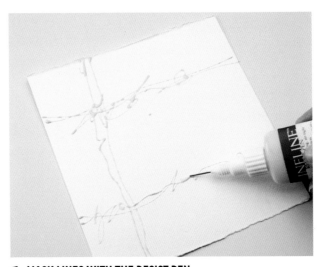

1 MASK LINES WITH THE RESIST PEN
On dry watercolor paper, use the Resist Pen to draw a series of lines.

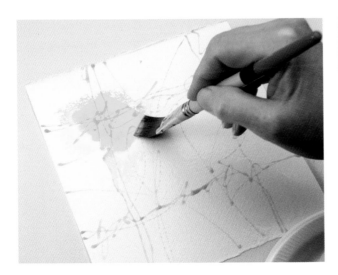

2 ADD COLOR
Lightly spritz the paper then begin painting with Hansa Yellow Light.

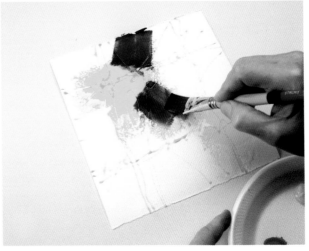

3 ADD ANOTHER COLOR
Apply Anthraquinone Blue next to the areas that contain Hansa Yellow Light. Repeat this in several areas.

VISIT ARTISTSNETWORK.COM/ABSTRACT-EXPLORATIONS FOR BONUS CONTENT.

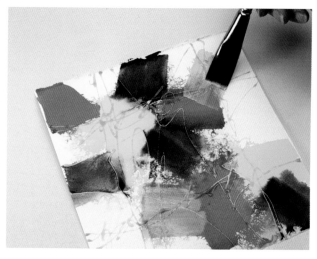

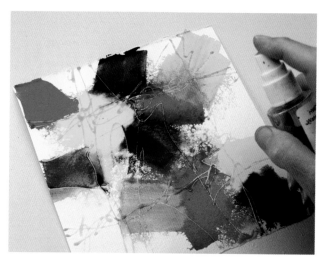

4 ADD MORE COLOR
Continue to place more color, adding Napthol Red Light. Paint in areas of color so that each color is balanced throughout the painting.

5 ENCOURAGE THE COLORS TO MIX
As you add each color, the combination of the wet paper and the overlapping of the color will cause the paints to flow into one another and combine to form new colors. It's best to choose colors, that when combined, will result in pleasing mixtures. If the colors are not bleeding and mingling, mist the paper with a fine mist spray bottle.

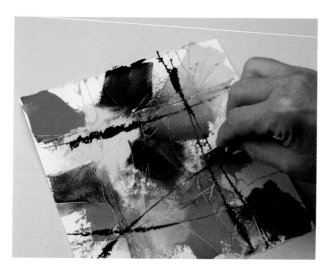

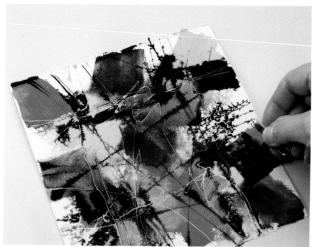

6 ADD INK WITH THE RAZOR BLADE
While all the colors are still wet (but not pooling in puddles), load the sharp side of the razor blade with India ink and draw its tip through the paint. If you have lightly spritzed your paper and have not added too much water to your paint, the surface should have just the right amount of moisture for the ink to transfer without spreading uncontrollably. It will take some practice to decipher exactly what is the optimal amount of moisture.

7 ADD SOME SOLID AREAS OF INK
If you want more black in your painting, drag the length of the loaded razor blade across the surface of the paper.

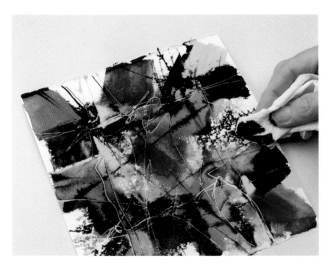

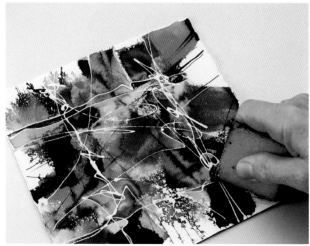

8 **BLOT THE EXCESS INK**
If the black ink is spreading too much, use a dry paper towel to blot up some of the ink. Lay the paper towel over the spot you wish to lift and apply pressure. Be sure to do this immediately after the ink has been placed or it will not lift.

9 **REMOVE THE MASK**
Allow the paint to dry and remove the mask.

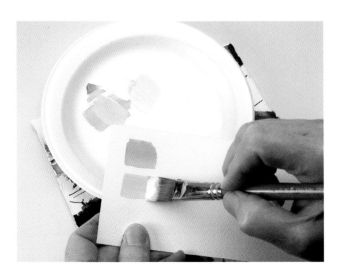

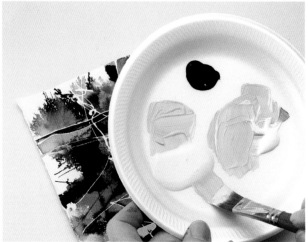

10 **MIX A NEUTRAL**
Use white gesso and India ink (or black gesso) to mix a neutral gray. You may also wish to mix in just a hint of one of the colors used in the painting. The color added will not be noticeable but will push the gray towards a warm or cool temperature. Sample the color on a scrap piece of paper to get the value you desire.

11 **MIX IN GLAZING LIQUID**
With the brush loaded with the gray mixture, pull out some glazing liquid and blend it into the paint on the brush. The addition of the glazing liquid will allow you to keep the gray areas translucent so that some of the underpainting will show through. Additionally, the glazing medium increases the working time of the paint. This allows you to scrape back through this layer with a razor blade or the end of your brush to reveal the color below. Both of these things help integrate this layer into the underpainting.

VISIT ARTISTSNETWORK.COM/ABSTRACT-EXPLORATIONS FOR BONUS CONTENT.

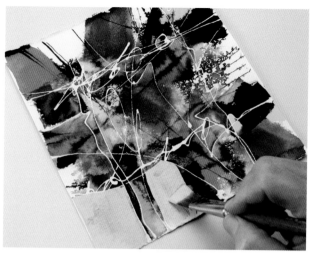

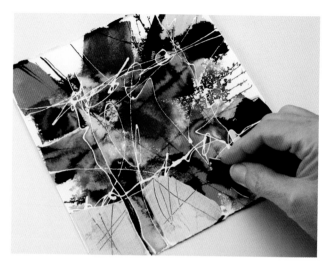

12 ADD GRAY
Use the lines as a loose guide to add areas of gray. Apply the gray to help define shapes that are emerging from the cross sections of the lines.

13 SCRAPE THROUGH THE GRAY
Scrape back through the paint with the tip of the razor blade. This adds a third type of line and allows the underpainting to show through. Then continue to add more gray throughout the painting.

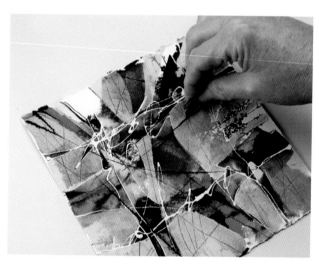

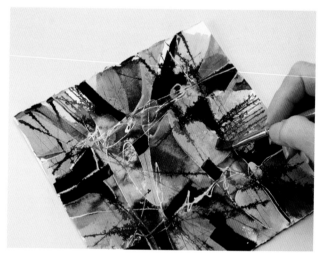

14 ADD ANOTHER LAYER OF INK LINES
Add another layer of lines made with the ink and razor blade. Remember, the ink won't transfer off of the razor blade onto dry acrylic paint, so wet the surface with a fine mist spray bottle. Run several ink lines across the painting and over the gray areas.

15 GLAZE COLOR
Add more color as necessary to help balance the color placement throughout the painting. Tint some or all of the white line with Cobalt Teal, then adjust the tone and temperature of the gray areas with glazes of the same color.

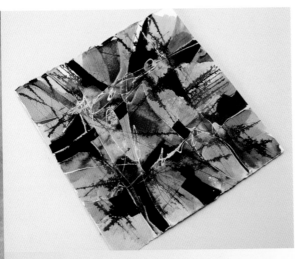

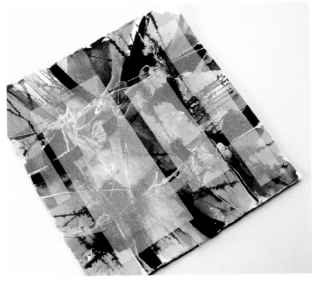

DECISION TIME

Often, once the gray areas are defined then I'm done—this is not one of those times. I like the color and the play of the transparent colors against the neutrals, but this demonstration sample still needs more definition. At this point I often use black gesso to define a large shape and push back areas of the painting into the background. However, this time I'm going to boldly go where I have never gone before with this technique and try something new. How can I ask you to experiment if I don't set the example?

16 CUT SHAPES OUT OF CONTACT PAPER
Add geometric structure to the sample by covering areas of the painting with rectangular pieces of contact paper. Burnish the edges so that the contact paper doesn't lift. You will be adding the next paint layer with a sponge instead of a brush so you do not need to mask around the edges of the contact paper.

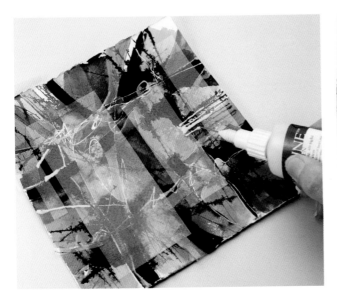

17 SAVE SMALL AREAS WITH THE RESIST PEN
Use the Resist Pen to save areas not covered by the contact paper that you want to remain visible. Run the masked lines from one shape to the next to help tie the shapes together.

18 TRANSFER PAINT WITH A SPONGE
Dip a make-up sponge into Titan Buff or white gesso and tap it on your palette until the paint is being transferred from the sponge in an even layer.

VISIT ARTISTSNETWORK.COM/ABSTRACT-EXPLORATIONS FOR BONUS CONTENT.

19 APPLY A TRANSLUCENT LAYER
With the sponge, tap a layer of translucent paint across the surface of the painting. Try to keep the paint from getting opaque so that the underpainting will be visible below this layer.

20 REMOVE THE CONTACT PAPER
This acrylic layer will dry very quickly, so you can remove the contact paper almost immediately. However, you must wait until the paint is completely dry before you remove the masked lines. Often the masked lines will pull up when you remove the contact paper, so it's best to wait for the paint to dry before removing any of the masked areas.

21 FINAL TOUCHES
Once the contact paper is removed, integrate this final layer by adding more razor blade lines over the sponged areas.

The underpainting is visible both where the large contact areas and Resist Pen were used. Using the sponge to create the translucent background sets off the vibrancy of the painted areas and the razor blade is visible throughout the layers.

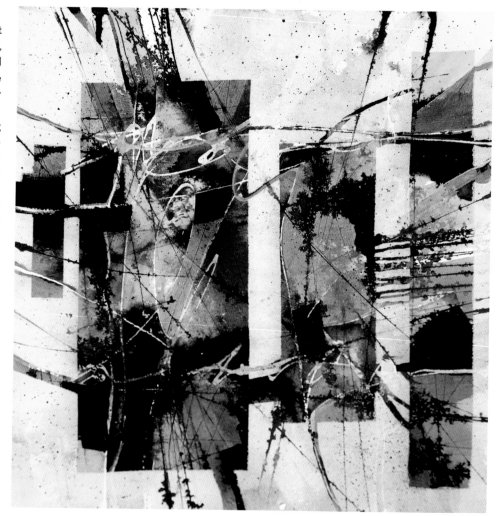

Finished Practice Sample
Jo Toye
8" × 8" (20cm × 20cm)
Acrylic on 140-lb. (300 gsm)
watercolor paper

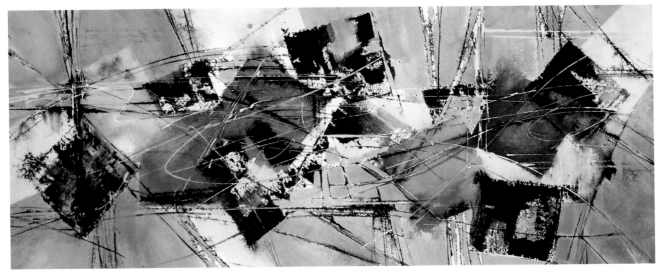

The Waltz
Jo Toye
9" × 22" (23cm × 56cm)
Acrylic and ink on 140-lb. (300 gsm)
watercolor paper

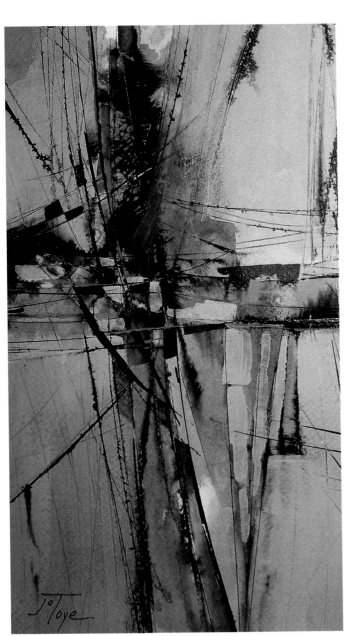

Previous Class Demo
Jo Toye
9" × 6" (23cm × 15cm)
Acrylic and ink on 140-lb. (300 gsm) watercolor paper

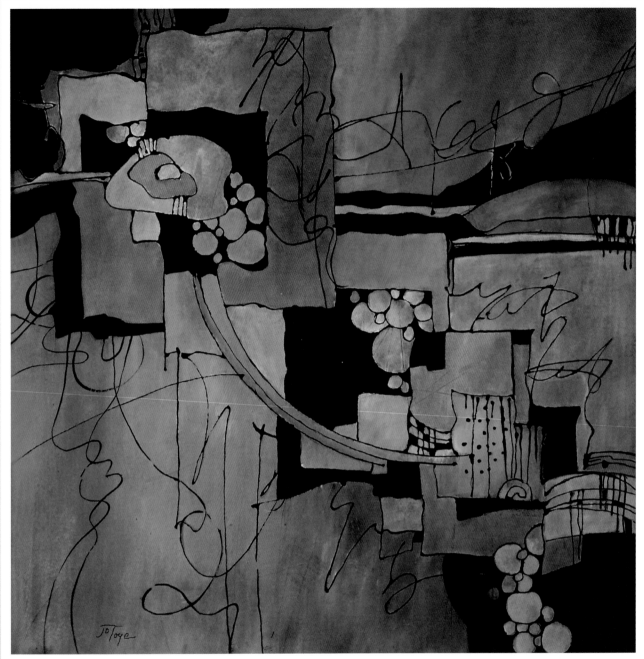

Waiting For Sunrise
Jo Toye
22" × 22" (56cm × 56cm)
Acrylic on 300-lb. (640 gsm)
watercolor paper coated with black gesso

PAINTING IN THE DARK

Several years ago I was wandering the galleries when my eye caught this stunning ceramic plate that had black lines running through it. I'd been using the Resist Pen for quite some time to save white lines in my paintings, and this plate got me thinking about how I could "save" a black line rather than applying one with a brush or other means. Thus, this technique was born.

In order to save a black line, your support must first be painted with black gesso before the masking fluid lines are added. Since you'll be working on a black, rather than white, surface it's necessary to use translucent or opaque paint to build up the paint layers.

I call this technique "painting in the dark" because at one point in the process the entire surface, including your masked line, is covered with paint, and it's very hard to imagine what it will look like once the mask is removed. Once the mask is removed, the colors are adjusted and areas of the painting are once again painted black. I think you'll find that painting on a black surface renders a quality to the paint that is not achieved in any other way.

BLACK LINE TECHNIQUE

In this demo you will use the Resist Pen on a black surface. The black line that you create will have a much different quality to it than one that is painted with a brush. This technique will be intriguing to most watermedia painters who are most familiar with painting on a white surface.

MATERIALS LIST

1 FLAT NYLON BRISTLE BRUSH

DRY ERASE MARKER

FINE MIST SPRAY BOTTLE

GESSO, BLACK AND WHITE

GLAZING MEDIUM

PALETTE KNIFE (OPTIONAL)

PAINTS, ASSORTED

PLASTIC SHEET, CLEAR

RESIST PEN

RUBBER CEMENT PICK-UP

WHITE TRACING PAPER OR
WHITE WATERCOLOR PENCIL

YUPO SURFACE

A FINE BALANCE

This technique relies on a fine balance between two things for its success: White gesso to add opacity to the paint and glazing medium to keep the paint from getting too opaque and to aid in the blending of the colors. Remember to add glazing medium every time you load your brush with paint.

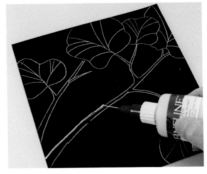

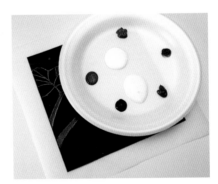

1 DRAW A DESIGN
Use a white watercolor pencil to draw a design onto a piece of Yupo that has been coated with black gesso. You can also draw your design out on paper and trace it onto your surface with white tracing paper.

2 MASK THE LINES
Using the Resist Pen, draw over the lines of the design with masking fluid. Let it dry.

3 PREPARE THE COLORS
Place the colors, along with white gesso and glazing medium, on the palette.

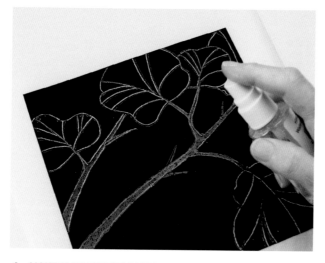

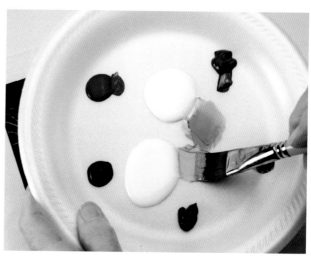

4 **LIGHTLY SPRITZ THE PAPER**
Lightly mist the paper using a fine mist spray bottle filled with water.

5 **BLEND WITH THE BRUSH**
Mix Quinacridone Nickel Azo Gold and Cerulean Blue Deep with the brush and blend in a small amount of white gesso. Add some glazing medium and blend it into the paint mixture on a palette.

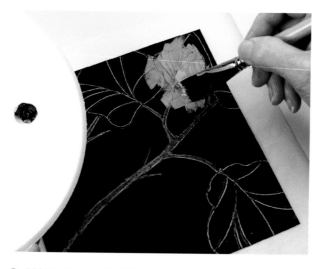

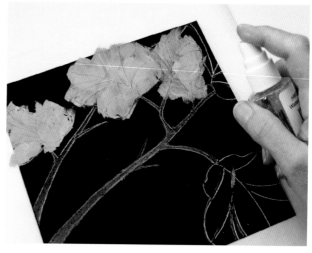

6 **APPLY PAINT TO THE SURFACE**
Add the paint mixture in a crisscross pattern with the brush. This aids in the ability to blend one color or brushstroke into the next.

7 **LIGHTLY SPRITZ WITH WATER**
Lightly spritz the surface with water so the paint doesn't dry out. This will blend each subsequent color with the last, and as the fine water droplets dry they leave a mottled texture in the paint.

NOT TOO MUCH

You are going to blend your paint colors together throughout the painting and this light layer of water aids in this process. If you get too much water on at this stage, when you apply the paint it will get watered down and will not maintain enough translucency to cover the black.

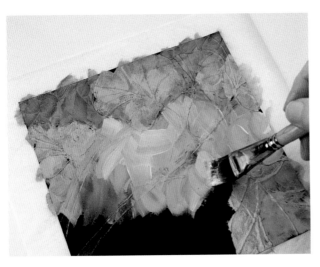

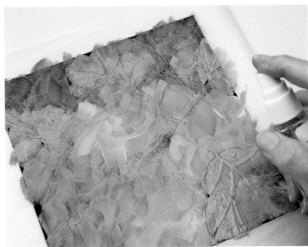

8 ADD MORE COLOR

While the first application of paint is still wet, continue to add more colors as your design dictates. Because I want a sky color, I'm adding a combination of Phthalo Blue mixed with a small amount of Quinacridone Nickel Azo Gold, plus the white and glazing medium. If you have a random abstract design, you can add colors as you wish across the surface. Just remember to blend the colors into one another as you move through the painting.

9 SPRITZ WITH WATER

Once all the paint is applied and before it dries, lightly spritz the painting one final time. This will give the entire surface a uniform texture, which isn't apparent until the paint begins to dry. If you don't see any texture it's probably because the paint was too dry when you applied the mist of water.

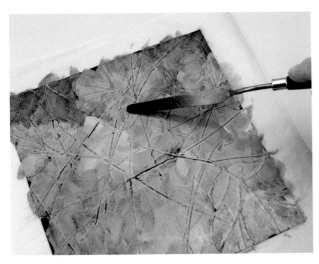

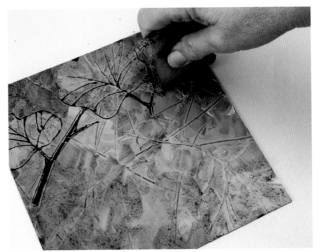

10 SCRAPE THROUGH THE PAINT

To add another quality of line to the painting and to allow more of the black to show through, take the end of a brush or a palette knife and gently scrape through the paint. This will reveal the black gesso layer beneath. Use a light touch because if the paper is too wet or you scrape too hard, you'll scrape through the black gesso and expose the white Yupo.

11 REMOVE THE MASK

Once the paint is completely dry, use your fingers or a rubber cement pick-up to remove the mask. This is when the fun begins because the black line running throughout your design immediately brings the painting to life!

VISIT ARTISTSNETWORK.COM/ABSTRACT-EXPLORATIONS FOR BONUS CONTENT.

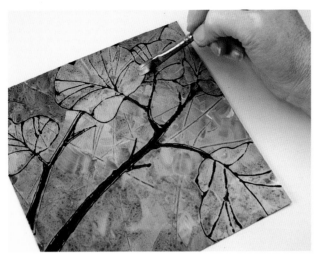

12 ADJUST COLOR
Adjust the color of an area by applying more paint to the surface, but be careful not to cover any of the black lines that you just exposed.

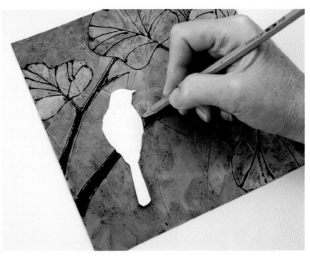

13 EXPERIMENT BEFORE PAINTING BLACK
Once you are happy with the color, decide where you will add black shapes back into your painting. These added shapes can be hard to change once they're painted with black gesso so you may want to test their placement. Cut out several templates in a range of sizes from a sheet of white paper, and trace around it as a guide for painting in the black gesso.

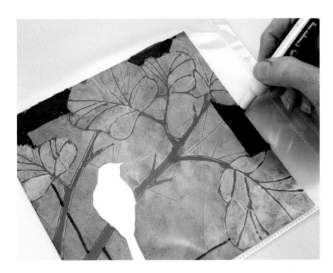

14 DEFINE THE BLACK SHAPES
Define other black shapes in your painting by using a sheet protector and a dry erase marker. Add and erase shapes endlessly until you're happy with all of the black areas.

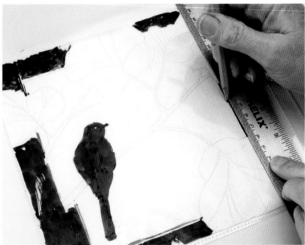

15 TRANSFER THE OUTLINE OF THE BLACK SHAPES
Once you have all of the black shapes defined, you can remove the sheet protector and use it as a visual guide as you paint in the black shapes. Alternately, you can slip in a piece of white transfer paper and trace on top of the plastic to transfer the design to your painting.

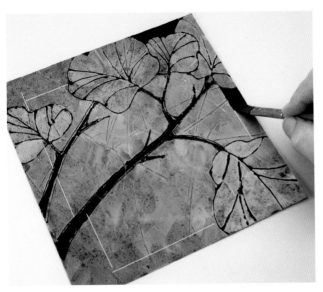

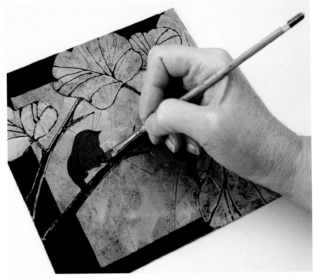

16 APPLY BLACK GESSO
Apply black gesso with a flat brush to paint in the black areas.

17 PAINT IN THE BIRD
Follow the outline of the bird that you traced earlier and paint the bird with black gesso.

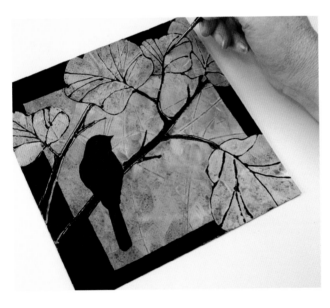

18 TOUCH UP THE BLACK LINES
Use a small round brush loaded with black gesso to touch up any of the original masked lines that have been covered by paint or that need to be adjusted.

ALTERNATIVE SURFACES

This technique can be done on any substrate that is painted with black gesso. Watercolor paper works well as does gessoed canvas, illustration board or gessoed masonite. Once coated with black gesso, watercolor paper will become less absorbent but will soak up the paint more quickly than the coated Yupo. Lightly spritz your paper more frequently to keep the paint from drying out so you can continue to blend the paint on the surface. Don't forget to add the glazing medium to your paint no matter what surface you choose to work on.

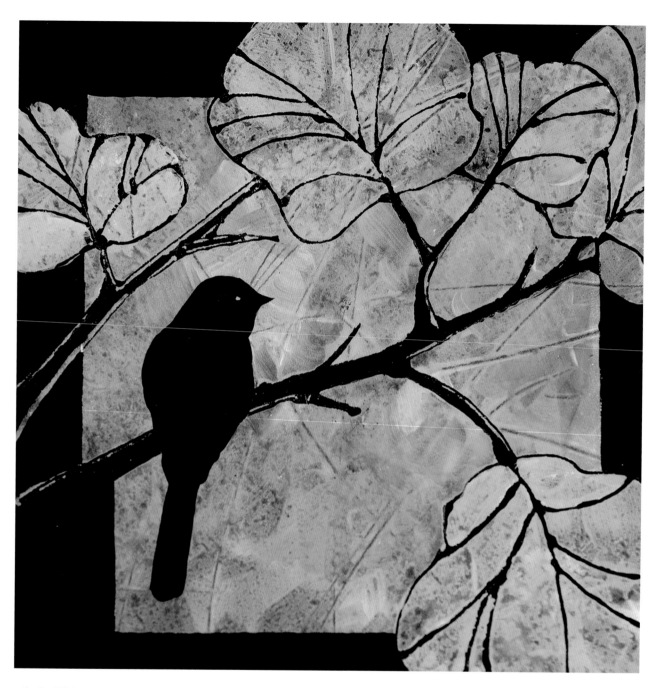

19 FINAL TOUCHES

Add final details and let the painting dry. By painting translucently you allow some of the black surface to peek through the color layers. The stippled texture in the leaves is the result of misting water onto the wet paint. Lines in the blue background were created by scraping through the paint before it was dry.

Finished Practice Sample
Jo Toye
8" × 8" (20cm × 20cm)
Acrylic on 140-lb. (300 gsm) watercolor paper

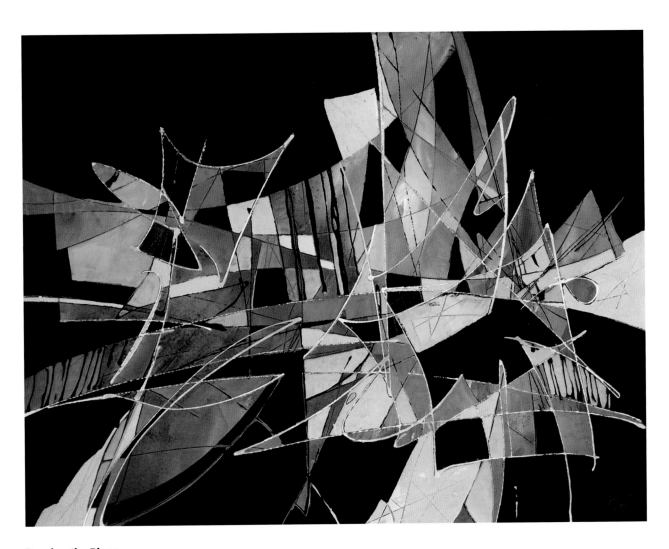

Dancing the Blues
Jo Toye
14" × 18" (36cm × 46cm)
Acrylic on 140-lb. (300 gsm) watercolor paper

If you're daring, you can take this technique one step further. Before you coat the paper with black gesso, apply a layer of masked line on top of the white paper. In effect, you will be saving a white line. Once the mask is dry, completely cover the paper and mask with black gesso and proceed through the steps in this demonstration. When you remove the mask in the final stages, you'll have saved both white and black lines. You can leave the white line as is or tint it with color. This painting was done in this manner.

VISIT ARTISTSNETWORK.COM/ABSTRACT-EXPLORATIONS FOR BONUS CONTENT.

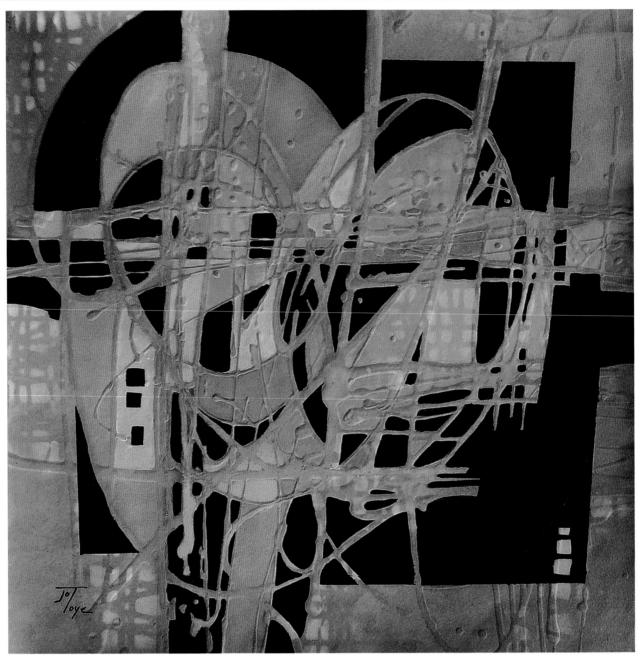

The Heart of the Matter
Jo Toye
12" × 12" (30cm × 30cm)
Acrylic on Yupo

STENCILS, SPONGES AND SPRAY

In my classes, this is one of my students' favorite techniques and it consistently produces a room full of great, little, sample paintings.

While I will be demonstrating using white over black, you don't need to stop there. To revive or transform an old painting, white can be stenciled over select portions of the painting. Once you apply the white, glaze over it with color to integrate it with the rest of the painting.

Of course, you can also sponge or spray any color onto a white or light surface for stunning results. The complete surface of the paper can be covered with sprayed texture, and then portions of the painting can be pushed back or cut away using translucent or opaque color. You can even apply a white pattern onto white paper and then apply color. Once you apply transparent color over the area that you've sprayed, the paint will absorb differently from the areas of plain paper—producing a very subtle but intriguing texture.

SPONGE AND SPRAY TECHNIQUE

For this sample, you will use stencils, sponges and the mouth atomizer to create both bold and subtle patterns on a black gesso surface. You will accomplish this by spraying or sponging white through stencils onto the black surface and then glazing over the patterned area with a layer of color. You can control the dominance of the pattern by how transparent or translucent you make this layer. I demonstrate using both the mouth atomizer and the sponge, but all of the patterns can be produced solely with one or the other.

MATERIALS LIST

APPLICATOR BOTTLE

GESSO, BLACK AND WHITE

GLAZING MEDIUM

MAKE-UP SPONGE

MOUTH ATOMIZER

PAINT, ASSORTED

PAPER, TRACING AND WATER-
COLOR

RESIST PEN

STENCILS

WATERCOLOR PENCIL, WHITE

WHITE HIGH FLOW ACRYLIC

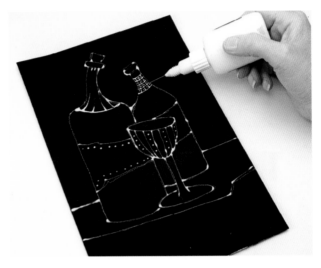

1 MASK A DESIGN
Use the Resist Pen to mask a design on a piece of paper that's been coated with black gesso. You can draw your design onto your paper or just apply the mask freehand. I find it useful to draw in the large shapes before masking, then add details spontaneously after the large shapes are masked.

2 PROTECT AREAS FROM SPRAY
When using the mouth atomizer you must protect areas that you do not want to be sprayed. Once the mask is dry, lay tracing paper over the masked design and use a marker to trace the area that you want to protect. Remove the tracing paper and cut.

3 REPLACE TRACING PAPER
Since the bottom part of the paper is going to be sprayed, cover the entire top portion of the paper. (Covering a few inches above where you're going to spray is not sufficient as the spray tends to travel far and wide.) Add another piece of tracing or regular paper to cover everything except the area where you want to add the sprayed pattern.

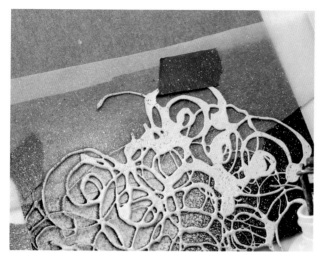

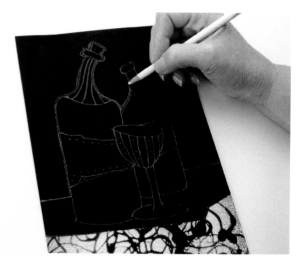

4 POSITION STENCIL AND SPRAY WHITE

Move the sample to an inclined or vertical surface for spraying. Tape down the paper, the tracing paper and the stencil. Using the mouth atomizer, spray an even layer of white. Be careful not to spray too heavy of a layer, as it will drip and seep under the stencil edges. Always practice spraying on a scrap piece of paper.

5 TRACE AROUND THE DESIGN

Remove the stencil and allow the paint to dry. Draw around your design, outlining with a white watercolor pencil. This will allow you to see your design through the stencil.

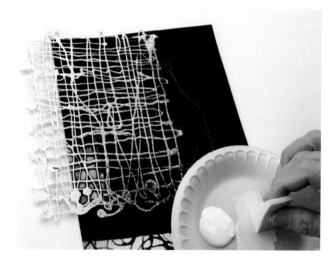

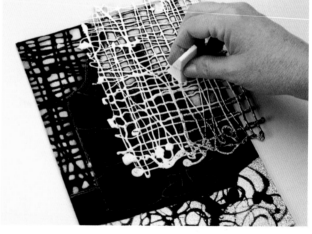

6 DAB WHITE GESSO ONTO THE SPONGE

Dip the make-up sponge into white gesso. Pat the sponge on your palette several times to remove the excess gesso and to ensure an even application.

7 STENCIL THE BACKGROUND

Use the sponge to apply gesso through the openings of your chosen stencil. Use a dabbing motion with enough pressure that the sponge reaches the paper surface through the stencil. Reload the sponge with gesso as necessary but always remember to remove the excess onto the palette or the sponged area will not be even. If the stencil is not big enough to cover the entire area that you want to pattern, apply the gesso to one area and then move the stencil and align it to blend in with the previously stenciled section.

STUDENT GRADE IS OK

This technique can be done on any surface that has been coated with black gesso, including Yupo and canvas. If you're using watercolor paper, this is the one time that you can use a student grade paper.

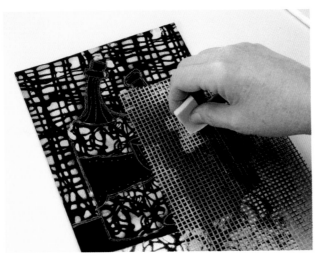

8 STENCIL OTHER AREAS

Continue to use a stencil and sponge to apply pattern to different areas. Small areas are best done with the sponge rather than the atomizer because you don't need to protect the rest of the painting from the spray. Allow the white gesso to dry.

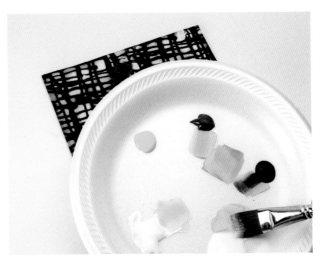

9 MIX THE PAINT

Mix Quinacridone Nickel Azo Gold and Cerulean Blue with white gesso and glazing medium to produce a translucent layer. If the mixture is opaque, you will cover all of the pattern you just worked so hard to create. The translucent layer will push back the top patterned area into the background without obliterating the pattern altogether.

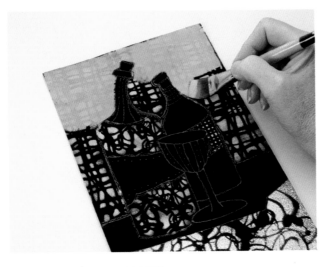

10 PAINT THE BACKGROUND

Paint the entire background with the paint mixture from step 9. Vary the color as you paint by varying the ratio of the gold to the blue.

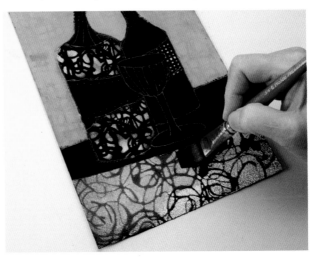

11 PAINT THE FOREGROUND

Use a transparent glaze of Quinacridone Nickel Azo Gold to paint over the white pattern at the bottom of the painting. Using transparent paint allows the pattern to remain entirely visible and is a good contrast to the translucent background.

PROBLEM SOLVED

The beauty of working on black gesso is that correcting errors can be very easy. To remove pattern from any area, simply paint over it with black gesso and you have solved your problem.

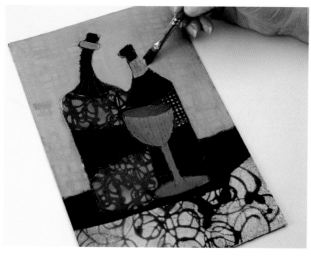

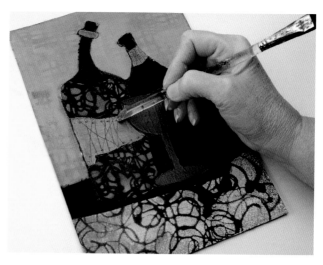

12 PAINT THE OTHER ELEMENTS

Continue to paint the rest of the elements in your design using a combination of transparent, translucent and opaque mixtures of paint. Consider placing transparent areas next to translucent or opaque areas for contrast (such as the transparent orange in the left bottle against the translucent green and the opaque black). The orange is a mixture of Quinacridone Nickel Azo Gold and Permanent Violet Dark. The bottle neck is Quinacridone Nickel Azo Gold and white gesso. The cup is a mixture of Cerulean Blue and Permanent Violet Dark.

13 SCRAPE THROUGH PAINT

Scrape through the paint with the end of your brush, palette knife or tip of a razor blade while the paint is still wet. This adds a very faint texture and helps opaque areas to blend in with the rest of the highly textured painting.

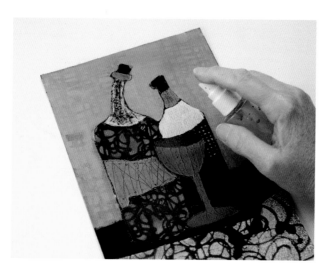

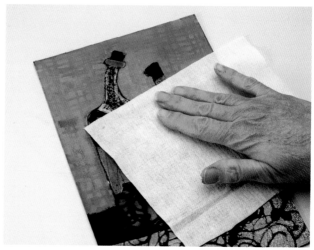

14 SOFTEN AND TEXTURE OPAQUE PAINT

If an area seems too opaque, spritz the paint with a fine mist of water while it is still wet.

15 BLOT THE OPAQUE PAINT

Immediately after adding the mist of water, lay down an absorbent towel and lightly pat the area. Lift the towel to see the softened opaque paint and a mottled texture added to your painting.

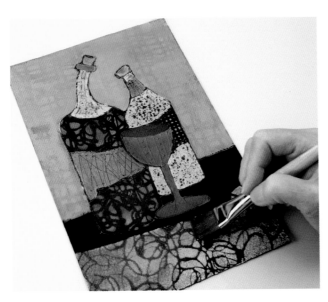

16 GLAZE TO ADJUST COLOR

Add a layer of transparent Quinacridone Nickel Azo Gold over the bottom portion. Then thin the gold down to apply a light glaze over the cream areas of the right bottle and the neck of the left bottle.

17 REMOVE THE MASK

Once you've made adjustments to color or value, and all of the paint is dry, remove the mask to reveal the black line.

GLAZING LIQUID

When painting transparent color over white, you don't need to add glazing liquid to your paint. However, there are advantages to doing so. Sometimes a thin glaze of transparent paint will bead up when applied over the white, especially over the High Flow acrylic. Adding glazing liquid to the paint will produce a thin glaze that will evenly cover the white areas. In addition, because glazing liquid slows drying time, it's possible to correct the color by wetting the areas and wiping off the paint with a paper towel. However, this must be done immediately after applying the paint.

18 TOUCH-UP THE BLACK LINE

Use an applicator bottle filled with black gesso to touch up areas of the black line. Because the applicator delivers a fine line, once that gesso dries you will not be able to distinguish the corrected area from the original masked line.

VISIT ARTISTSNETWORK.COM/ABSTRACT-EXPLORATIONS FOR BONUS CONTENT.

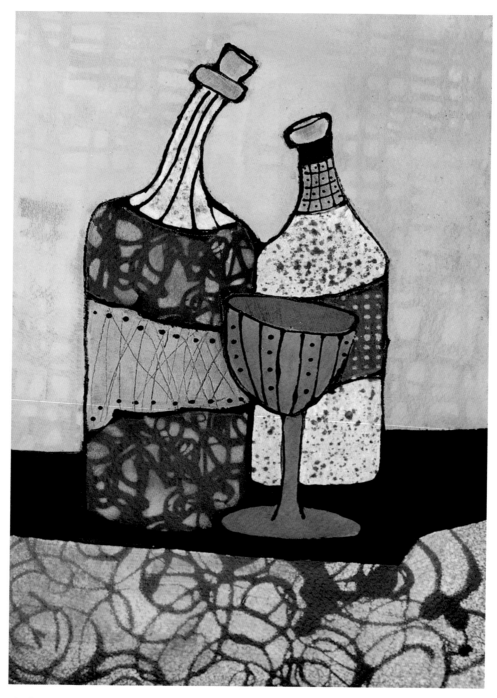

19 FINAL TOUCHES

Apply any additional final touches and let the painting dry. The use of opaque, translucent and transparent paint makes this sample a great reference for a variety of textures and patterns. Don't forget to record how you achieved the various effects.

Finished Practice Sample
Jo Toye
11" × 7" (28cm × 18cm)
Acrylic on 140-lb. (300 gsm) watercolor paper

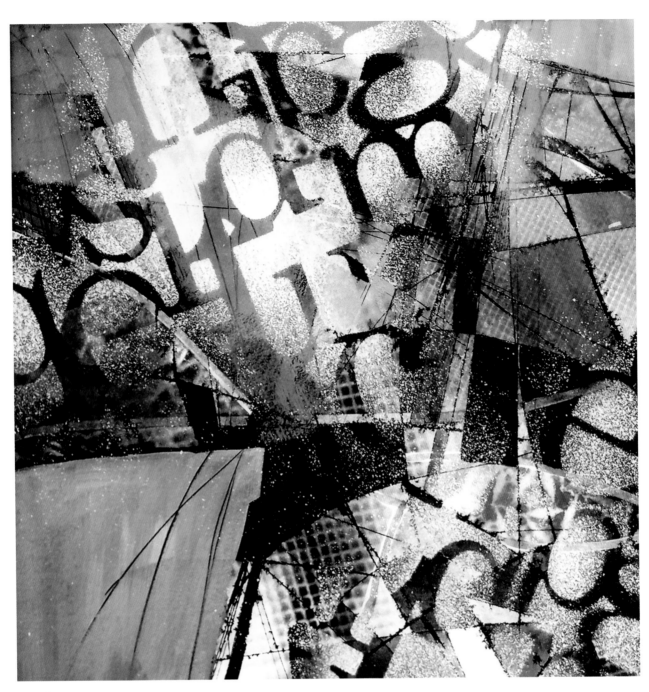

Genesis
Jo Toye
12" × 12" (30cm × 30cm)
Acrylic and ink on 140-lb. (300 gsm) watercolor paper

Genesis *started out as a piece cut from an old painting. I sprayed white*
airbrush paint through a stencil and then glazed with turquoise ink.

VISIT ARTISTSNETWORK.COM/ABSTRACT-EXPLORATIONS FOR BONUS CONTENT.

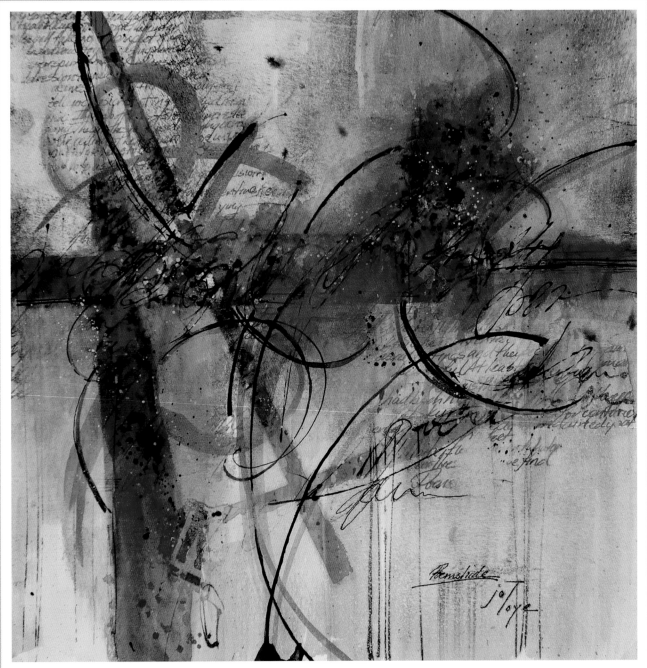

Sacred Conversations Series: Poems Hide
Jo Toye
12" × 12" (30cm × 30cm)
Acrylic on Yupo coated with white gesso

FOAM ROLLERS TO THE RESCUE

A few years ago my husband was reading *Frankenstein* and shared with me the author's name for his "creatures" that didn't quite turn out right. They were called, *gone wrongs*. I thought that was a great way to refer to those paintings that we might otherwise refer to as less-than-successful (if we're in a generous mood) or downright-total-failures (if we've just been rejected from our fifth exhibition in a row).

With an over abundance of *gone wrongs* in my studio, I came up with the following technique. Once I created this technique I was so excited that I started rummaging through my flat files looking for candidates!

DEMONSTRATION
MASK TECHNIQUE

By using paper as a mask to save some of the original painting and by rolling white gesso over the rest of the surface, you literally give yourself a new start. The best part is that you're not starting with a totally white sheet of paper, which can be daunting. For even more interest, make sure you roll the gesso on thinly so that parts of the underpainting show through. This will not only add interest but will introduce a sense of depth and integration to the final painting. Have fun and may all your *gone wrongs* go right!

MATERIALS LIST

FLUID ACRYLIC

GESSO, BLACK AND WHITE

MASKING PEN

MASKING TAPE

OLD PAINTING

PAPER, HEAVYWEIGHT

SMALL FOAM ROLLER

PICKING PAPER

You can use any type of paper for the mask, but heavier paper like card stock resists buckling. You can tear your paper for a ragged edge or you can cut the masks out of contact paper for shapes with hard edges.

The advantage of contact paper is that you don't need to tape the shapes down. Be sure that the contact paper isn't too tacky or it may tear the underpainting when it's removed. The painting, *Poems Hide* was done with torn paper, whereas the sample in this demo is done with paper that's been cut.

1 USE AN OLD PAINTING
Choose an old painting or piece of an old painting that has some interest and variety. Avoid paintings that have a lot of white or that have large areas of one color.

2 CUT OR TEAR PAPER SHAPES
Using a heavyweight paper, cut or tear various shapes to use as masks. Cut circles to suggest planets and long strips of paper in various widths. You can also use different sizes and torn pieces of masking tape to mask off areas of the painting.

3 DECIDE ON PLACEMENT
Arrange the paper shapes over the painting. Keep in mind that the paper represents the areas of the painting that will still be visible once the layer of gesso is added. With this in mind, check to see if the painting beneath the paper shapes are parts that you want to keep. You can play with the placement of the shapes and cut or tear more if needed.

VISIT ARTISTSNETWORK.COM/ABSTRACT-EXPLORATIONS FOR BONUS CONTENT.

4 TAPE DOWN THE SHAPES

Tape down the shapes. Tape beyond the edge of the painting and on the backside of your shapes. Place enough tape to hold the shapes securely in place, but don't worry if they are not tightly adhered on all edges. You will be rolling over the shapes instead of painting with wet paint so the paint should not seep under the edges unless the shapes move.

5 ADD MORE LINE WITH MASKING FLUID

Use the Resist Pen to add fine line detail throughout the painting. The masked line will add variety, repetition and unity to the linear elements already present in the design.

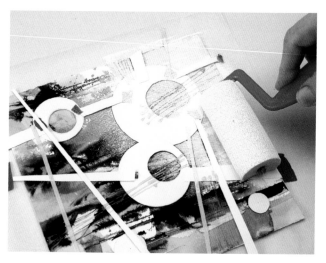

6 COAT THE FOAM ROLLER

Place a large puddle of white gesso in the center of a disposable plate or palette. Roll a dry foam roller through the paint. Continue to add paint and roll until the foam roller is completely covered with a smooth uniform layer of gesso. Be sure this layer is thinly coating the roller. If not, roll off some of the paint onto another surface. If the layer of gesso on the roller is uneven or too thick, once you apply it to your painting, you will get uneven results. It's always wise to test the roller on a piece of scrap painting before rolling on your sample.

7 ROLL GESSO ONTO THE PAINTING

Once you have the roller covered evenly, roll a translucent layer of gesso across the painting.

INTEGRATING LAYERS

This technique works best when the underpainting is veiled but not completely covered with a layer of gesso. Rolling a translucent, rather than opaque, layer of gesso allows the underpainting to be faintly visible under the gesso. Having the underpainting partly visible helps to integrate the subsequent layers.

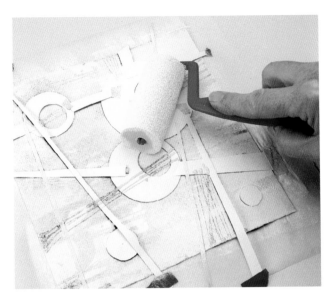

8 COVER THE SURFACE

Continue rolling until the whole surface of the sample is covered with an even layer of gesso. If the paint on the roller is running out, try putting more pressure on the roller. Because you have less gesso on the roller, the additional pressure will release a light coating of gesso that is often just the amount you need to keep the layer translucent.

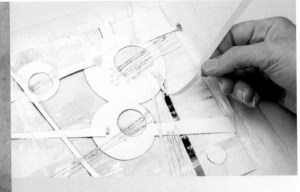

CHECK THE RESULTS

Before removing the masked areas, lift up one of the shapes to evaluate if the white layer is heavy enough to provide the contrast you want. If not, replace the paper and roll another light coat of gesso.

WATERCOLOR RESULTS

If the underpainting was done in watercolor, you're in for a pleasant surprise. When you roll the white gesso over your painting, the gesso will pick up some of the watercolor beneath it and instead of a layer of white, you will have a layer tinted by the colors used in your painting. This can produce surprising and beautiful results.

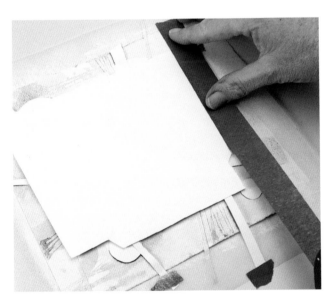

9 TAPE OFF A LARGE SHAPE

Cut out a large paper shape and lay it over a select area of the painting. Use this shape as a guide for adhering the masking tape.

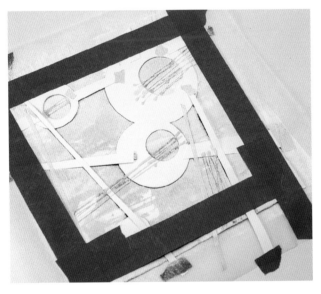

10 MASK THE OUTLINE OF THE SHAPE

Use masking tape to mask off the shape created in step 9.

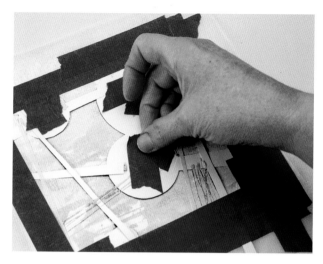

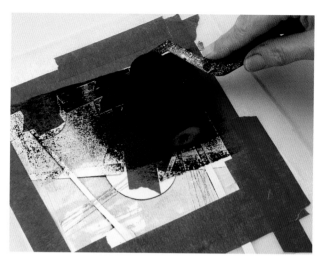

11 MASK AREAS THAT WILL REMAIN WHITE

Cover any areas that you want to be protected from the black gesso. The initial masks are protecting the underpainting, so any new masks will protect the white that was applied with the roller.

It's helpful to mask off some of the white because you will retain white both inside the painting as well as in the framework around the painting. This will help to integrate all the layers. Tape over the center of the circles so that they will remain white.

12 ROLL BLACK GESSO

Load a clean, dry, foam roller with black gesso, just as you did with the white. Be sure there is a smooth even layer on the roller, but this time you want the layer to be opaque rather than translucent. Cover all the area inside the taped shape.

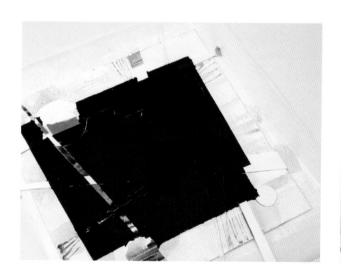

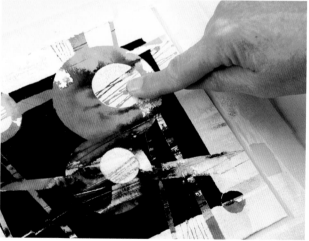

13 REMOVE THE TAPE AND MASKS

Allow the black gesso to dry for a few minutes then remove the tape and masks.

14 REMOVE THE MASKING FLUID

Once you've pulled up the tape and paper masks, check to make sure that there's not any masking fluid still on the surface. Use your finger to feel for the masked lines and remove any masking fluid that still remains.

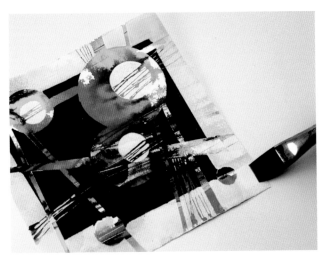

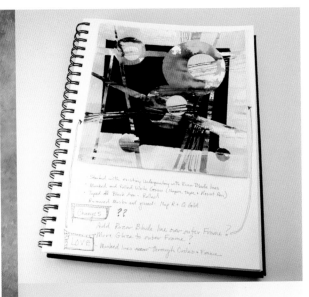

15 GLAZE THE WHITE

Leave the white as is or glaze the white with color. I glazed the outer white frame but left the inner circles white. Use very thin washes of the colors that are in the underpainting. Once again, by glazing with colors that are contained within the painting you create color harmony and integrate the various layers.

EVALUATE THE RESULTS

If you don't know what to do, leave the painting and go on to your next sample. Often looking at your painting with fresh eyes a day or two later will make what needs to be done obvious. Most of all, remember that these are just practice samples. Write down what worked and what you would do differently, and store this information with the sample in a clear sheet protector, file folder or notebook.

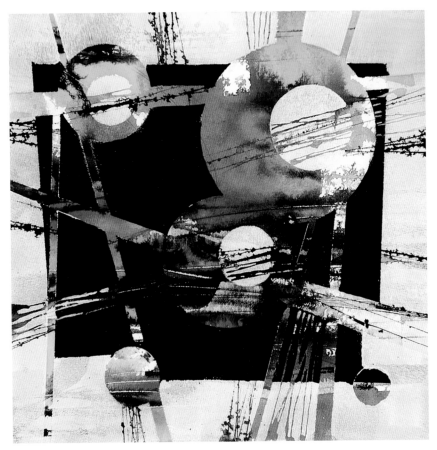

COMPLETED SAMPLE

After taking my own advice, I waited several weeks before finishing the sample. Since the underpainting had lines made with the razor blade I added some razor blade lines in the final layer.

16 ADD FINAL DETAILS

Once the white has been glazed, if you're happy with the results you can stop there. If you still feel that the sample needs something, step back and take time to consider it.

Finished Practice Sample
Jo Toye
8" × 8" (20cm × 20cm)
Acrylic on 140 lb. (300 gsm)
watercolor paper

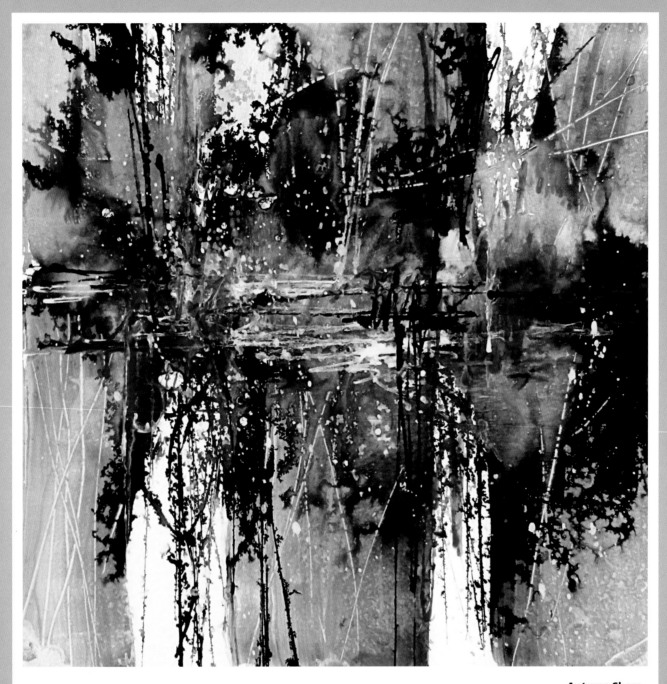

Autumn Shore
Jo Toye
12" × 12" (30cm × 30cm)
Acrylic and ink on Yupo

GESSO PULL

If you want to make your colors sing, include some neutral colors along with all the other vibrant colors in the painting. In this sample demonstration, you will "pull" white gesso on a brush through wet color and black line on the painting surface. This immediately creates beautiful neutrals that integrate seamlessly with the bold colors in the rest of the painting.

This process demands that you move quickly as most of the painting must be done while all the paint is wet. Both watercolor paper and Yupo can be coated with white gesso and used for this technique. Both give lovely results, but the watercolor paper dries a bit more quickly and the colors will absorb into the paper more than on the Yupo.

GESSO PULL TECHNIQUE

Before you start this demo gather all the required supplies and have them ready for use. This is one of the fastest demos in the book and you won't have time to stop and find something you need. This demo consistently produces satisfying results.

<div style="writing-mode: vertical">MATERIALS LIST</div>

APPLICATOR BOTTLES

COTTON SWAB

FINE MIST SPRAY BOTTLE

FLUID ACRYLICS, ASSORTED

GESSO, WHITE

INDIA INK

PAINTBRUSH

PAPERTOWELS

RAZOR BLADE

SPONGE

YUPO

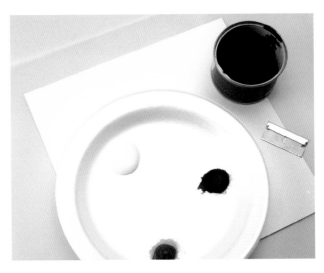

1 GATHER SUPPLIES

You can use as many colors as you want but I find that you will obtain good results by using only two. Arrange Quinacridone Nickel Azo Gold and Antraquinone Blue along with the white gesso on a palette. Be sure to have your India ink poured out into the container and a razor blade clean and ready.

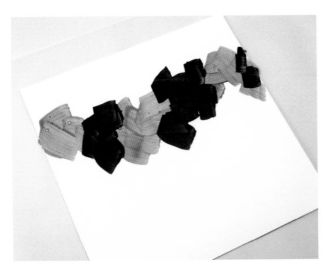

2 PAINT IN TWO COLORS

About a third of the way down from the top, use a damp brush to paint alternate swatches of Quinacridone Nickel Azo Gold and Antraquinone Blue across the paper. Do not dilute this color beyond the small amount of water in the damp brush.

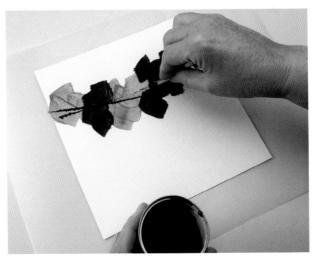

3 ADD BLACK LINES

With a razor blade and black India ink, draw several lines across the painted area. Be sure that these lines are toward the middle to the bottom of the painted strip, rather than toward the top of the painted area.

VISIT ARTISTSNETWORK.COM/ABSTRACT-EXPLORATIONS FOR BONUS CONTENT.

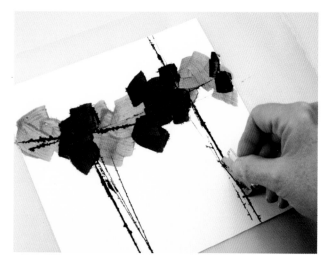

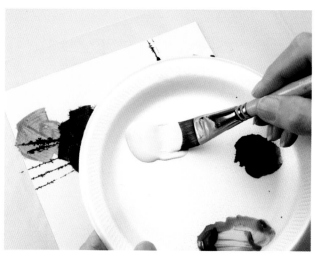

4 ADD SOME VERTICAL LINES

Use the razor blade to add a few vertical lines from the painted area down to the bottom of the page. Add some vertical lines above the painted area as well, but don't get too much black above the line. You want to keep the upper portion less neutralized than the bottom portion.

5 APPLY WHITE GESSO TO THE BRUSH

Apply white gesso to a 1" (25mm) flat brush. Start on the left side and place your brush so that you catch some of the black ink line that runs through the strip of paint. In one continuous motion, pull the brush down through the color to the bottom of the paper. Do not pull any gesso towards the top of the painting.

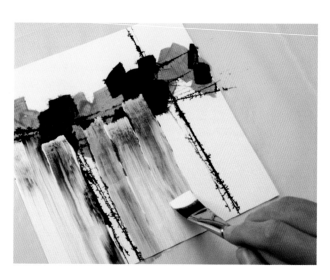

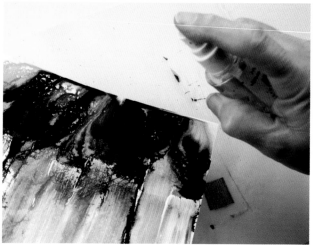

6 REPEAT ACROSS THE SAMPLE

Continue to apply gesso to the brush, and pull the ink and color down the page as you move across the painting. Do not pull the white gesso over the vertical ink lines. You don't have to clean or apply gesso to the brush with every pull, but be aware that with each successive pull the paint will become more neutral and darker.

7 SPRITZ THE TOP PORTION

Lift the paper off of the painting surface and tilt the top slightly down towards the table. With your fine mist spray bottle, spray the top of the painting to encourage the paint to flow into the unpainted white area. Try not to spray too much of the black or it can easily take over the color. If the paint has gotten too dry it will not flow. Add some more wet paint on top of the first layer of color and spritz again.

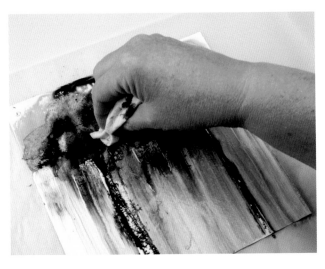

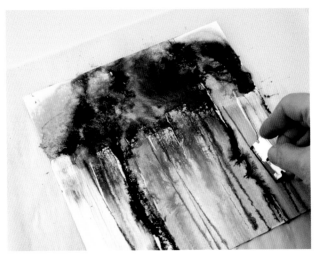

8 **BLOT UP EXCESS BLACK**
Lay the sample back down on the surface. If too much of the ink has spread, use a paper towel to blot some of it off of the surface.

9 **ADD MORE LINES**
Add more black razor blade lines into the bottom area. If you have a lot of black already, you may not want to do this. If the bottom area has become too neutralized and dark, you can let the paint dry and then lay down a little more color.

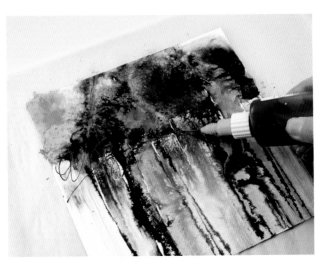

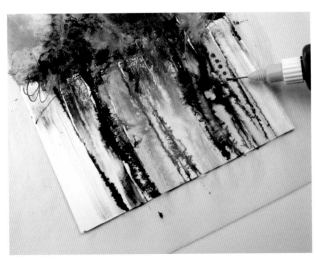

10 **ADD CALLIGRAPHY**
Use an applicator bottle filled with fluid acrylic to add calligraphy. This application of paint will serve to tie the top and bottom of the painting together.

11 **ADD DOTS OF COLOR**
Use the applicator bottle to add dots to the painting. If you add dots in one area, make sure to add a few in several other places.

VISIT ARTISTSNETWORK.COM/ABSTRACT-EXPLORATIONS FOR BONUS CONTENT.

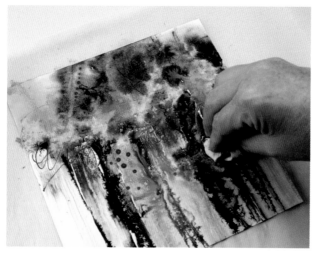

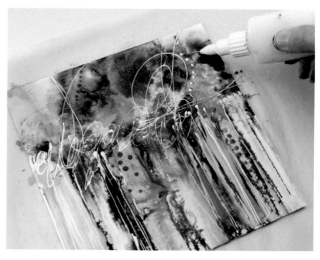

12 LIFT SOME COLOR
Use a cotton swab, sponge or paper towel to lift color and bring back areas of the white paper.

13 ADD WHITE CALLIGRAPHY
Use an applicator bottle filled with white gesso to add white calligraphic lines across the painting. White draws the eye, so use it to integrate the different areas of white throughout the painting.

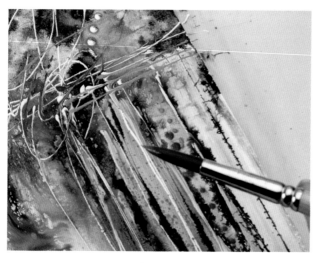

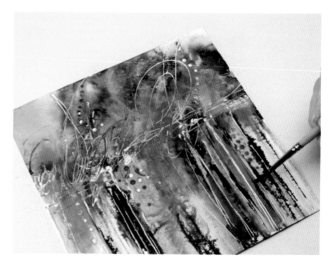

14 SPATTER TO ADD COLOR
If you need to add a small amount of color to an area, apply diluted paint to the brush and tap the brush against your finger in order to fling droplets of paint to the surface. Use this technique judiciously, as spattering can be so much fun that you can get carried away. The spatter should be an accent rather than cover the entire surface of the painting. Allow the painting to dry.

15 GLAZE IN COLOR
Apply a glaze combination of Quinaquidone Nickel Azo Gold and Napthol Red Light towards the top of the painting. Then glaze with Quinacridone Nickel Azo Gold in the lower portion.

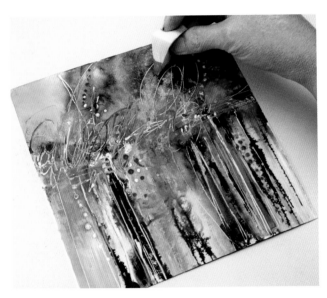

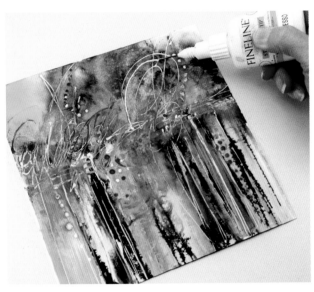

16 CORRECT AND CHANGE AREAS
Add a line of Cobalt Teal with an applicator bottle and sponge off some of the orange mixture added from the previous step.

17 BRING BACK THE WHITE
Add calligraphy with the white gesso and add more white lines to ensure that the previous layers look integrated into the rest of the painting. Add some more Cobalt Teal to act as a contrast to the orange.

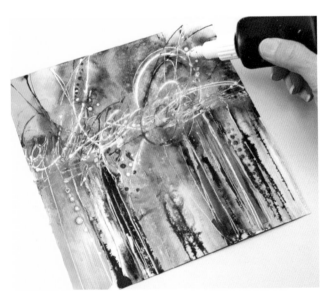

18 ADD A BLACK LINE
Because you started with black lines in the original painting, use black gesso in an applicator bottle to add the final layer. By adding black at the end, you imbed, or sandwich, all of the other layers between your initial use of the black ink lines and these final lines made with the applicator bottle.

INK VERSUS BLACK GESSO

At any point you can substitute black gesso for the ink and vice versa. When doing so, consider these guidelines:

• Only the ink can be applied with the razor blade because the gesso is too thick.

• Ink can be put in a fine tipped applicator bottle, but it takes some practice and a light touch to avoid getting too much ink flowing onto the surface.

• Ink and the razor blade can be substituted wherever black gesso and the applicator bottle are used, thus avoiding the need to purchase the applicator bottles.

• Ink and the razor blade are best suited for straighter lines while the applicator bottle can easily make multidirectional marks.

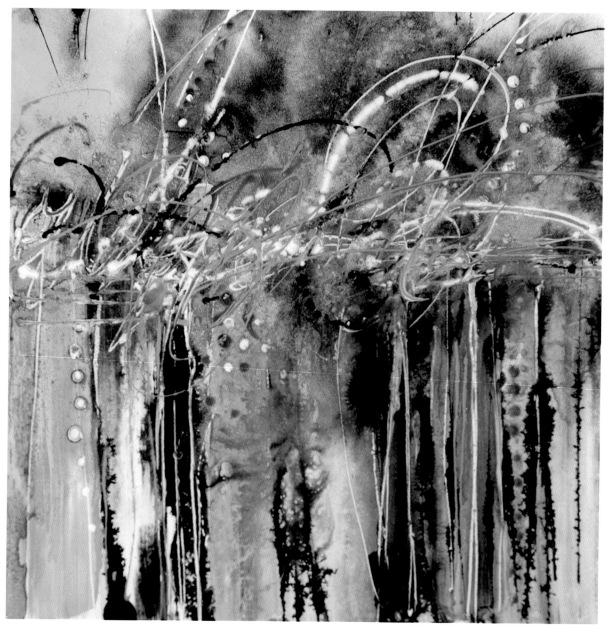

19 ADD FINAL TOUCHES

Add any final touches to the painting and let dry. I employed extensive use of the applicator bottles but this is not always necessary. Often, once you pull the gesso on the bottom portion of the sample and spritz the top portion, the sample is finished.

Finished Practice Sample
Jo Toye
8" × 8" (20cm × 20cm)
Acrylic on Yupo

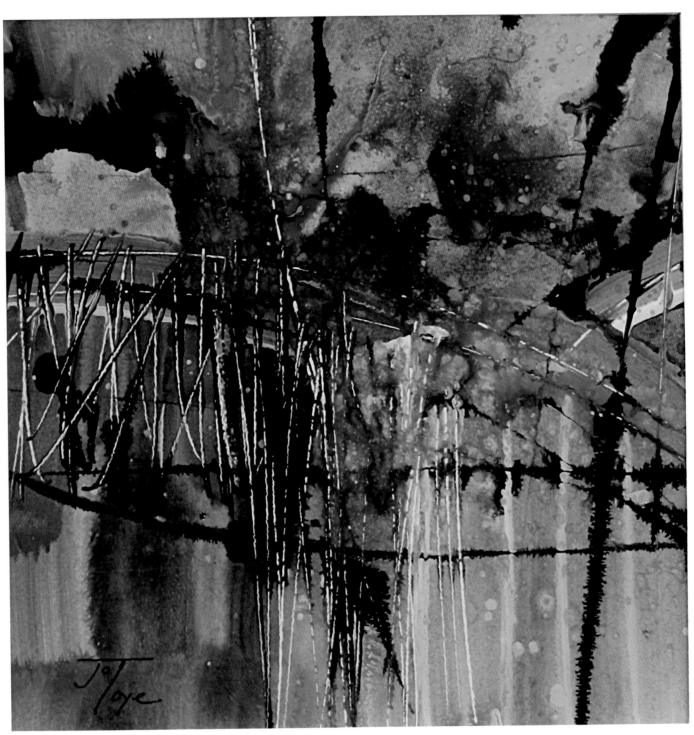

Previous Class Demo
Jo Toye
6" × 6" (15cm × 15cm)
Acrylic on Yupo coated with white gesso

VISIT ARTISTSNETWORK.COM/ABSTRACT-EXPLORATIONS FOR BONUS CONTENT.

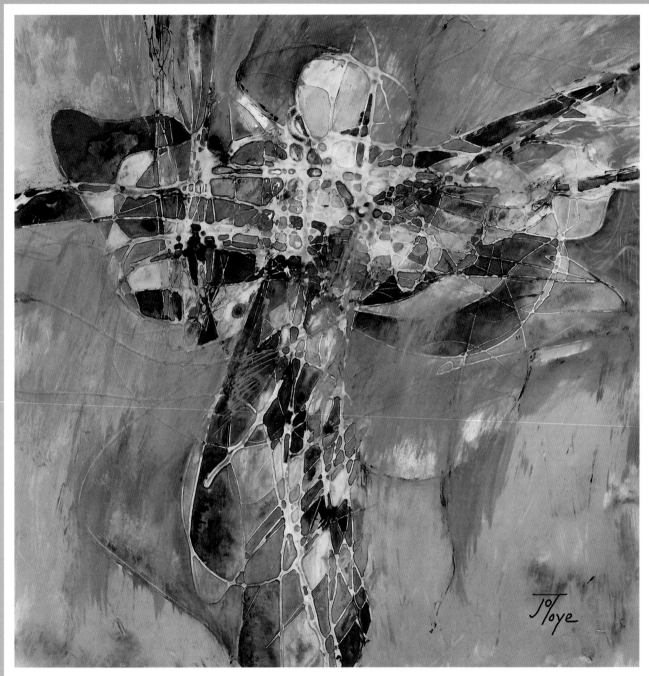

Someone to Watch Over Me
Jo Toye
12" × 12" (30cm × 30cm)
Acrylic on Yupo

CLEARLY THIS ISN'T TAR

For this sample we'll be experimenting with a fun product called Clear Tar Gel. It's a wonderful product to have in your arsenal for creating line. I first used it when I was challenged to do a painting without using a brush. I had a jar of it sitting in my closet since the eighteenth century and decided this was the push I needed to give it a try. I scooped some of it up with a palette knife and dripped it in long stringy lines in a random design across my paper. When it was dry I started to drop color onto the surface and that's when the magic began.

The raised Clear Tar Gel lines, which previously had been barely visible, became a web of intricate designs as the paint pooled and spread across the surface. Since then I've become somewhat obsessed. I've used it on paper, Yupo and canvas with differing but satisfying results. It can be applied to painted surfaces and on Yupo coated with white or black gesso. Since the gel is clear, once it is dry, the lines created will look as if they are the color that lies beneath them.

CLEAR TAR GEL TECHNIQUE

In this demo we will be using Clear Tar Gel on Yupo that has been coated with white gesso. When you want to be sure your design stays loose and random, drip your Tar Gel from a palette knife. When you want more control of the gel's placement, apply the gel from a squeeze bottle. Different size tips will produce varying widths of line. When working small you will get better results using a bottle with a very fine tip. The Tar Gel lines tend to spread out as they dry, so if they're too thick and too closely spaced they'll tend to form big unsightly blobs instead of distinct lines.

MATERIALS LIST

ACRYLIC GLAZING LIQUID

BRUSH, ASSORTED

CLEAR TAR GEL

DRY ERASE MARKER AND CLEAR PLASTIC

FINE MIST SPRAY BOTTLE

FLUID ACRYLICS, ASSORTED

GESSO, BLACK AND WHITE

MAKE-UP SPONGE

THIN PALETTE KNIFE

WATERCOLOR PENCIL, WHITE

YUPO

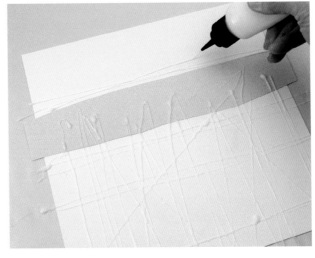

1 PROTECT THE PAINTING SURFACE

Before applying the Tar Gel, protect the table with newspaper or wax paper. Once Tar Gel dries it is difficult to remove. Cut or tear a piece of paper and place it across the top of the Yupo. Then apply Tar Gel across the surface in thin lines

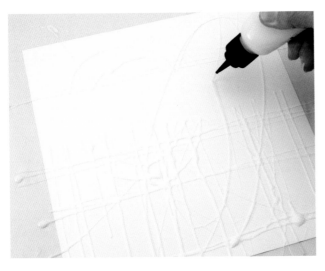

2 REMOVE THE PAPER MASK

Remove the paper mask. Add more Tar Gel, dripping it over this previously saved area and into the surrounding areas. This will integrate the different parts of the painting but will allow the area that had been covered to have less and a different pattern from the rest of the painting.

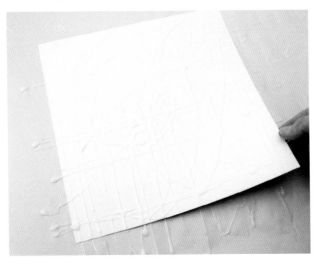

3 MOVE THE PAINTING

Carefully move the painting to a clean piece of paper to dry. Save the excess gel that was applied beyond the paper's edges by using a palette knife to scrape it up and return it to the jar.

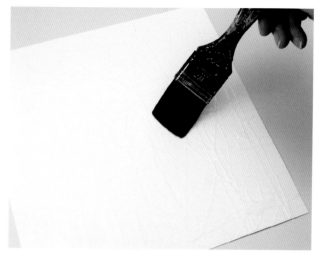

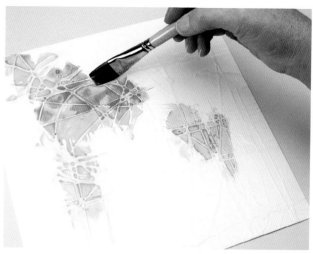

4 APPLY A LIGHT LAYER OF WATER
When the Tar Gel is dry, use a large flat brush to completely cover the surface with a thin layer of water. This will allow the paint to move and flow freely across the raised lines.

5 APPLY FLUID ACRYLIC
Apply Quinacridone Nickel Azo Gold to the painting. Touch the brush to the wet surface and the paint will bleed and spread. Place your first color in several places across the surface.

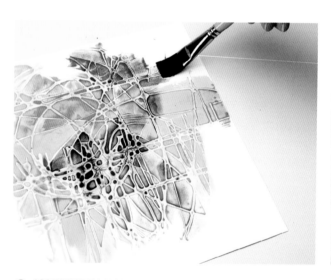

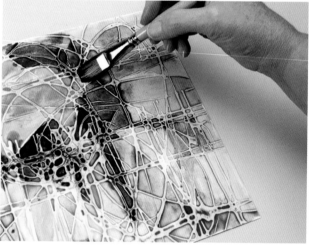

6 APPLY MORE COLORS
While the surface and paint is still wet, apply Anthraquinone Blue and then Permanent Violet Dark across the painting.

7 ADD SOME DARK VALUE
While all the paint is still wet, add some passages of darker value. Don't add too much because you can always darken the value later, but you can not lighten the value unless you use opaque paint. Try to work as transparently as you can in the beginning stages.

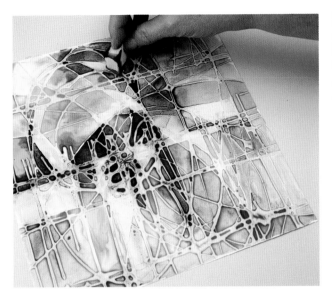

8 PULL OUT THE LIGHTER VALUES WITH A SPONGE
While the paint is still wet, adjust the values further. If the colors have gotten too dark or if you want to recapture some of the white paper, use a make-up sponge, paper towel or cotton swab to lift color from the surface.

DETERMINE THE LARGE SHAPES

At this point you have several options. You can continue to work transparently or add opaques or black. Before you add black or any other dark opaque, it's helpful to experiment with its placement by using the plastic and dry erase marker or the computer. For this stage, I took a picture of the painting after I had all the transparent colors in place. In Photoshop I added the black shapes and when I was satisfied, I printed out a black and white copy. My goal is to create a pleasing large shape by "cutting away" part of the design with the outer dark shapes.

9 PAINT BLACK GESSO
Use the printout as a guide and paint in the dark shapes with black gesso. You can reference the picture or you can use a white watercolor pencil to draw guide-lines so you don't get confused where the black should go. Be sure to use a flat brush when you are painting straight edges.

10 MAKE ADJUSTMENTS
Leave the dark shapes black or adjust their color and value. Use a color or combination of colors that's already in the painting and add white gesso and glazing medium until it's translucent. You may want to use masking tape so that you can apply this color over the black in a freer fashion.

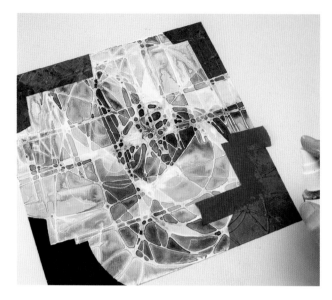

11 SPRITZ THE WET PAINT

To create texture in the translucent areas, lightly spritz the paint while it's still wet. Once the water droplets dry they will leave a subtle but intriguing texture.

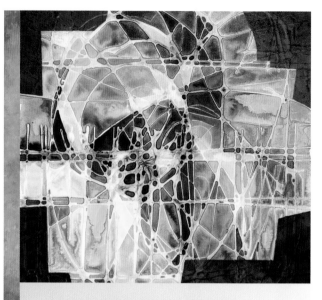

CONSIDER YOUR OPTIONS

Once this layer is dry you have several alternatives. Depending on the design, value pattern and preferences, you can either continue with transparent, translucent, opaque paint or black gesso. After considering my design, and because I really like black in my paintings, I went with black to define shapes and move the eye through the painting. Remember if you are going to add black, you may first want to work out your design using the clear plastic or the computer.

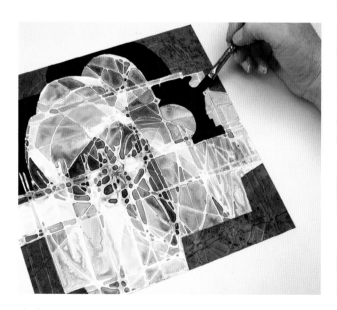

12 DEFINE SHAPES

Use black to define shapes throughout the painting. Start with the large, outer shapes before moving on to the smaller detailed shapes within the painting. Do not be discouraged if this stage of "defining shapes" is difficult at first. The more you practice at seeing and defining shapes, the easier it will become.

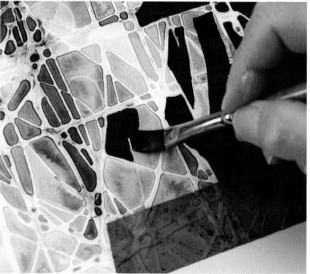

13 PAINT POSITIVE AND NEGATIVE SHAPES

Continue to define shapes but be aware of both the positive and negative shapes that are created. Often the areas that are painted black will appear as "holes" or negative shapes in your painting, and the areas you leave unpainted will create the positive shapes. This becomes more evident the further you progress with the black shapes.

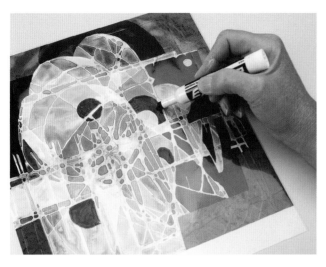

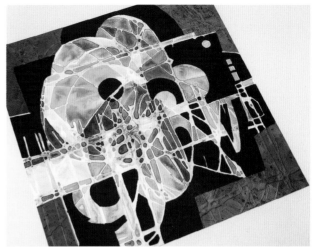

14 PAINT OUTSIDE THE LINES
Create shapes that don't follow the Tar Gel lines. When making shapes that are not apparent, such as circles or other geometric shapes, use the clear plastic and the dry erase marker to evaluate the shape and placement. Then use a white watercolor pencil to draw the shape onto your painting so that you have a guide to follow.

15 REPEAT ELEMENTS
Because the Tar Gel lines created larger circular patterns throughout the painting, I used the black gesso to repeat smaller circular shapes where none were indicated by the original gel lines. The small black circle towards the center on the left, the orange moon shape towards the center on the right and the tiny orange circle towards the upper right edge were all created where no Tar Gel lines existed.

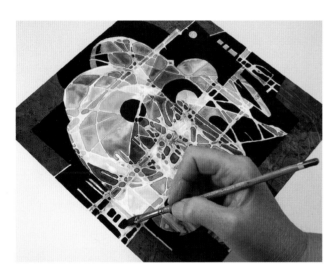

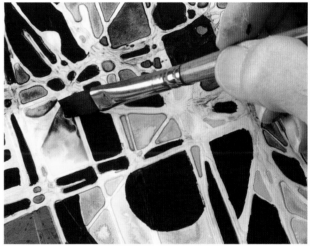

16 CONTINUE WITH SMALLER DETAILS
Continue to paint in the black as you define the smaller details. Be careful at this stage not to go too far. The further along you get in the painting, the more thought you should put into each shape you add. Maintain a balance between the negative black shapes and the positive shapes created by their placement.

17 ADD COLOR WHERE NEEDED
Add color to any areas of the painting that need more value contrast or color intensity. Because the underpainting was done wet-into-wet, when you add color, wet the surface with water and then drop in the paint. This will allow all of the painted areas to have the same fluid quality. The loosely painted areas contrast nicely against the hard-edged shapes created by the black gesso.

VISIT ARTISTSNETWORK.COM/ABSTRACT-EXPLORATIONS FOR BONUS CONTENT.

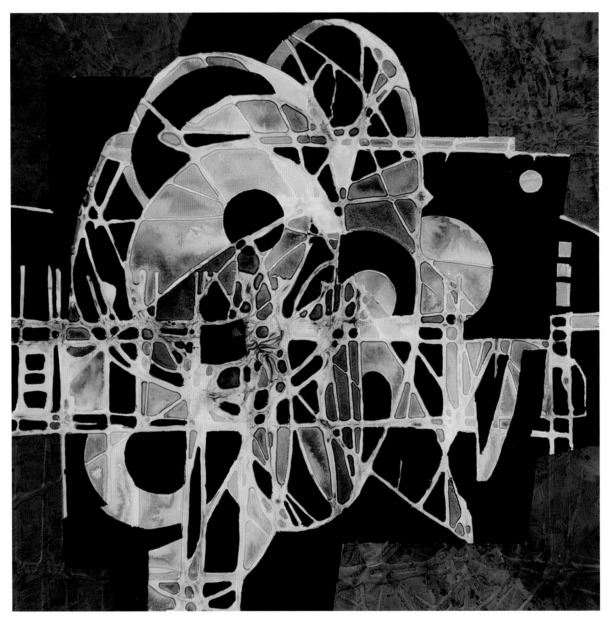

18 ADD FINAL TOUCHES

Add any final touches and let the painting dry. This finished sample is a bit larger than the previous demonstrations. Working on a larger surface keeps the Tar Gel from filling in the open areas as it dries and spreads. Many of my original Tar Gel lines are now covered by opaque and black paint allowing the tinted lines and transparent passages to lead the eye through the painting.

Finished Practice Sample
Jo Toye
10" × 10" (25cm × 25cm)
Acrylic on 140-lb. (300 gsm) Yupo

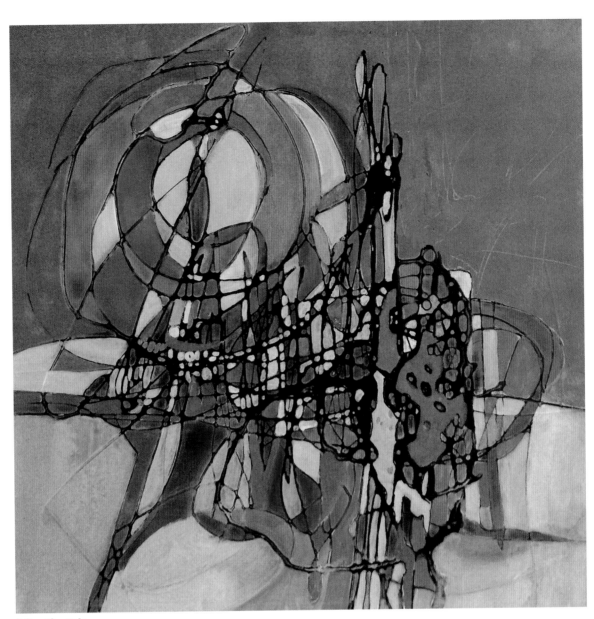

After the Fair
Jo Toye
12" × 12" (30cm × 30cm)
Acrylic on Yupo

All of the black lines in this painting were created with Tar Gel that has been applied over a surface coated with black gesso. Since Tar Gel is clear when it dries, it will appear the color of whatever lies beneath it. A black Tar Gel line can also be achieved by adding a small amount of black gesso or paint to the Tar Gel before it is applied to the surface.

VISIT ARTISTSNETWORK.COM/ABSTRACT-EXPLORATIONS FOR BONUS CONTENT.

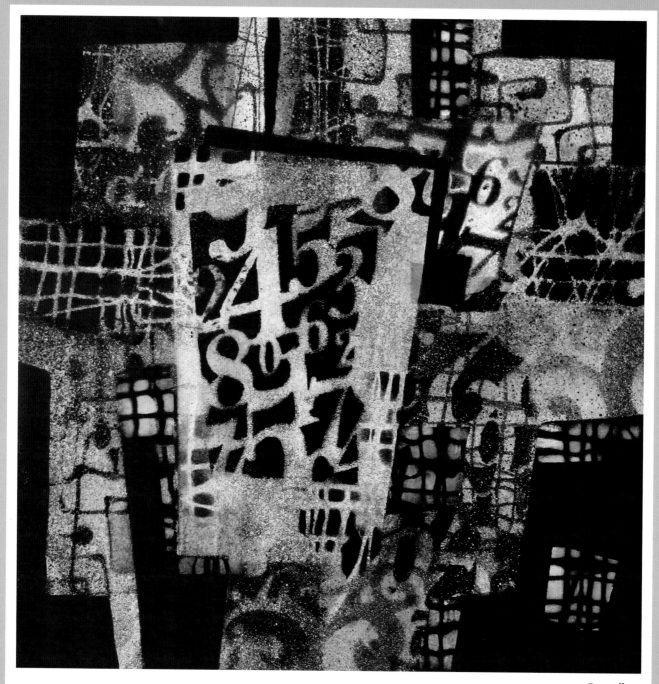

Boundless
Jo Toye
10" × 10" (25cm × 25cm)
Acrylic on 140-lb. (300 gsm) watercolor paper

NOTHING'S EVER BLACK AND WHITE

For our final technique, we'll once again be using stencils and the mouth atomizer. As with the other demonstrations, if you do not have an atomizer use the make-up sponge and white gesso.

This time we will create a surface full of texture and pattern using only black and white. Black and white paintings can have dramatic impact, and at the end of this technique you can choose to leave your sample as is or add color as desired. The hardest part about this technique is not getting the texture and pattern onto the paper, but deciding what portions of all this luscious surface you'll take away. You won't actually take away any of the texture but you will paint over it with solid areas of black gesso to develop contrast and an overall pleasing design.

BLACK AND WHITE TECHNIQUE

A great aspect about this technique is that it's infinitely correctable. Because you're working on a black gesso surface, at any time you can paint black gesso over any part, or all, of the painting and start over. Working on white watercolor paper never affords this flexibility and, unlike working directly on a black surface, the white pattern that you create will allow you to use transparent glazes if you decide you want to add color at the end. After all, nothing is ever black and white!

MATERIALS LIST

GESSO, BLACK AND WHITE

HIGH FLOW ACRYLIC, WHITE

MOUTH ATOMIZER

MAKE-UP SPONGE

PAINTBRUSHES, ASSORTED

STENCILS, ASSORTED

1 COVER PAPER WITH CONTACT PAPER
Cut a shape from contact paper and place it on the surface to protect that area from the spray. Because this will provide an area of greater contrast, consider placing this shape where you think you may develop your focal point. Then choose a stencil and position it in an area where you want to spray the first pattern.

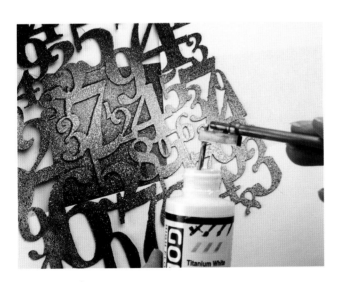

2 SPRAY
Place sheets of typing paper under the stencil to confine the spray to a specific area. Then use the mouth atomizer to spray the white acrylic ink.

3 REPEAT THE PATTERN
Use the same stencil and spray another area. Often it is good to repeat elements in multiples of three but because you are working on a small surface, two will work.

4 COVER THE ENTIRE SURFACE
With the contact paper still in place, continue to use different stencils to cover the entire surface with the sprayed white pattern.

5 SPRAY BLACK
Cover some areas by spraying black. Once again, you can spray directly through the stencil or protect the rest of the painting with paper. Spraying black can help add contrast back to those areas where overspray has softened the pattern.

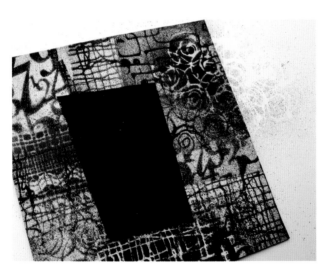

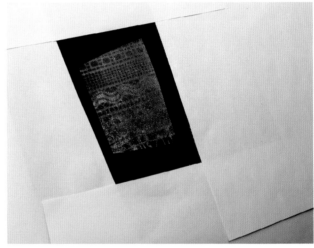

6 REMOVE THE CONTACT PAPER
Let the sprayed paint dry then remove the contact paper. You now have a little "canvas" inside all the rest of the texture.

7 PROTECT FROM OVERSPRAY
Use paper to cover the rest of the painting while leaving the black rectangle exposed. At this stage you can place your stencil and spray, or you can protect a smaller area with another piece of contact paper, as I have done here.

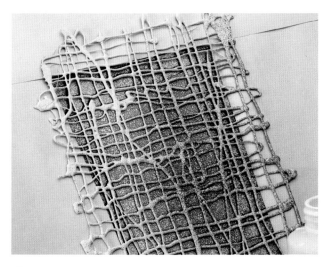

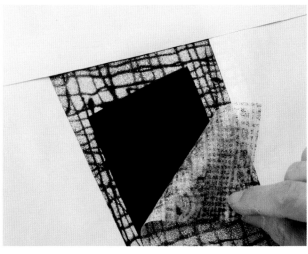

8 SPRAY THOUGH A STENCIL
Use the mouth atomizer to spray through another stencil over this area.

9 REMOVE THE CONTACT PAPER
Peel back the contact paper to reveal another black rectangle. By progressing this way you have created a frame around this smaller rectangle.

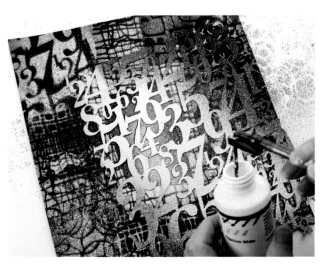

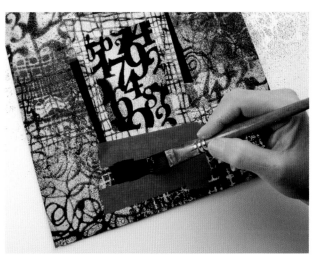

10 COVER WITH SPRAY
Choose a stencil that has larger openings or a unique pattern to spray this final rectangle. This area will become the center of focus so it's important for it to have an interesting and well-defined pattern.

11 DEFINE SOME BLACK AREAS
To further define this area as your center of focus, add areas of black gesso. Be careful not to paint a complete rectangle as this will look too solid against all of the other texture. Use masking tape to help paint a straight edge where desired.

VISIT ARTISTSNETWORK.COM/ABSTRACT-EXPLORATIONS FOR BONUS CONTENT.

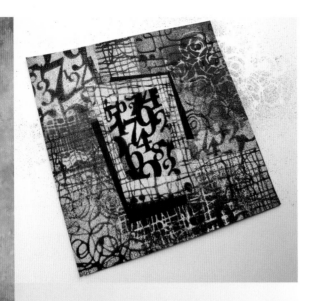

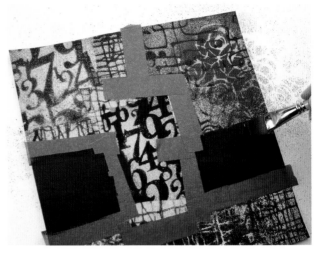

STEP BACK AND EVALUATE

Once the texture is sprayed and the focal area defined, it's important to consider if anything needs to be changed before proceeding. Physically step back from the painting by taping the painting to the wall or other vertical surface. After having been so close to your work while painting, it's amazing what you'll notice when you get some distance. Consider where you may not like the pattern or where you think it needs more definition.

12 PAINT AREAS BLACK

To change portions of your painting, tape those areas off and completely cover them with black. You can change as much or as little of your background as you wish. If you are really unhappy with the results, you could cover the whole surface with black gesso and start over.

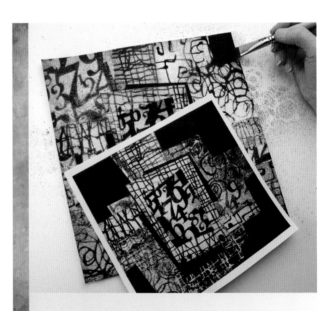

PAINT BLACK AREAS USING A PHOTO REFERENCE

In previous demos you have learned how to use clear plastic and a marker to experiment with the placement of the black. An alternative is to take a picture of your sample and experiment with changes in an image editing program such as Photoshop. Use a printed copy as a guide and paint in the black areas.

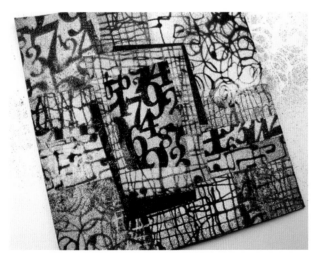

13 SPRAY OVER BLACK

Once the black gesso is dry, use a stencil and reapply white over the black. If you want to contain the overspray, be sure to use paper to cover the rest of the surface. After you take off the tape decide if you have achieved the results you were after. If not, tape off the areas you still are not pleased with and repeat.

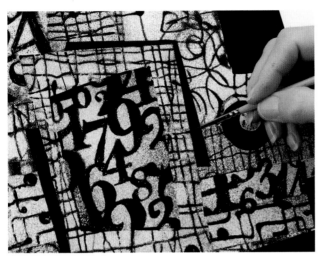

14 TOUCH-UP DETAILS

Use a brush and paint areas black. Then use a small brush and black gesso to touch up any areas of the black that have lost definition or that have overspray where you do not want it.

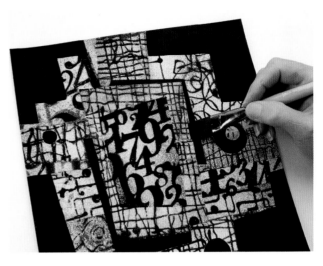

15 ADD COLOR

If you choose, you can leave your sample black and white or add glazes of color. I used a light glaze of walnut ink because it's water-soluble and can be easily removed.

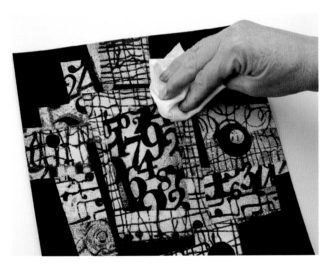

16 REMOVE COLOR

Spritz the area with water and wipe with a paper towel to remove some of the areas of color that you do not like. Depending on the color and paint that was used, often you can completely remove all traces of color.

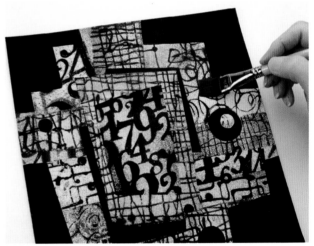

17 ADD GLAZE

Continue to add glazes of color to the surface. Use only one or two colors to unify the highly patterned surface.

VISIT ARTISTSNETWORK.COM/ABSTRACT-EXPLORATIONS FOR BONUS CONTENT.

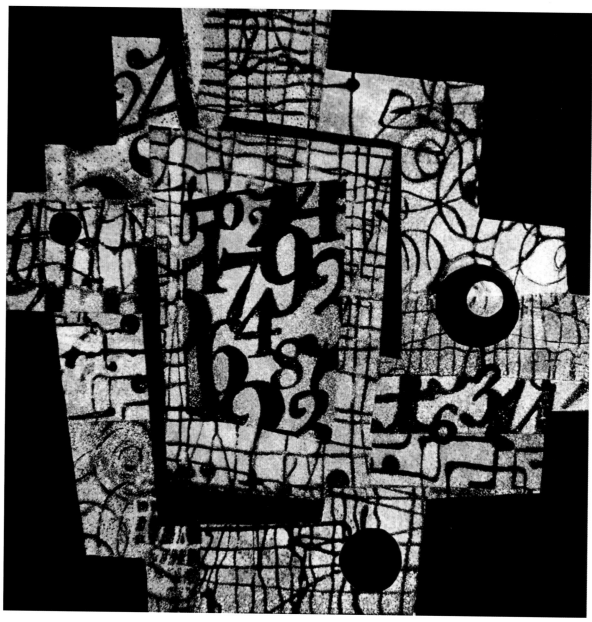

19 FINAL DETAILS
Add any final details and let the painting dry.

Finished Practice Sample
Jo Toye
10" × 10" (25cm × 25cm)
Acrylic on 140-lb. (300 gsm) watercolor paper

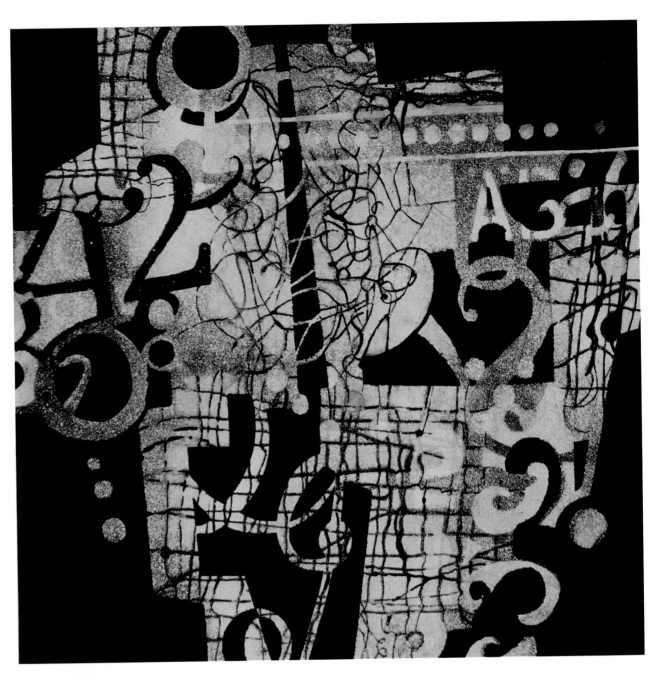

Calculated Risk
Jo Toye
12" × 12" (30cm × 30cm)
Acrylic on 140-lb. (300 gsm) watercolor paper

This painting is a good example of the gradation of value that you can obtain when using the mouth atomizer. Where the spray is less dense, the white appears gray. Although the eye sees "gray" amidst the black and white shapes, only white High Flow acrylic was sprayed.

VISIT ARTISTSNETWORK.COM/ABSTRACT-EXPLORATIONS FOR BONUS CONTENT.

GALLERY

Here are a few more examples of the various ways I utilize line in my paintings. Use these examples as inspiration for exploring your own unique style using the techniques you have learned.

Liquid Gold
Jo Toye, collection of Jane Underhill
13" × 13" (33cm × 33cm)
Acrylic on rice paper

After the Rain
Jo Toye
10" × 24" (25cm × 61cm)
Acrylic and ink on paper

**Sacred Conversations Series:
Fully Alive**
Jo Toye
12" × 12" (30cm × 30cm)
Acrylic on 140-lb. (300 gsm) water-
color paper

Seasoned Opponents
Jo Toye
20" × 16" (51cm × 41cm)
Acrylic on rice paper

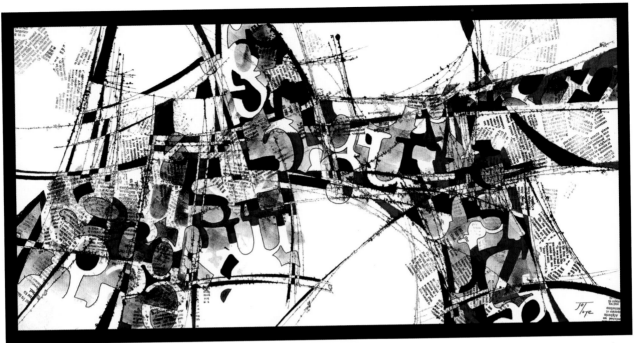

Unspoken
Jo Toye
12" × 24" (30cm × 61cm)
Acrylic and ink on Yupo

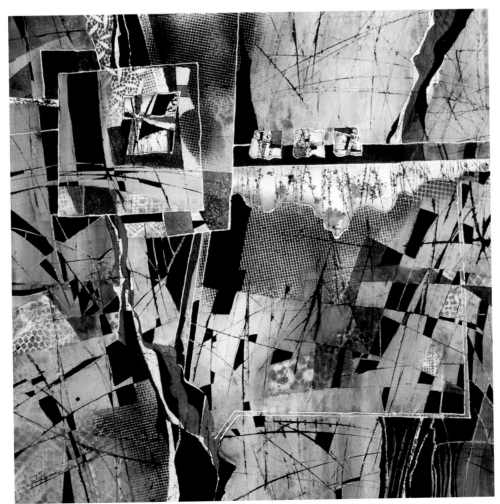

Field of Dreams
Jo Toye
20" × 20" (51cm × 51cm)
Acrylic and ink on 140-lb. (300 gsm)
watercolor paper

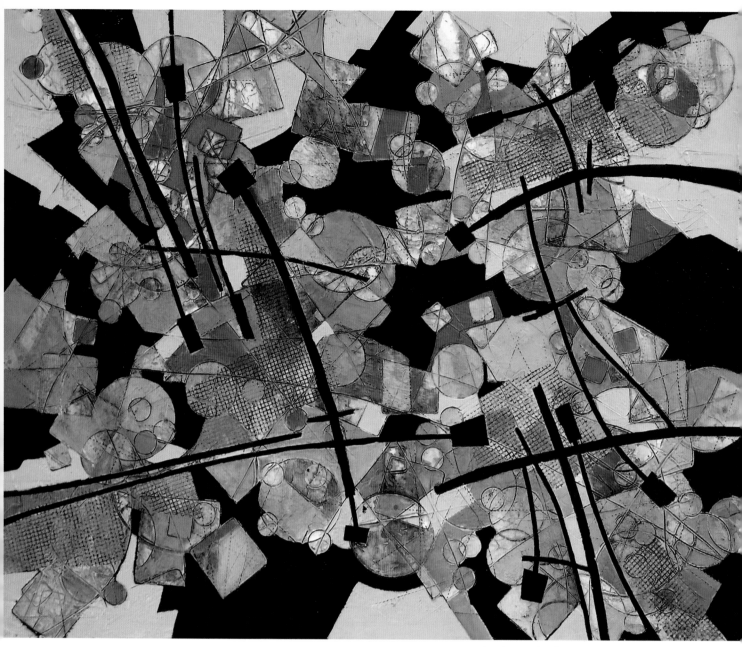

In the Beginning
Jo Toye, collection of The Church
of the Beatitudes
18" × 22" (46cm × 56cm)
Acrylic on 300-lb. (640 gsm) water-
color paper

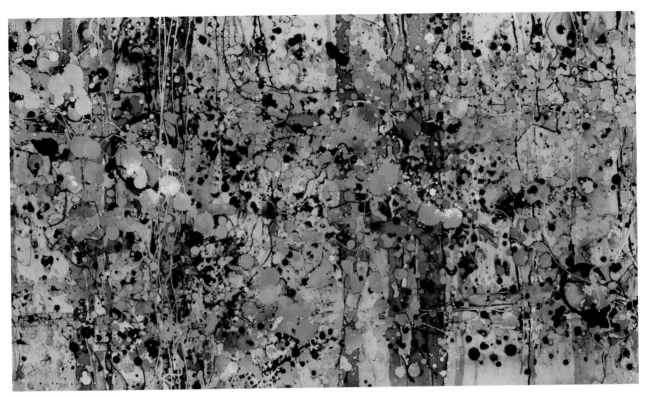

Rhythms of Change
Jo Toye
12" × 24" (30cm × 61cm)
Acrylic and ink on paper

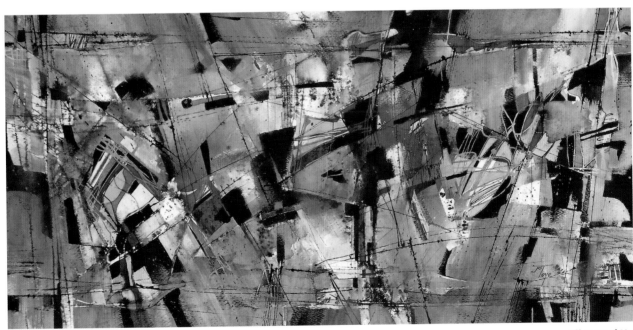

All Jazzed Up
Jo Toye, collection of Barb and Jeremy Jones
10" × 22" (25cm × 56cm)
Acrylic and ink on paper

137

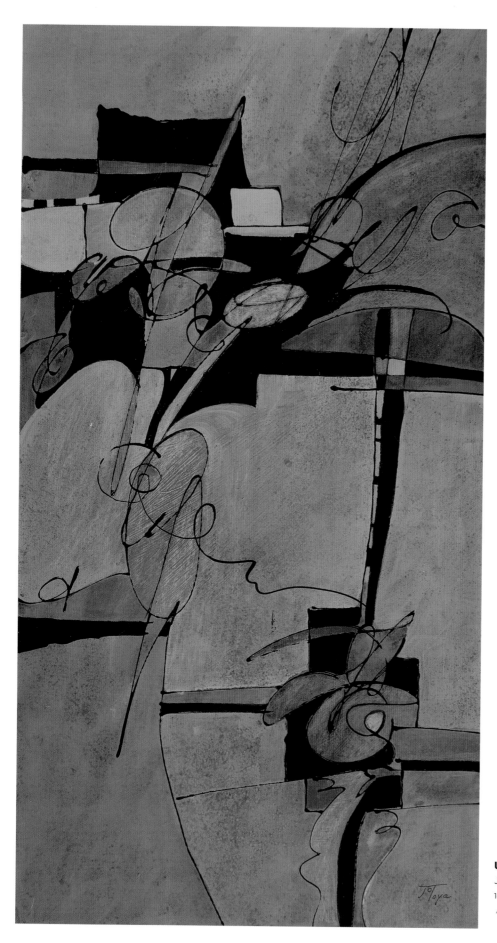

Untitled
Jo Toye
18" × 10" (46cm × 25cm)
Acrylic on Yupo

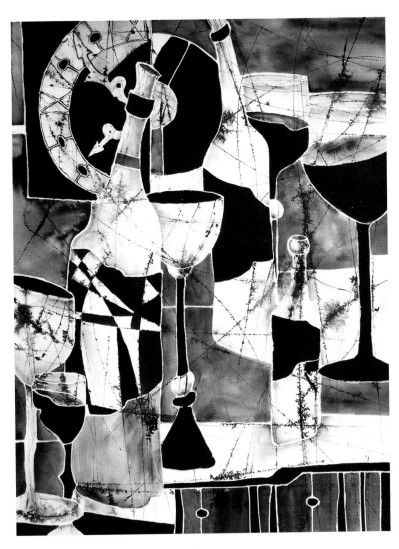

Nothing Is Ever Black and White
Jo Toye
20" × 15" (51cm × 38cm)
Acrylic and ink on 140 lb. (300 gsm) watercolor paper

RESOURCES

I encourage you to shop at your local art supply store, which should carry most of the items used throughout the book. For those few specialized items such as the Resist Pen and applicator bottles, if you cannot find those locally many of the online art suppliers now carry them. Otherwise, here are some resources for the pipettes and mouth atomizers.

•Jeff's Atomizer (Because these are handmade, at times there may be limited quantities available.)
www.inspiredpalettestudio.com

•Pat Dew's Atomizer
Cheap Joe's
www.cheapjoes.com

•Pipettes (They also carry the Resist Pen and applicator bottles.)
Paper and Ink Arts
www.paperinkarts.com

•Arizona Art Supply (where I conduct many of my local classes) carries most of the supplies (except the custom mouth atomizers) mentioned in the book. They have five locations throughout the Phoenix metropolitan area as well as an online presence.
Arizona Art Supply
www.arizonaartsupply.com

INDEX

a content + ecommerce company

Other fine North Light Books are available from your favorite bookstore, art supply store or online supplier. Visit our website at fwmedia.com.

20 19 5

DISTRIBUTED IN CANADA BY FRASER DIRECT
100 Armstrong Avenue
Georgetown, ON, Canada L7G 5S4
Tel: (905) 877-4411

DISTRIBUTED IN THE U.K. AND EUROPE
BY F&W MEDIA INTERNATIONAL LTD
Brunel House, Forde Close, Newton Abbot, TQ12 4PU, UK
Tel: (+44) 1626 323200, Fax: (+44) 1626 323319
Email: enquiries@fwmedia.com

DISTRIBUTED IN AUSTRALIA BY CAPRICORN LINK
P.O. Box 704, S. Windsor NSW, 2756 Australia
Tel: (02) 4560-1600; Fax: (02) 4577 5288
Email: books@capricornlink.com.au

ISBN 13: 978-1-4403-4153-3

Edited by Brittany VanSnepson
Designed by Corrie Schaffeld and Breanna Loebach
Photography by Jeff Toye
Production coordinated by Jennifer Bass

ACKNOWLEDGMENTS

This book could never have come into being without my husband and best friend, Jeff. He encouraged me from the beginning, cheered me on throughout the whole process, and pulled me back from the edge when I was feeling overwhelmed. He cleaned the house, washed the clothes, did the grocery shopping, cooked the meals, and even did the dishes! (I know what you are thinking, and no, I will not loan him out!) To top it off, he took all of the pictures for the book and fixed my computer problems along the way. During this time I have jokingly referred to him as my "man servant," but the reality is that he has unreservedly served me with his time, his talent, his understanding, and his heart. Nothing I can say here could begin to express my gratitude.

My deepest gratitude to Betsy Dillard Stroud, who first saw the artist in me and beckoned her to come out, and to the late Dick Phillips, who inspired me to become the artist I am today.

To my students, who repeatedly asked me to write this book, I am deeply indebted. They have bravely and willingly charted new territories with me, shared amazing discoveries of their own, and have been a constant source of encouragement and delight.

And finally, a special thanks to the staff of F+W who gave me this incredible opportunity: To Kristy Conlin for believing in the idea for this book; Brittany VanSnepson, my editor, for graciously enduring my epistles full of questions and guiding the books creation; and to the design team who brought what I could only envision into reality.

METRIC CONVERSION CHART

To convert	to	multiply by
Inches	Centimeters	2.54
Centimeters	Inches	0.4
Feet	Centimeters	30.5
Centimeters	Feet	0.03
Yards	Meters	0.9
Meters	Yards	1.1